FANTASY COSTUMES

for MANGA, ANIME & COSPLAY

A Drawing Guide and Sourcebook

Junka Morozumi
& Tomomi Mizuna

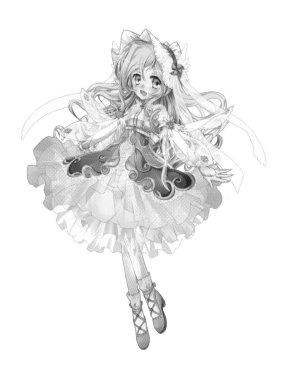

TUTTLE Publishing

Tokyo | Rutland, Vermont | Singapore

Contents

CHAPTER 1:
Mixing It Up

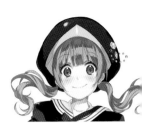

2 Military Apparel

3 Casual Basics

4 Gothic & Formal Wear

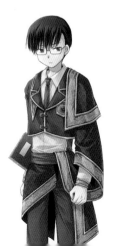

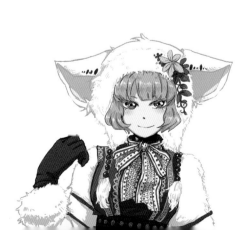

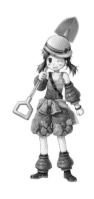

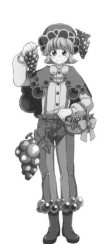

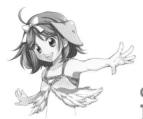

CHAPTER 2:
Variations

CHAPTER 3:
Distinctive Accessories

CHAPTER 4:
Decorations & Embellishments

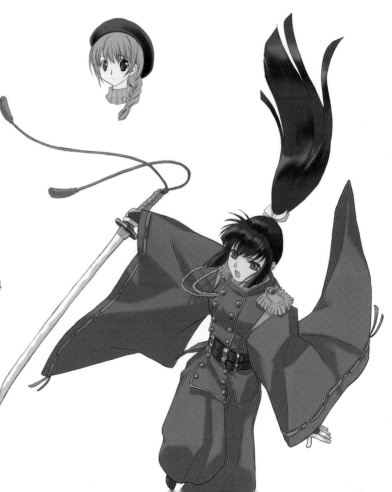

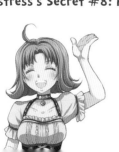

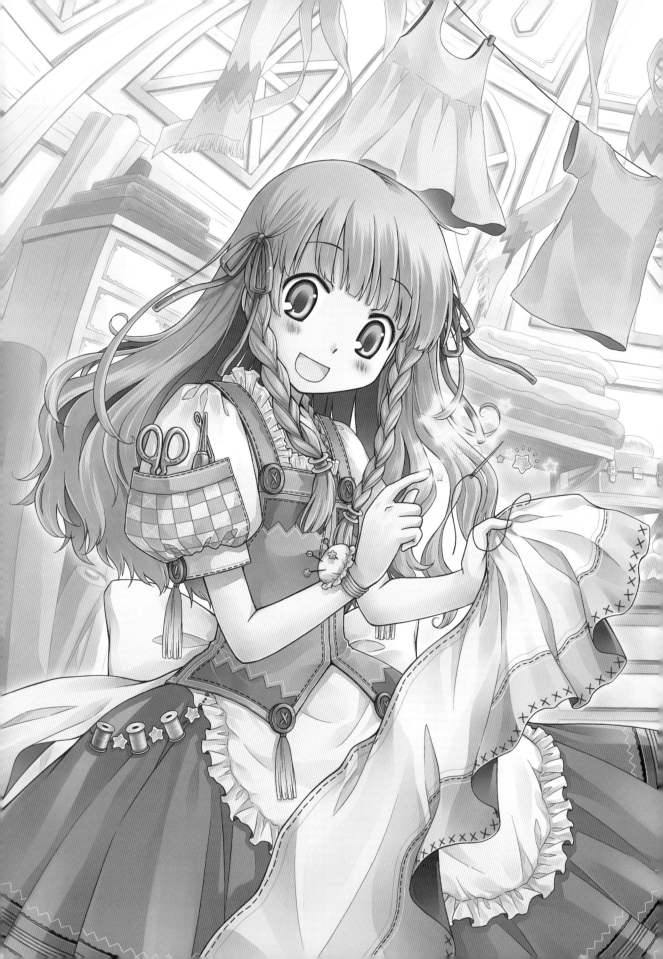

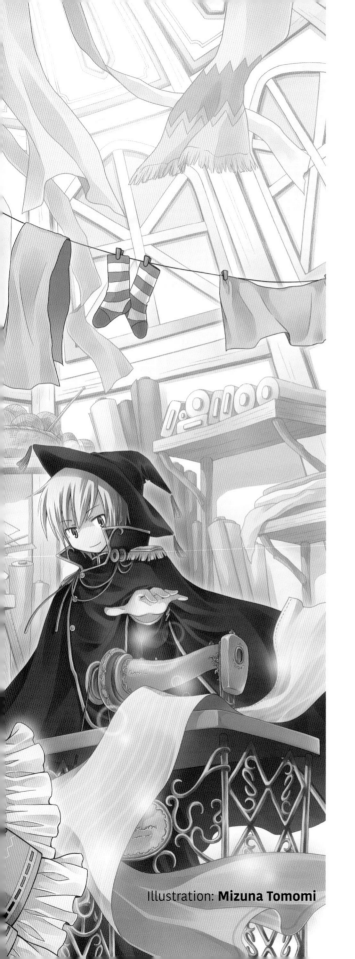

Illustration: **Mizuna Tomomi**

Prologue

"I want to draw captivating characters in spectacular outfits, but I can't think of any good costumes and the characters in my drawings always end up looking the same."

Sound familiar? This book was born from a desire to alleviate—however slightly—those concerns.

Flipping through the pages of fashion magazines, regular outfits and uncomplicated color combinations abound, but it's hard to find the fantastic designs like those at fashion shows, or clothing that uses colors that immediately catch the eye.

So where should people who have trouble thinking up costumes look for inspiration? In this book, we show you how to come up with new, never-before-seen designs by using the method of "multiplying" two elements together. We have also featured the winning entries of a costume design contest held in collaboration with TINAMI, an illustration exchange SNS site—there are more than 120 spectacular costume designs.

So embrace the matrix and use the multiplying method to create unique, original costumes!

Military Apparel × Winter

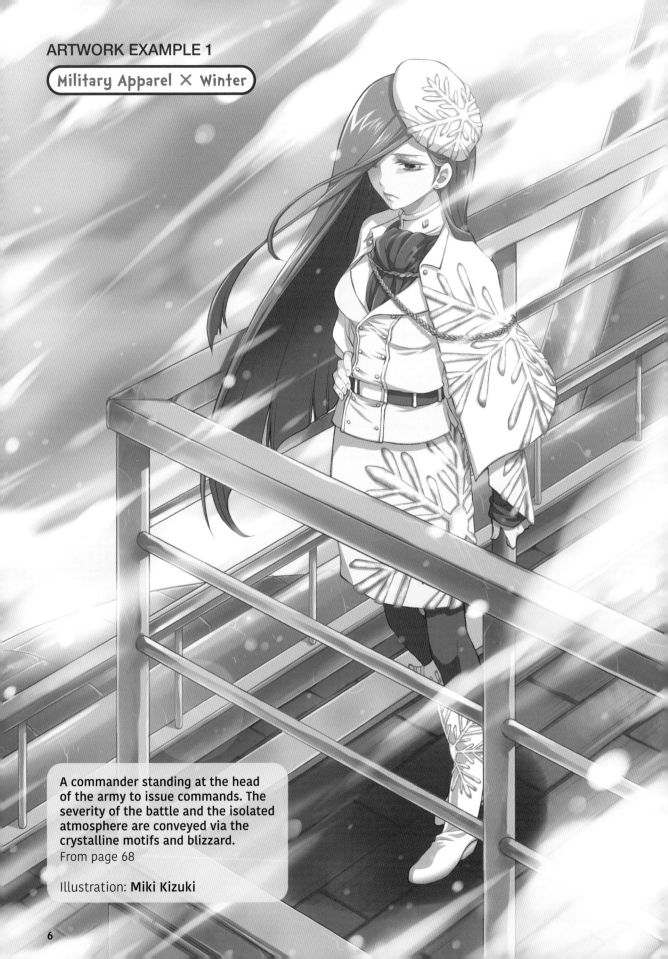

A commander standing at the head of the army to issue commands. The severity of the battle and the isolated atmosphere are conveyed via the crystalline motifs and blizzard.

From page 68

Illustration: **Miki Kizuki**

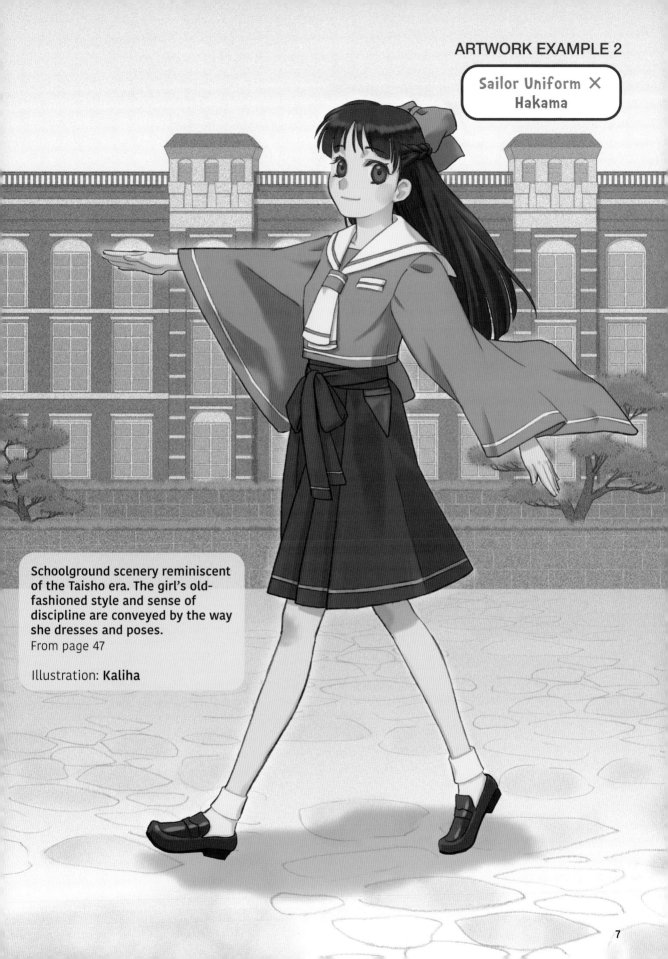

Sailor Uniform ✕ Hakama

Schoolground scenery reminiscent of the Taisho era. The girl's old-fashioned style and sense of discipline are conveyed by the way she dresses and poses.

From page 47

Illustration: **Kaliha**

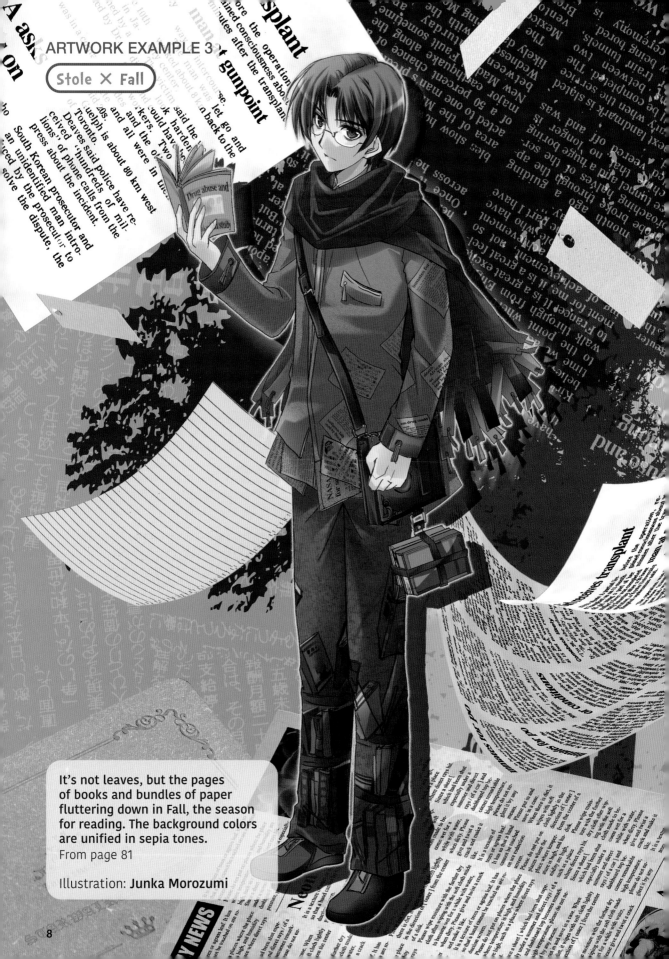

ARTWORK EXAMPLE 3

Stole × Fall

It's not leaves, but the pages of books and bundles of paper fluttering down in Fall, the season for reading. The background colors are unified in sepia tones.

From page 81

Illustration: **Junka Morozumi**

ARTWORK EXAMPLE 4

Costumes themed after elements such as fire and water are presented in card form. Create a composition where the costume is clearly seen, while creating a sense of cohesion and balance between the costume, frame and background.

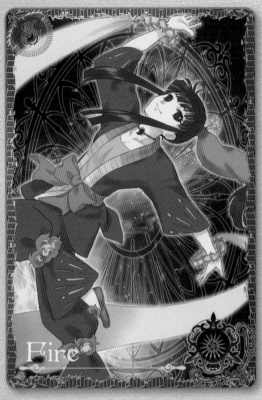

Fire

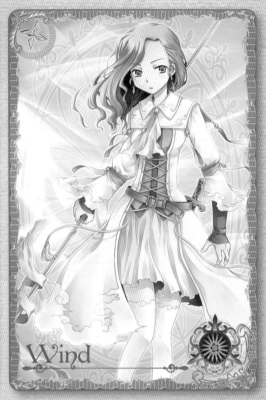

Wind

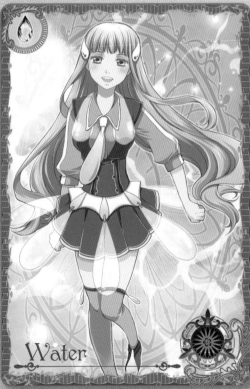

Water

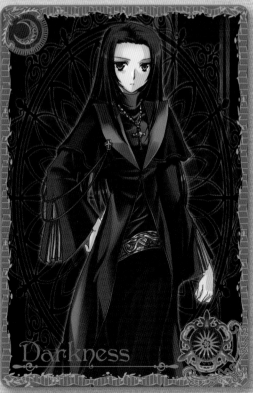

Darkness

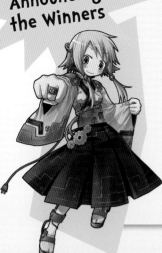
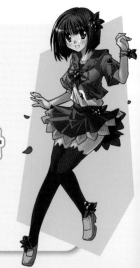

Your drawings are now in a book!

Tinami Maar-sha Costume Design Contest

Contest was held on TINAMI (http://www.tinami.com/), a comprehensive information site for anime and manga creators.

Contest themes

Uniform	Gothic Lolita/Lolita	Japanese Dress	Ethnic Costumes

×

Fire	Water	Wind	Earth	Animals	Plants	Mechanical Objects

The contest called for original costume designs created by combining one element each from the "Base" and "Motif."

Results

Grand Prize Three winners

Artworks are on pages 11–13. For winners' comments and profiles, see the end of the book.

⦿ろろろ子さん Rororoko　⦿武田ほたるさん Takeda Hotaru　⦿sava さん

Outstanding Performance Award

Artworks are introduced within the text throughout the book. For winners' comments and profiles, see the end of the book.

⦿水森みけさん Mike Mizumori　⦿灯章さん Akari Fumi　⦿ekm さん　⦿nasako さん
⦿音月もづくさ Mozuku Ototsuki　⦿深山キリさん Kiri Fukayama　⦿形状さん Keijo
⦿有村さんArimura　⦿しいなさん Shiina　⦿絵西さん Enishi

Honorable Mention 30 winners

Artworks are introduced within the text throughout the book. For profiles, see the end of the book.

⦿東雲ネコ太郎さんNekotaro Shinonome　⦿mochi さん　⦿ネコタさん Nekota　⦿hariko さん　⦿ツキカゲさん Tsukikage　⦿仲原さん Nakahara　⦿天満あこさん Tenman Ako　⦿葉月結さん Hazuki Yui　⦿水海碧さん Aoi Mizuumi　⦿骨軒さん Koken　⦿inari さん　⦿murach さん　⦿あもさんAmo　⦿神木せなさん Sena Kamiki　⦿小日向らいちさん Raichi Kohinata　⦿musubi さん　⦿Nia さん　⦿akito さん　⦿つのつきさん Tsunotsuki　⦿くれさん Kure　⦿ゆえなつきさん Natsuki Yue　⦿色 s さん　Iro s　⦿深見小春さん　⦿灯章さん Akari Fumi　⦿かるもんさん Karumon　⦿れいらさんReira　⦿高橋陸さん Riku Takahashi　⦿準さんJun　⦿ウツヒラさん Utsuhira　⦿茶波さん Chanami

Congratulations to all the winners, and thank you to everyone who participated.

(In no particular order)

⑤ Japanese Dress ✕ ⑨ Nature

Japanese Dress ✕ Earth

A cross between a samurai or god of Japanese mythology and earth/nature motifs. While incorporating several elements such as rock, jade and copper, the unified color scheme creates a clean and cohesive look.

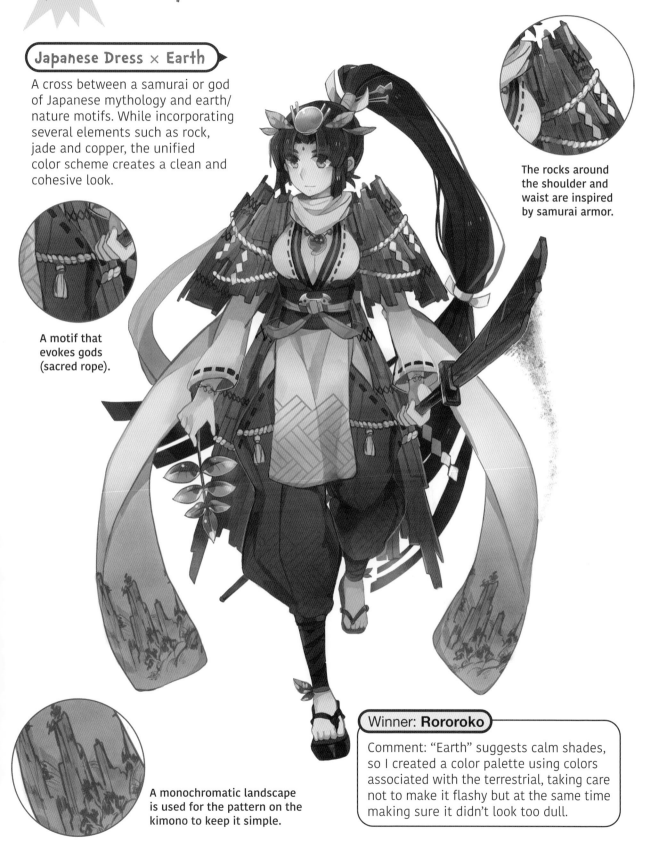

A motif that evokes gods (sacred rope).

The rocks around the shoulder and waist are inspired by samurai armor.

A monochromatic landscape is used for the pattern on the kimono to keep it simple.

Winner: **Rororoko**

Comment: "Earth" suggests calm shades, so I created a color palette using colors associated with the terrestrial, taking care not to make it flashy but at the same time making sure it didn't look too dull.

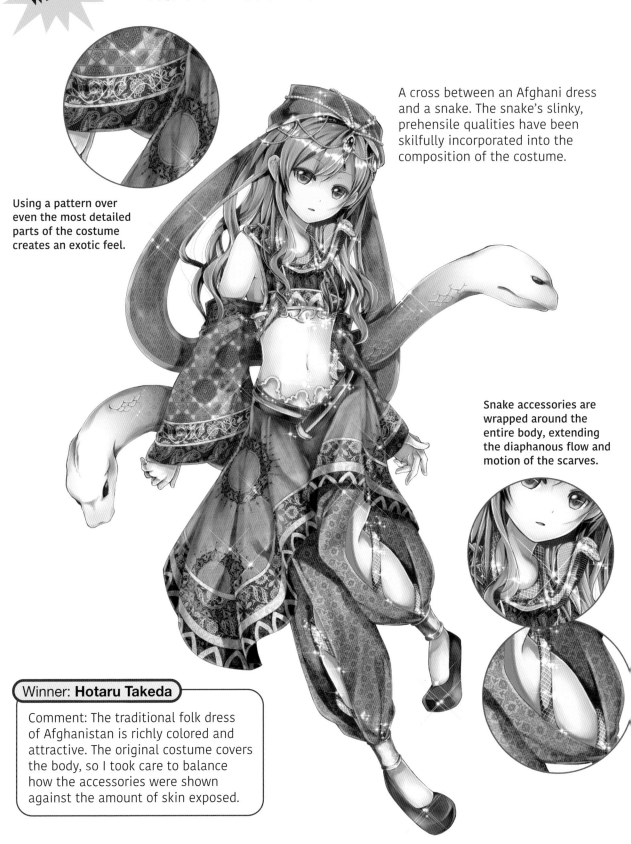

A cross between an Afghani dress and a snake. The snake's slinky, prehensile qualities have been skilfully incorporated into the composition of the costume.

Using a pattern over even the most detailed parts of the costume creates an exotic feel.

Snake accessories are wrapped around the entire body, extending the diaphanous flow and motion of the scarves.

Winner: **Hotaru Takeda**

Comment: The traditional folk dress of Afghanistan is richly colored and attractive. The original costume covers the body, so I took care to balance how the accessories were shown against the amount of skin exposed.

Winner ⑥ Ethnic Costumes ✕ ⑩ Mechanical Objects

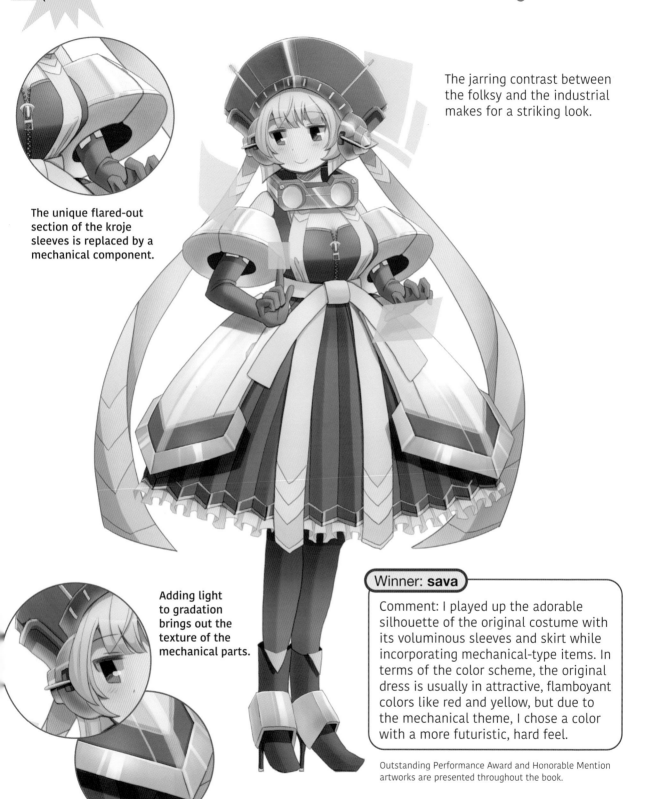

The unique flared-out section of the kroje sleeves is replaced by a mechanical component.

The jarring contrast between the folksy and the industrial makes for a striking look.

Adding light to gradation brings out the texture of the mechanical parts.

Winner: sava

Comment: I played up the adorable silhouette of the original costume with its voluminous sleeves and skirt while incorporating mechanical-type items. In terms of the color scheme, the original dress is usually in attractive, flamboyant colors like red and yellow, but due to the mechanical theme, I chose a color with a more futuristic, hard feel.

Outstanding Performance Award and Honorable Mention artworks are presented throughout the book.

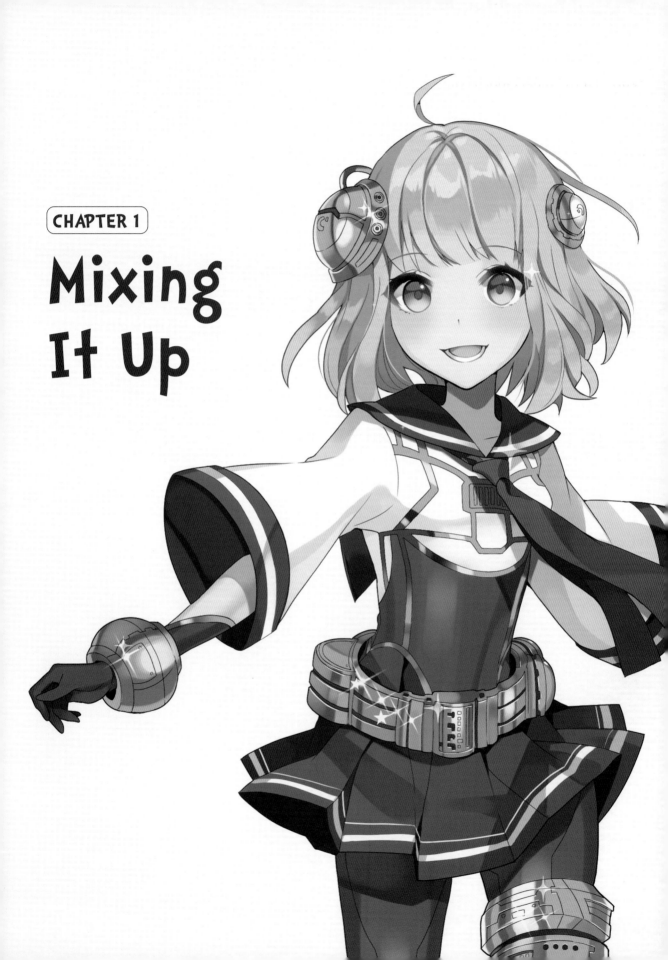

CHAPTER 1

Mixing It Up

Although it's fun to devise an original design, creating a fresh new look is difficult. Start by mixing existing elements ("multiplying" or "crossing"), for example blending everyday clothes and ethnic costumes with motifs derived from plants and nature.

The costumes of characters in manga, anime and games are novel and unique, but if you look at them closely, many of them are based on existing apparel combined with motifs that define that particular character. In this chapter, we'll present new costume designs created by crossing six base types and five motif types. Try using this as a reference for how to effectively play up a base design and discover what to focus on to convey the main theme.

Design Bases

- **1** School Uniforms
- **2** Military Apparel
- **3** Casual Basics
- **4** Gothic & Formal Wear
- **5** Japanese Dress
- **6** Ethnic Costumes

×

Motifs (themes & characteristics)

- **7** Plants
- **8** Animals
- **9** Nature
- **10** Mechanical Objects
- **11** Seasons

You can also cross two bases. Consider using Base × Base or Base × Motif.

For example: Sailor Uniform × Japanese Dress
(base × base)

Gothic Lolita × Rabbit
(base × motif)

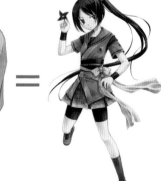

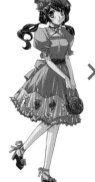

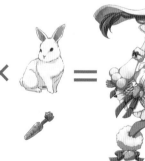

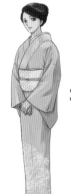

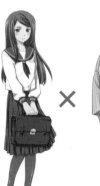

I see! If it's a matter of mixing elements, I should be able to do it too! But even when it comes to familiar garments, it's sometimes difficult to remember exactly what they look like. Start by checking the basic forms of each item!

Let's start by confirming the basics! ▶▶▶

1 School Uniform Basics

▼ Girl's Blazer

The single-breasted type with 2–3 buttons is common. There is a pocket on the left breast.

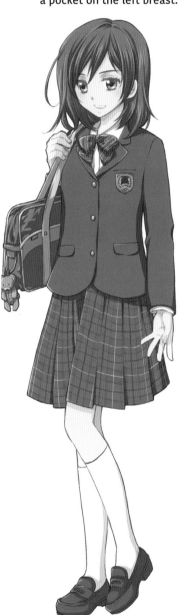

▶ Boy's Blazer

Boys wear a necktie with blazers. Boys' blazers button left over right.

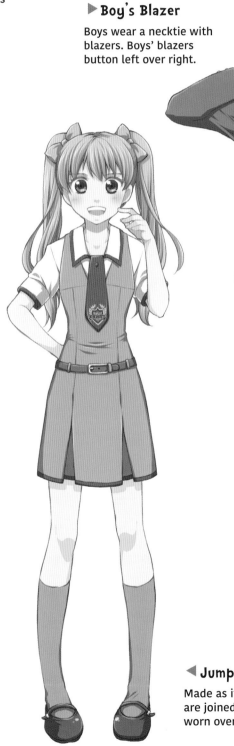

Girls' blazers button right over left. Pair the blazer with a pleated check-pattern skirt or a skirt made from the same fabric as the blazer.

◀ Jumper

Made as if the vest and skirt are joined together. A jacket is worn over it in winter.

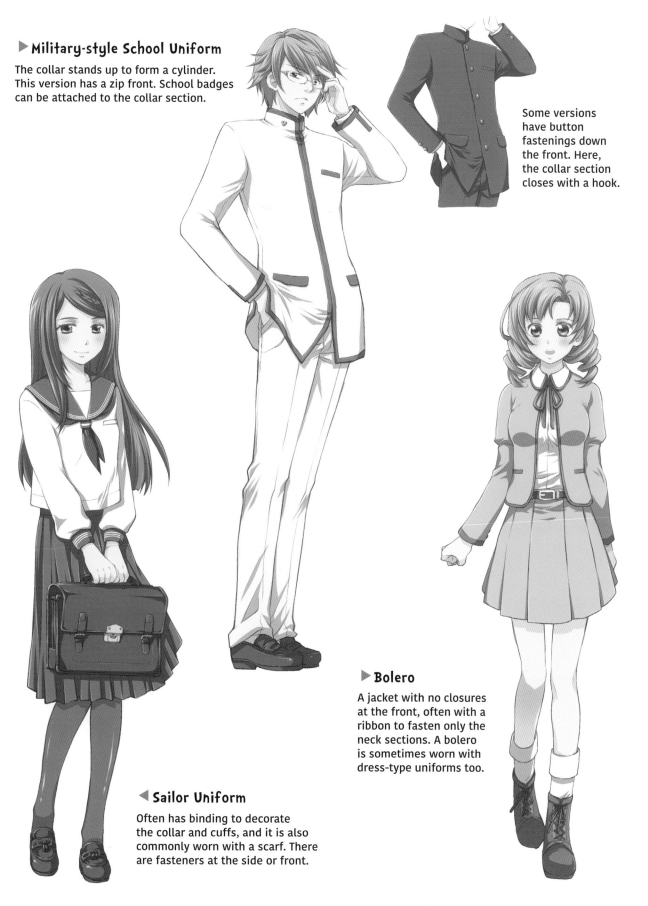

▶ Military-style School Uniform

The collar stands up to form a cylinder. This version has a zip front. School badges can be attached to the collar section.

Some versions have button fastenings down the front. Here, the collar section closes with a hook.

▶ Bolero

A jacket with no closures at the front, often with a ribbon to fasten only the neck sections. A bolero is sometimes worn with dress-type uniforms too.

◀ Sailor Uniform

Often has binding to decorate the collar and cuffs, and it is also commonly worn with a scarf. There are fasteners at the side or front.

2 Military Apparel Basics

Key points for making military apparel look authentic

- epaulettes •ornamental braided cord •military cap •standing collar •boots •leather shoes •medals •belts •gold buttons •shoulder armor •camouflage patterns •center-creased pants •arm badges •piping on pants and cuffs

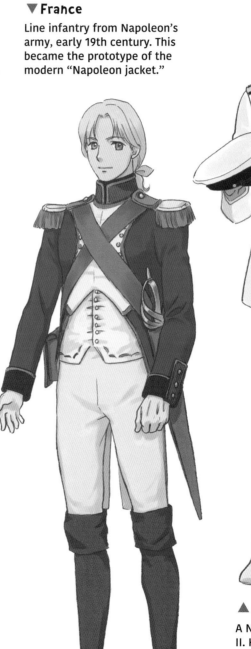

▼ **France**

Line infantry from Napoleon's army, early 19th century. This became the prototype of the modern "Napoleon jacket."

▲ **Germany**

Gothic armor from the end of the 15th century. Lilies and other patterns are depicted via embossing and engraving.

▲ **Japan**

A Navy major during World War II. He wears a dagger at his waist. The standing collar is the prototype of the boys' school uniform known as a *gakuran*.

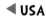
▼ Germany

A Secret Police (SS) officer during the Nazi era in 1932. He is distinguished by his black uniform and khaki shirt. The color of the epaulette (only on the right shoulder in this uniform), collar badges and piping on the cap indicate the rank of the soldier.

◄ USA

A mechanic in the U.S. Army. She wears coveralls in a camouflage print. The coveralls open at the front and fasten with a zip.

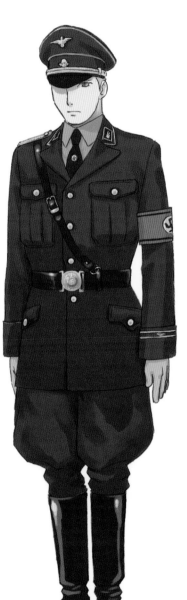

If you remove the top of the U.S. Army mechanic's coveralls and tie the sleeves around the waist, it looks like this.

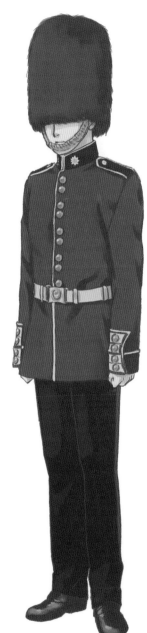

▲ England

A Queen's Guard attached to the royal residence, still seen today. There are five regiments, each with its own particular jacket buttons and collar insignia. This infantryman belongs to the Coldstream Regiment.

③ Casual Basics

▼ Two-piece set

The upper section and the skirt are separate but made from the same fabric. Design-wise, there is a sense of unity between the top and bottom sections.

▶ Blouse

Made from a soft fabric. Usually fastens with buttons at the front.

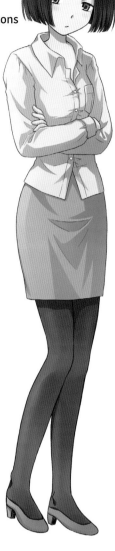

▲ Dress

The upper section and the skirt are joined. Even if the fabric changes below the chest or at the waist, as long as it's all connected, it's still called a dress.

A blouse with a standing collar. There are various designs for the collar.

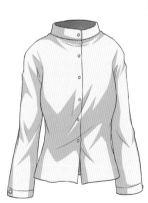

A combination of rounded collar and puffed sleeves. There are also many variations for the sleeves.

Key points for creating a casual look

• loose, relaxed silhouette • often in soft fabrics • relaxed neckline • colorful shades • embellishment is not overly flashy but simple • can be worn regardless of gender and nationality

▼ Parka

Describes a garment with a hood at the neckline and pockets around the stomach. Mainly worn against the cold, it's made from windproof material.

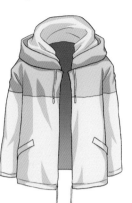

◀ Pullover

A garment with no opening in the front or back that is worn by pulling it over the head. Many dresses and sweaters are pullover types.

▼ Coat

Worn against the cold, this is a trenchcoat. It has characteristic epaulettes and a belt.

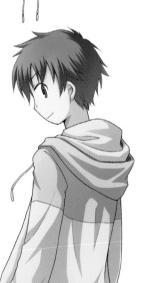

▼ Duffle coat

Hooded, with toggles at the front that fasten through loops.

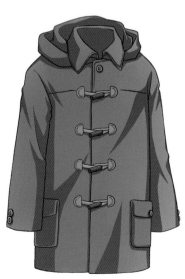

Casual clothes are easy to move in, with many designs focusing on functionality.

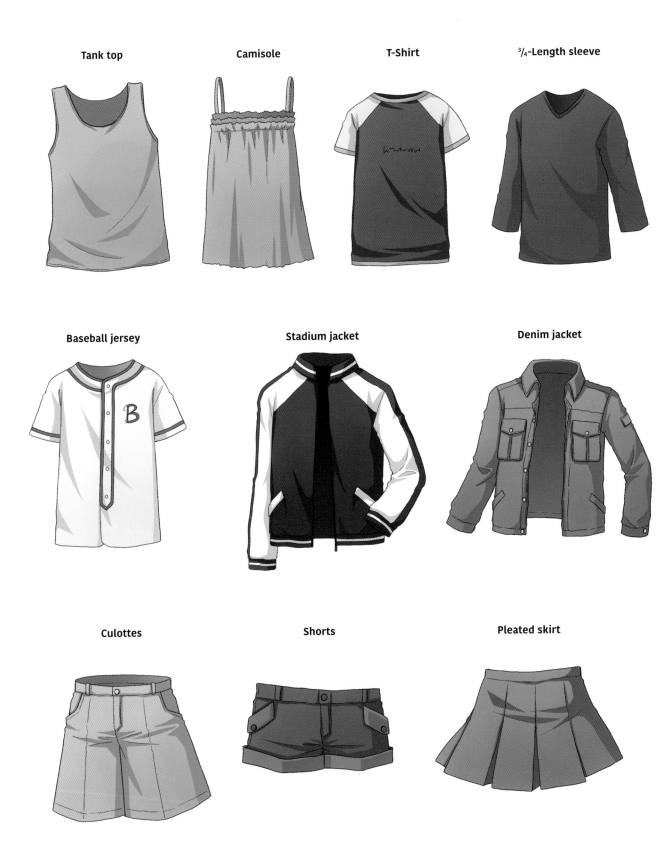

Tank top

Camisole

T-Shirt

³/₄-Length sleeve

Baseball jersey

Stadium jacket

Denim jacket

Culottes

Shorts

Pleated skirt

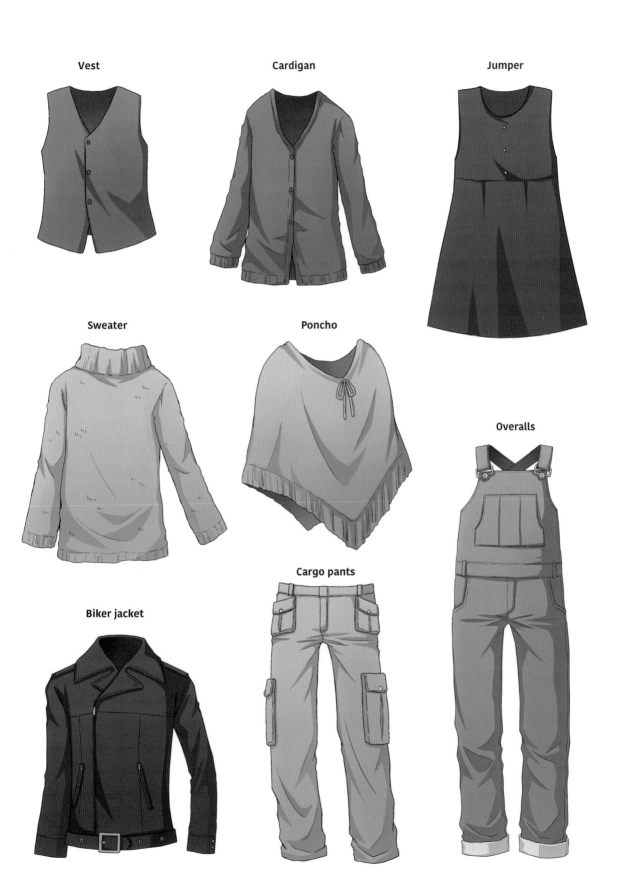

Vest

Cardigan

Jumper

Sweater

Poncho

Overalls

Biker jacket

Cargo pants

4 Gothic & Formal Wear Basics

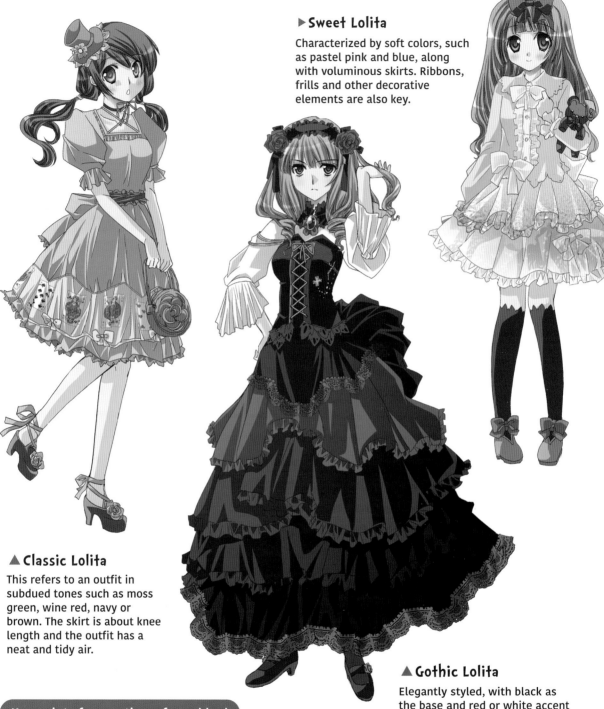

▶ Sweet Lolita

Characterized by soft colors, such as pastel pink and blue, along with voluminous skirts. Ribbons, frills and other decorative elements are also key.

▲ Classic Lolita

This refers to an outfit in subdued tones such as moss green, wine red, navy or brown. The skirt is about knee length and the outfit has a neat and tidy air.

▲ Gothic Lolita

Elegantly styled, with black as the base and red or white accent colors. Use luxurious fabrics such as satin and velvet.

Key points for creating a formal look

- subdued colors such as black, navy, purple, wine red, deep green
- rigid, thick fabrics • luxurious fabrics such as silk and velvet
- gorgeous decorations such as frills and lace • shoes with heels
- custom-made dimensional cutting to fit the body • classical items such as capes, corsets, hats, hairpieces and ornate hair accessories

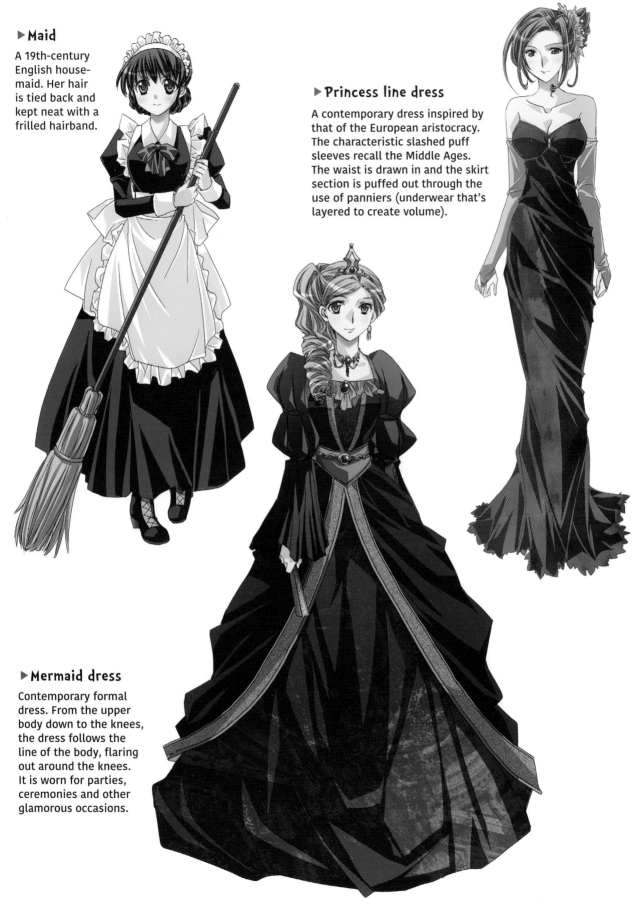

▶Maid

A 19th-century English house-maid. Her hair is tied back and kept neat with a frilled hairband.

▶Princess line dress

A contemporary dress inspired by that of the European aristocracy. The characteristic slashed puff sleeves recall the Middle Ages. The waist is drawn in and the skirt section is puffed out through the use of panniers (underwear that's layered to create volume).

▶Mermaid dress

Contemporary formal dress. From the upper body down to the knees, the dress follows the line of the body, flaring out around the knees. It is worn for parties, ceremonies and other glamorous occasions.

◀ Boyish Lolita

A fop-style old-fashioned way of dressing. The hat and the pumpkin-shaped pants are key to creating a boyish throwback look.

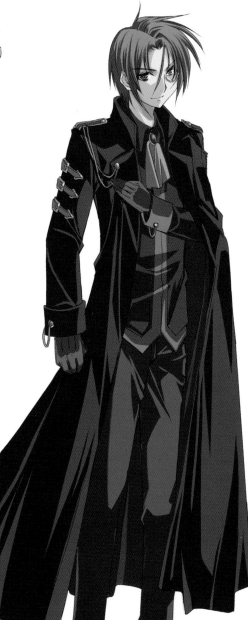

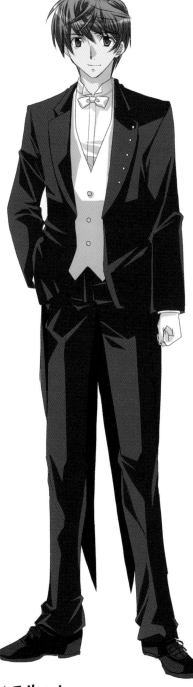

▶ Men's Gothic

Contemporary male style. The long black coat and leather shoes create a chic look. Using ribbon ties, gloves and other small items is also effective.

▲ Tailcoat

Men's contemporary formal wear, originating in the 18th century. The back of the jacket is divided like a swallowtail. The shirt, tie and waistcoat must all be white.

Gothic & Formal Wear Accessories

There are many items that are gorgeous and have a sense of presence even on their own. Using too many looks cluttered, so consider the character's personality and use items as key accents.

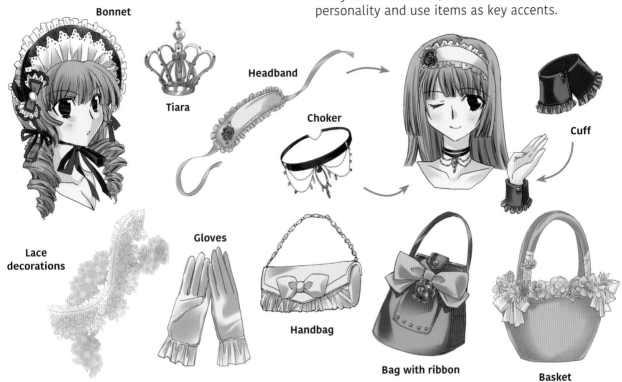

Bonnet

Tiara

Headband

Choker

Cuff

Lace decorations

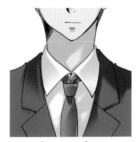

Gloves

Handbag

Bag with ribbon

Basket

Men's Accessories

Men have few accessories, there are many ornamental items that have formal meaning, such as neckties tied differently depending on the occasion.

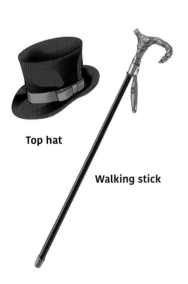

Top hat

Walking stick

Men's Neckties

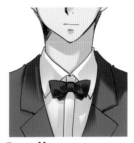

Regular necktie

Has a wide range of uses, from military uniforms to suits to everyday wear.

Bow tie

Formal dress for parties and other formal occasions.

Continental tie

A simplified version of the bow tie. It can also be called a cross tie.

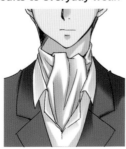

Ascot

Makes a more casual impression than formal attire.

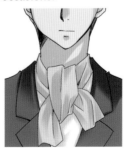

Scarf tie

Often used in equestrian wear.

String tie

A cord necktie that works with collarless shirts as well. Also called a loop tie.

5 Japanese Dress Basics

Key points for creating authentic Japanese dress

- left side of a garment over the right side • shoulder seams are lower than those of Western dress • black hair • obis • Japanese hairstyles • Japanese flower decorations such as cherry or citrus flowers • traditional Japanese colors such as leek green and vermilion • Japanese motifs such as flowing water • straw sandals and wooden *geta* sandals

◀ Kimono (contemporary)

Formal attire for women, designed so that the motifs connect when the fabric is sewn into a kimono (*ebazuke*).

▶ Samurai attire (Edo period)

A samurai in the formal attire of *hakama* (men's divided skirt) and *haori* jacket. The family crest is resist dyed into the fabric in five places—both sides of the chest and both sleeves, plus the center back. When samurai met with their lord, they wore a *kamishimo* (old ceremonial dress) instead of a *haori*.

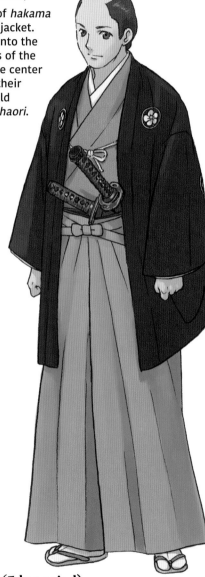

◀ Furisode (Edo period)

A girl from a samurai family wearing a *furisode* over a *kosode* (small-sleeved kimono). The *kosode* and *uchikake* (a short-sleeved kimono worn over a *kosode*) were patterned with motifs dyed in the *yuzen-zome* style or embroidered in fine thread. Many of today's designs that are known as "traditional patterns" originated in the Edo period.

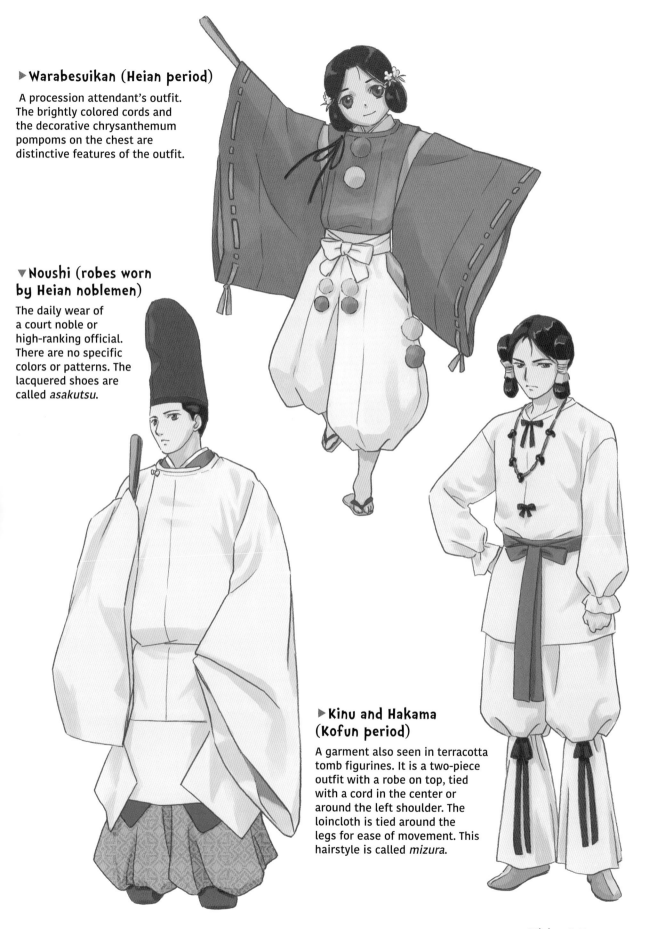

▶Warabesuikan (Heian period)

A procession attendant's outfit. The brightly colored cords and the decorative chrysanthemum pompoms on the chest are distinctive features of the outfit.

▼Noushi (robes worn by Heian noblemen)

The daily wear of a court noble or high-ranking official. There are no specific colors or patterns. The lacquered shoes are called *asakutsu*.

▶Kinu and Hakama (Kofun period)

A garment also seen in terracotta tomb figurines. It is a two-piece outfit with a robe on top, tied with a cord in the center or around the left shoulder. The loincloth is tied around the legs for ease of movement. This hairstyle is called *mizura*.

6 Ethnic Costume Basics

▶ India

The sari is worn as everyday apparel. One piece of fabric is wound around the body starting at the waist, then brought up over the chest to drape over one shoulder. On the upper body, a short blouse called a *ghagra* is often worn beneath the fabric.

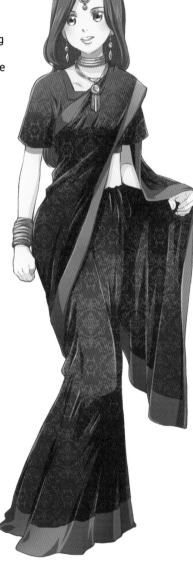

▲ China

The cheongsam. In Chinese, it is called *chousan* (long dress) and is characterized by its standing collar and side slit. There are more than 50 ethnic groups living in China, so there are many other ethnic costumes other than the cheongsam.

▶ Vietnam

Ethnic dress called an ao dai (meaning "long item of clothing"). In the vein of Chinese apparel, it's worn with white pants called *quan* and, when the sun is strong, a hat called a *non la*.

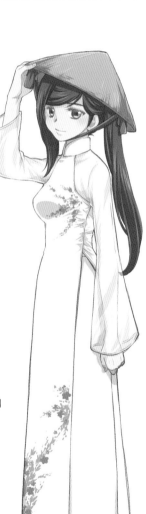

Disclaimer: The details of ethnic dress of each country differ slightly depending on region and era; those shown here are only representations.

◀ Ainu (Japan)

The dress of the indigenous people who live in Hokkaido. Called an *attush*, it's made from fabric woven from tree bark fibers and embroidered and edged in cotton. The neck decoration made from metal and glass beads is called a *tamasai*.

▼ Russia

An ankle-length pinafore called a *sarafan*. Traditional customs once dictated that married women cover their hair with a scarf or hat.

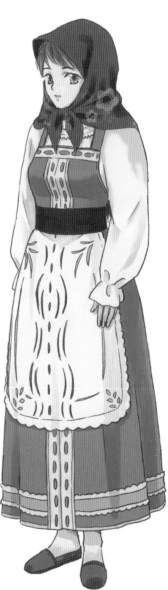

▶ Georgia

Georgia is a country in western Asia. Worn with narrow boots, this long coat is called a *chokha*, and is ethnic attire for men. The bandolier on the chest is a remnant of the times when it was worn as battle dress.

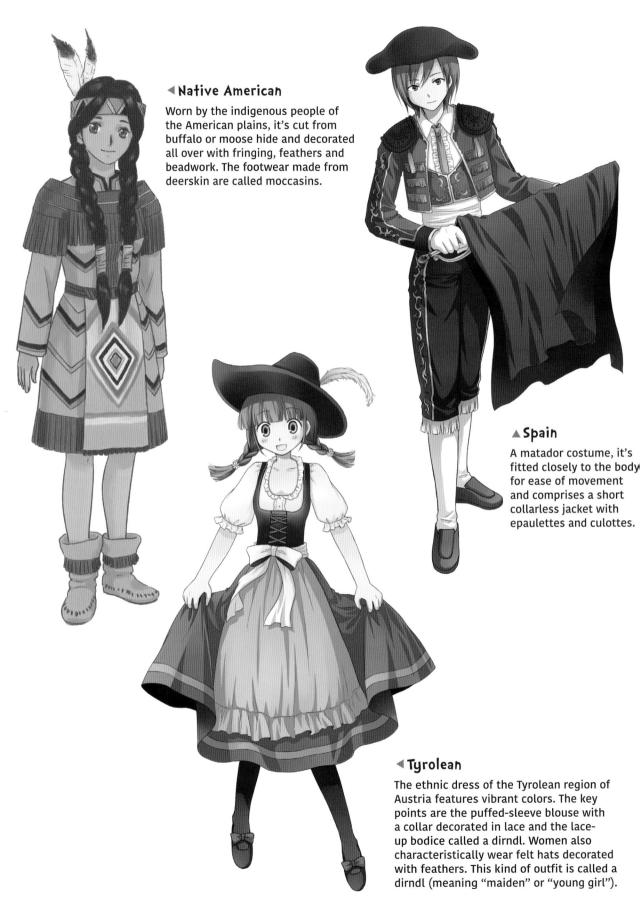

◀ Native American

Worn by the indigenous people of the American plains, it's cut from buffalo or moose hide and decorated all over with fringing, feathers and beadwork. The footwear made from deerskin are called moccasins.

▲ Spain

A matador costume, it's fitted closely to the body for ease of movement and comprises a short collarless jacket with epaulettes and culottes.

◀ Tyrolean

The ethnic dress of the Tyrolean region of Austria features vibrant colors. The key points are the puffed-sleeve blouse with a collar decorated in lace and the lace-up bodice called a dirndl. Women also characteristically wear felt hats decorated with feathers. This kind of outfit is called a dirndl (meaning "maiden" or "young girl").

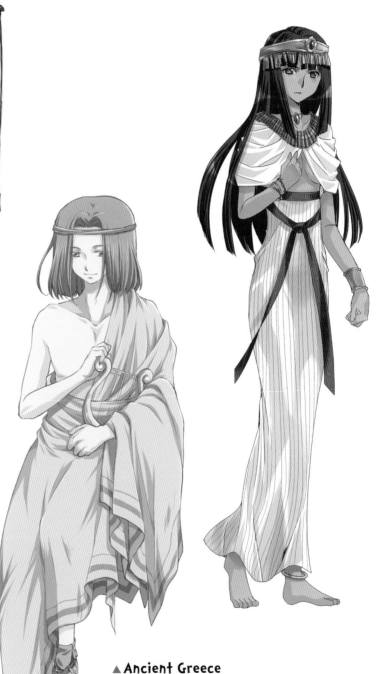

▼ Ancient Egypt

A woman of high status, wearing a conical dress made from cotton or linen with an upper garment draped around her shoulders. She wears accessories made from gold, glass, precious stones and leather.

▲ Scotland

The same tartan fabric used for the kilt is draped over the shoulder like a manteau. The check pattern differs from family to family. The traditional instrument called bagpipes make for the ultimate accessory.

▲ Ancient Greece

Over a simple loincloth—the himation—a large rectangular piece of *raxa* cloth (wool woven cloth) was wrapped. The himation was usually white, but gradually various colors came to be used. The leather sandals are called crepidula.

7 Plant Basics

Plant motifs evoke a range of seasonal images and hues. Leaves and greenery can create a calm impression, while fruit is often used to add fun contemporary colors.

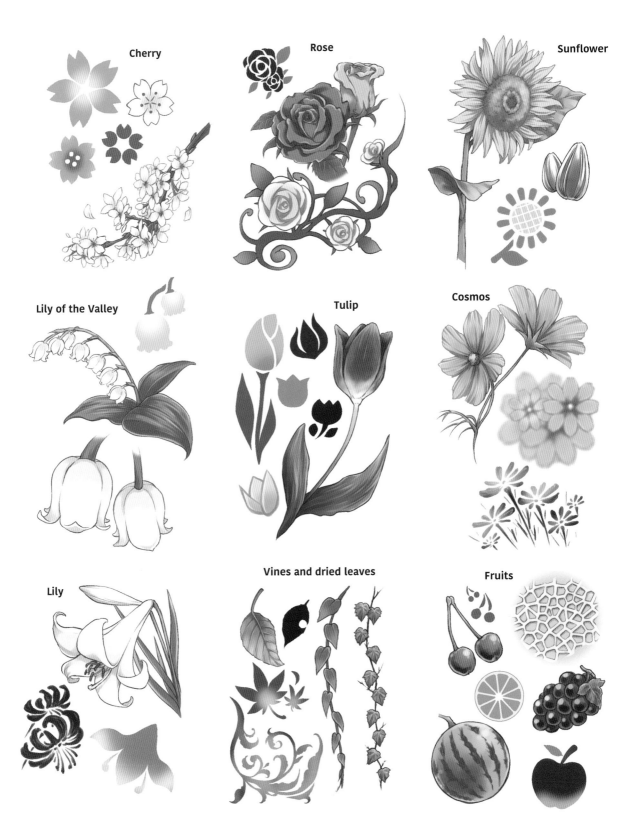

Cherry

Rose

Sunflower

Lily of the Valley

Tulip

Cosmos

Lily

Vines and dried leaves

Fruits

8 Animal Basics

If you use an animal as a motif, you can give the character the same qualities as the animal. Let's start by taking a closer look at a range of furry, feathered and finned creatures.

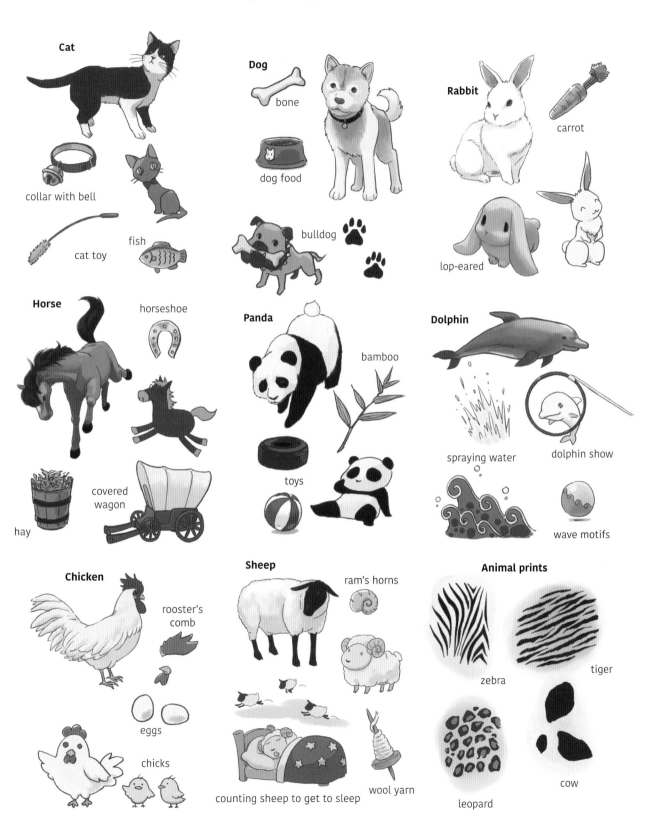

Cat

collar with bell

cat toy

fish

Dog

bone

dog food

bulldog

Rabbit

carrot

lop-eared

Horse

horseshoe

hay

covered wagon

Panda

bamboo

toys

Dolphin

spraying water

dolphin show

wave motifs

Chicken

rooster's comb

eggs

chicks

Sheep

ram's horns

counting sheep to get to sleep

wool yarn

Animal prints

zebra

tiger

leopard

cow

9 Nature Basics

Nature and the elements are powerful forces than can lend unusual imagery and fresh inspiration to your characters' costumes. Summoning the forces of nature might also inform your storylines, as your heroes and villains vie for supremacy.

Fire

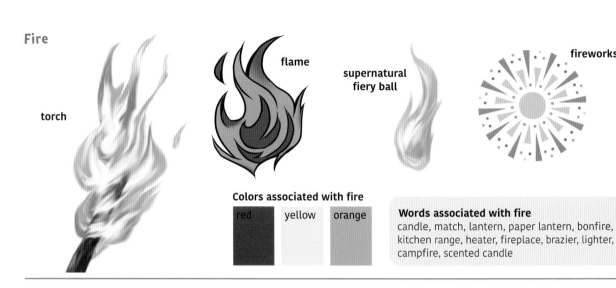

torch

flame

supernatural fiery ball

fireworks

Colors associated with fire

red	yellow	orange

Words associated with fire

candle, match, lantern, paper lantern, bonfire, kitchen range, heater, fireplace, brazier, lighter, campfire, scented candle

Water

waterfall

droplet

ripple

river

crown-shaped splash

Colors associated with water

blue	sky blue	navy

Words associated with water

ocean, wave, brook, canal, water wheel, spray, dew, ice, rain, swimming, fish, sky blue, puddles, water pistol, water balloon, bathing, whirlpools

Wind

tornado

windmill

weathervane

wind symbol

Colors associated with wind

light green	green	sky blue

Words associated with wind

spring wind, north wind, south wind, zephyr, squall, typhoon, gusts, twisters, hurricanes, coastal disturbances, tornados, sea breezes, windmills, flapping flags, windbreakers, windswept plains, Windy City

Earth

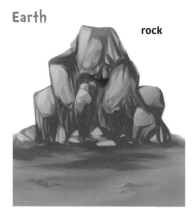

rock

clay figurine

strata

minerals and precious stones

ground

Colors associated with earth

brown	ochre	reddish brown

Words associated with earth

sand, soil, land, the Earth, sand, earthenware, mud, mole, worm, tree roots, ant nests, ground, mud wall, clay, desert, cave, limestone, quartz, marble, earthquake, tremors, seismic activity

Light

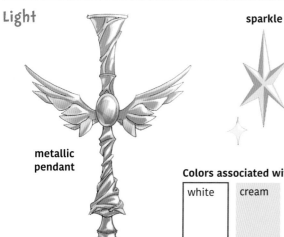

metallic pendant

sparkle

feathers

cross

Colors associated with light

white	cream	gold

Words associated with light

sun, dappled, mirror, prism, lens, kaleidoscope, firefly, rainbow, aurora, diamond dust, flash, lamp, beams, rays, sunrise, sunset, dawn, dusk, gloaming, eclipse, blinding light

Darkness

Demon wings

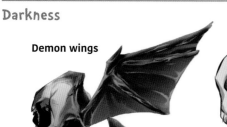

snake

skull

moonlit night

spiderweb

Colors associated with darkness

black	gray	purple

Words associated with darkness

demon, cemetery, gravestone, coffin, Dracula, ghosts, ravens, bats, moonlit nights, outer space, solar eclipse, lunar eclipse, the Milky Way, shooting stars, obsidian

⑩ Mechanical Object Basics

Mechanical items and devices are associated with works of science fiction, so incorporating their characteristics allows futuristic characters to come to life. Steampunk style, with its fusion of the antiquated and the mechanistic, works well with Gothic costumes.

Digital & Outer Space Items

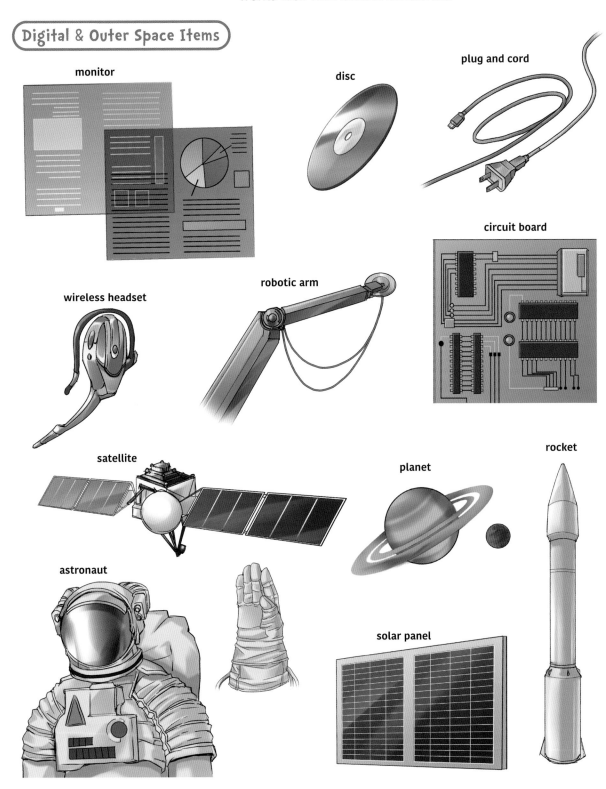

monitor

disc

plug and cord

circuit board

wireless headset

robotic arm

satellite

planet

rocket

astronaut

solar panel

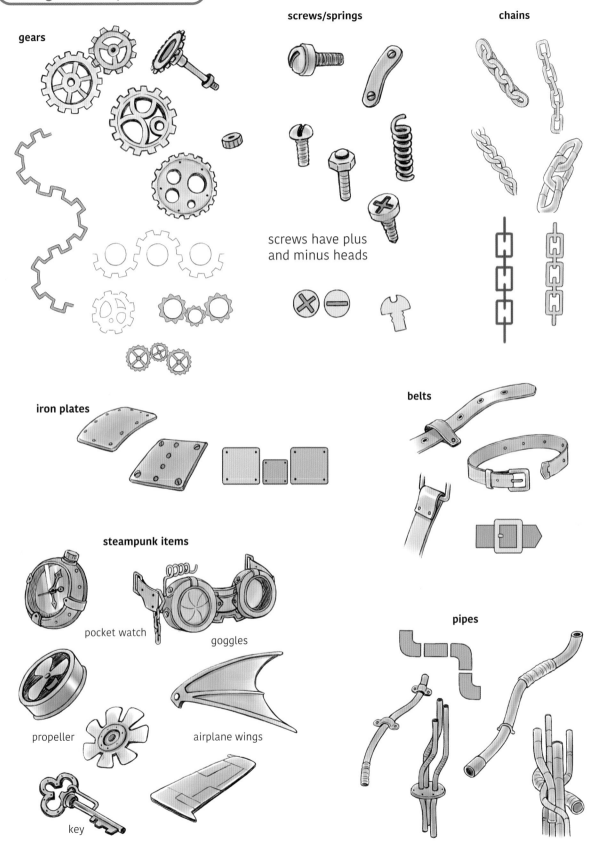

gears

screws/springs

chains

screws have plus
and minus heads

iron plates

belts

steampunk items

pocket watch

goggles

pipes

propeller

airplane wings

key

11 Seasonal Motifs

The months and seasons conjure a wealth of images and associations. Incorporating motifs from events throughout the year anthropomorphizes the seasons to interesting effect. These motifs also work well for calendar and planner illustrations.

① **January**

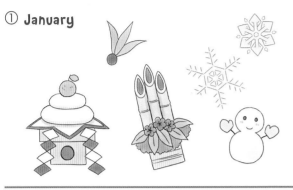

② **February**

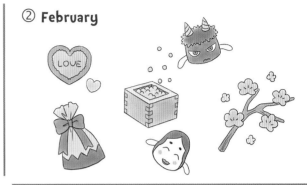

④ **April**

⑤ **May**

⑦ **July**

⑧ **August**

⑩ **October**

⑪ **November**

③ March

⑥ June

⑨ September

⑫ December

Annual Calendar Events

① January
New Year/New Year's cards/Chinese zodiac/kite flying/first sunrise of the year/New Year's Day/snowmen/Martin Luther King Jr. Day/garnet/carnation/camellia/new beginnings

② February
Valentine's Day/winter/snow/snowballs/snow forts/skiing/snowshoeing/ice skating/violets/irises/amethyst/tigers/Black History Month/leap year

③ March
Aquamarine/bloodstone/lions and lambs/daffodils/Women's History Month

④ April
Cherry blossoms/butterflies/crocuses/new shoots/tulips/April Fools' Day/diamond/daisy/sweet pea/spring break

⑤ May
emerald/lily of the valley/Memorial Day/Mother's Day/tadpoles/springtime

⑥ June
hydrangeas/umbrellas/rainboots/snails/frogs/swallows/thunder/rainbows/Father's Day/cherries/graduation

⑦ July
seagulls/whales/dolphins/shells/morning glories/fireworks/vacations/cookouts/Fourth of July/parades/camp

⑧ August
summer holidays/shaved ice/watermelons/ice cream/palm trees/swimming pools/camping/clouds/sunflowers/hand-held fan/garden vegetables/hiking, camping and backpacking

⑨ September
Labor Day/back to school/cluster amaryllis/harvest festivals/scarecrows

⑩ October
fall sports/Indigenous Peoples' Day/Halloween/pumpkins/monsters/witches/brooms/bats/apples/persimmons/pears/mushrooms/pumpkin carving/corn mazes/haunted houses/fall foliage/gourds/squash/costumes/trick or treat

⑪ November
fall foliage/harvest moon/Thanksgiving/raking leaves/topaz/citrine/chrysanthemum

⑫ December
Christmas/pine trees/bells/holly/mistletoe/holiday cookies/Hanukkah/Kwanzaa/Santa Claus/reindeer/presents/parties/oranges/winter solstice/wreaths/candy canes/ornaments/carols

How to Use This Book

All the pages in Chapter 1 follow this layout!

The base and motif looks that are being crossed and combined.

The costume design resulting from the blending of the two elements. It might be interesting to look at this picture first and try to guess what elements have been combined to make the costume before reading the text!

Essential information about the base and motif being crossed. Details such as the type of clothing, the name of the region for ethnic costumes and plant and animal names are listed here.

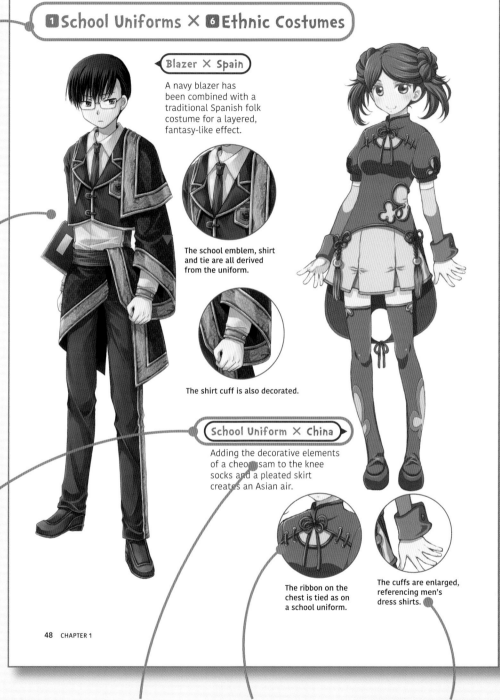

❶School Uniforms ✕ ❻Ethnic Costumes

Blazer ✕ Spain

A navy blazer has been combined with a traditional Spanish folk costume for a layered, fantasy-like effect.

The school emblem, shirt and tie are all derived from the uniform.

The shirt cuff is also decorated.

School Uniform ✕ China

Adding the decorative elements of a cheongsam to the knee socks and a pleated skirt creates an Asian air.

The ribbon on the chest is tied as on a school uniform.

The cuffs are enlarged, referencing men's dress shirts.

Supplementary information or points to note for the elements being crossed. Please refer to these when creating your own designs.

Close-ups highlight details to note.

Explanations of key points. Looking at details more closely can lead to a new look or direction.

①School Uniforms ✕ ②Military Apparel

Standing Collar ✕ Military Apparel

The check pattern and loose shirt indicate a school uniform, while the epaulettes and ornamental braid introduce the influence of military apparel.

Match the color of the epaulette decorations with the pants for a sense of cohesion.

Leave the shirt untucked to create a youthful air.

Blazer ✕ Military Apparel

School uniforms are derived from military apparel, so it's easy to mix the two. Make sure to bring out the hairstyle, the school emblems or colors and other related elements.

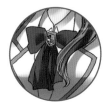

Medal-style ribbon.

Emblem on armband.

School Uniforms ✕ Casual Basics

School Uniform ✕ Parka

Cargo pants hanging off the hips and his hands in his pockets make for a casual, unpolished impression.

School emblem on arm pocket.

Use small items such as wristwatches to create a casual feel.

School Uniform ✕ Parka

Heart and polkadot patterns add a youthful and casual air.

Heart decorations on cords.

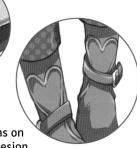

Heart patterns on boots for cohesion.

❶ School Uniforms ✕ ❹ Gothic & Formal Wear

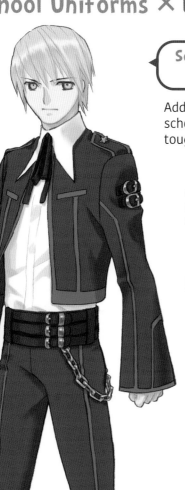

School Uniform ✕ Gothic Wear

Add Gothic elements to a school uniform to impart a tougher or edgier style.

A decorative belt replaces the emblem on the sleeve.

A three-tiered belt adds a sense of solidity.

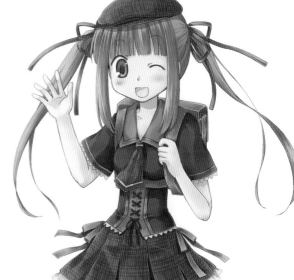

Corset-like lacing.

School Uniform ✕ Lolita

While ribbons and lace are used abundantly, the subdued color scheme of navy and bordeaux create the look of a school uniform.

The knee socks are in the same color scheme as the uniform.

① School Uniforms ✕ ④ Gothic & Formal Wear

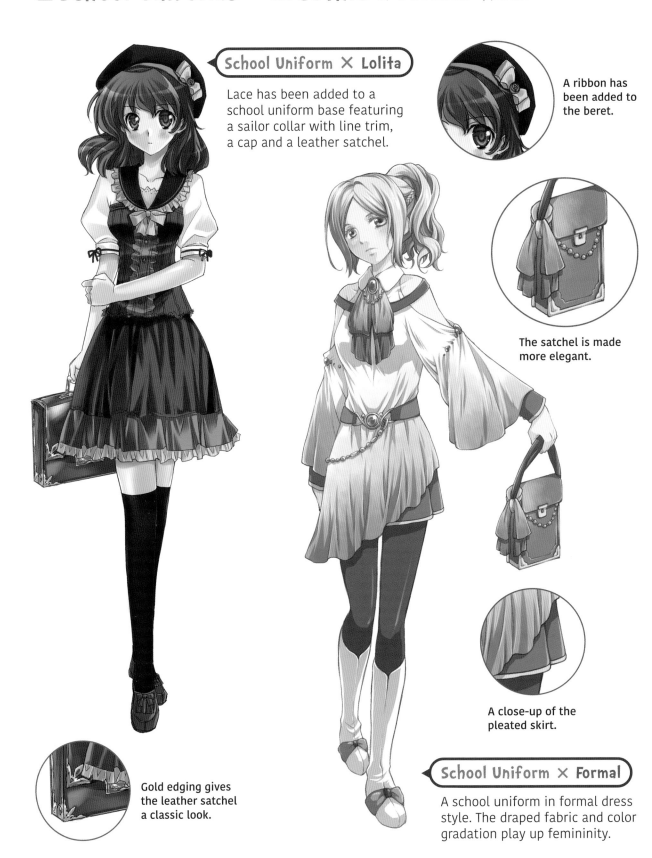

School Uniform ✕ Lolita

Lace has been added to a school uniform base featuring a sailor collar with line trim, a cap and a leather satchel.

A ribbon has been added to the beret.

The satchel is made more elegant.

A close-up of the pleated skirt.

Gold edging gives the leather satchel a classic look.

School Uniform ✕ Formal

A school uniform in formal dress style. The draped fabric and color gradation play up femininity.

❶ School Uniforms ✕ ❺ Japanese Dress

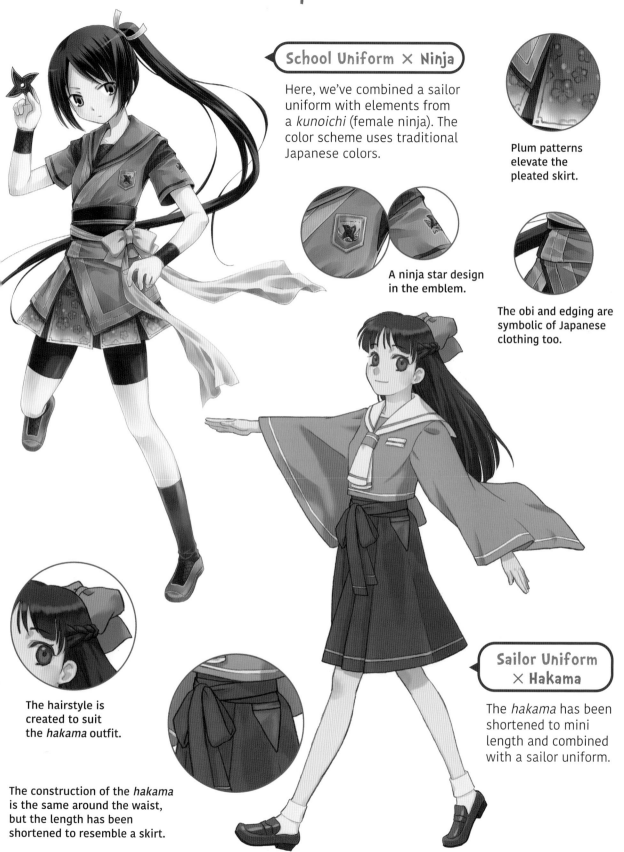

School Uniform ✕ Ninja

Here, we've combined a sailor uniform with elements from a *kunoichi* (female ninja). The color scheme uses traditional Japanese colors.

Plum patterns elevate the pleated skirt.

A ninja star design in the emblem.

The obi and edging are symbolic of Japanese clothing too.

The hairstyle is created to suit the *hakama* outfit.

Sailor Uniform ✕ Hakama

The *hakama* has been shortened to mini length and combined with a sailor uniform.

The construction of the *hakama* is the same around the waist, but the length has been shortened to resemble a skirt.

❶School Uniforms ✕ ❻Ethnic Costumes

Blazer ✕ Spain

A navy blazer has been combined with a traditional Spanish folk costume for a layered, fantasy-like effect.

The school emblem, shirt and tie are all derived from the uniform.

The shirt cuff is also decorated.

School Uniform ✕ China

Adding the decorative elements of a cheongsam to the knee socks and a pleated skirt creates an Asian air.

The ribbon on the chest is tied as on a school uniform.

The cuffs are enlarged, referencing men's dress shirts.

1 School Uniforms ✕ 7 Plants

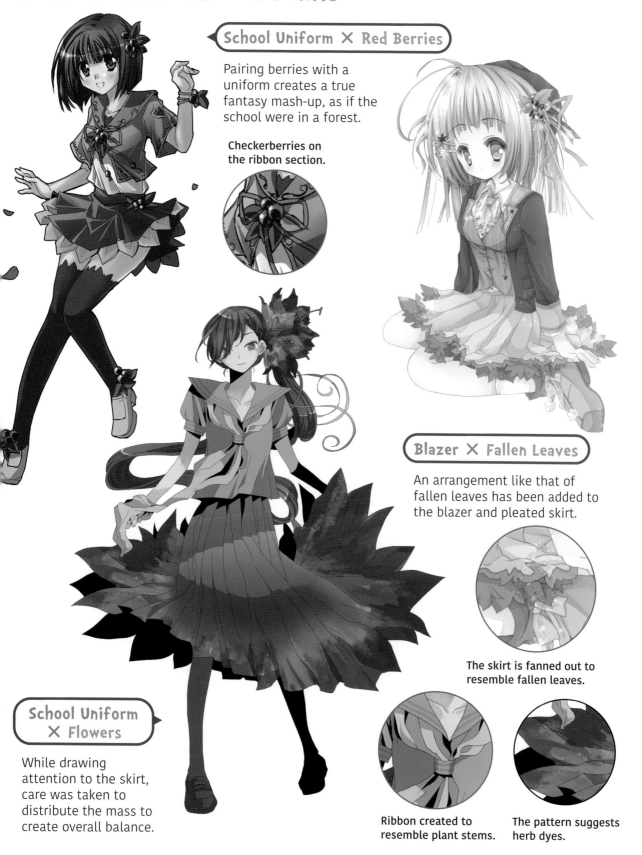

School Uniform ✕ Red Berries

Pairing berries with a uniform creates a true fantasy mash-up, as if the school were in a forest.

Checkerberries on the ribbon section.

Blazer ✕ Fallen Leaves

An arrangement like that of fallen leaves has been added to the blazer and pleated skirt.

The skirt is fanned out to resemble fallen leaves.

School Uniform ✕ Flowers

While drawing attention to the skirt, care was taken to distribute the mass to create overall balance.

Ribbon created to resemble plant stems.

The pattern suggests herb dyes.

❶School Uniforms ✕ ❽Animals

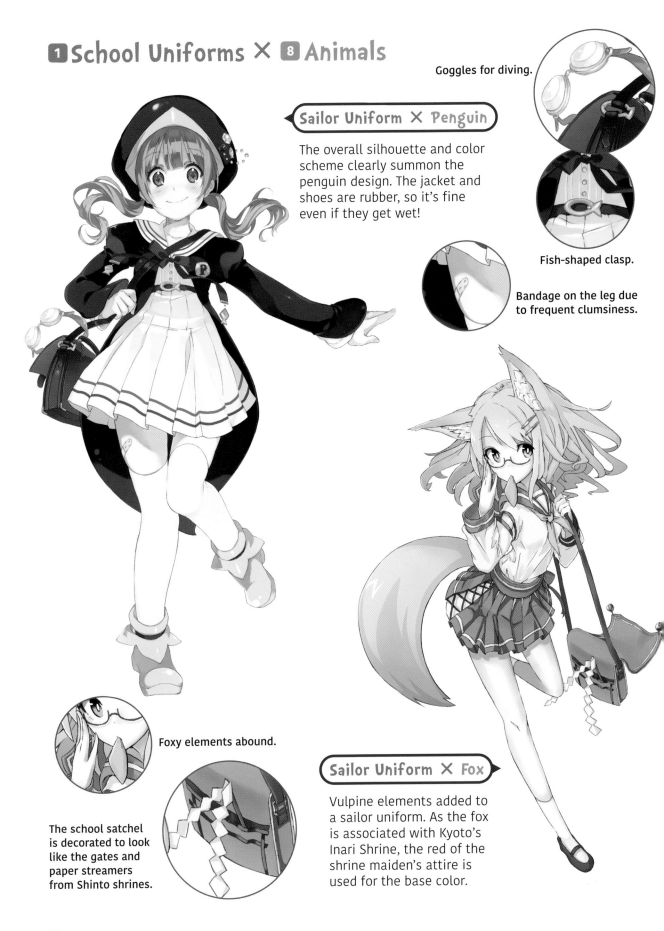

Goggles for diving.

> **Sailor Uniform ✕ Penguin**

The overall silhouette and color scheme clearly summon the penguin design. The jacket and shoes are rubber, so it's fine even if they get wet!

Fish-shaped clasp.

Bandage on the leg due to frequent clumsiness.

Foxy elements abound.

The school satchel is decorated to look like the gates and paper streamers from Shinto shrines.

> **Sailor Uniform ✕ Fox**

Vulpine elements added to a sailor uniform. As the fox is associated with Kyoto's Inari Shrine, the red of the shrine maiden's attire is used for the base color.

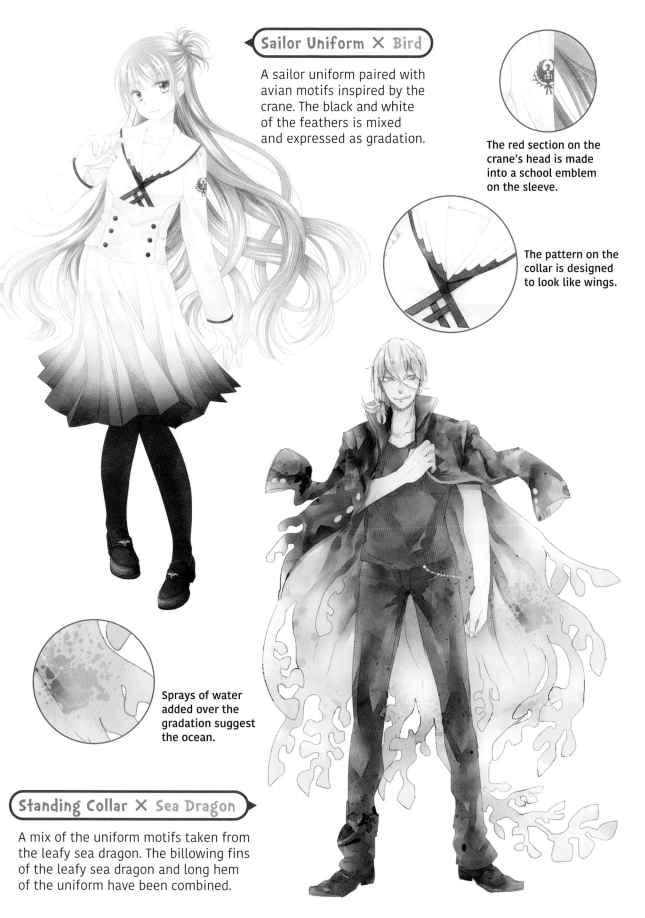

Sailor Uniform ✕ Bird

A sailor uniform paired with avian motifs inspired by the crane. The black and white of the feathers is mixed and expressed as gradation.

The red section on the crane's head is made into a school emblem on the sleeve.

The pattern on the collar is designed to look like wings.

Sprays of water added over the gradation suggest the ocean.

Standing Collar ✕ Sea Dragon

A mix of the uniform motifs taken from the leafy sea dragon. The billowing fins of the leafy sea dragon and long hem of the uniform have been combined.

❶ School Uniforms ✕ ❾ Nature

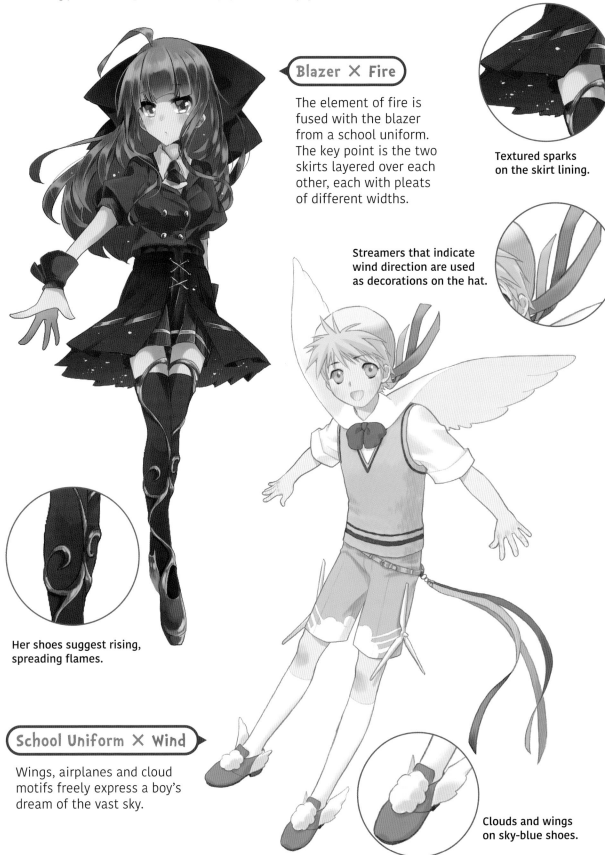

Blazer ✕ Fire

The element of fire is fused with the blazer from a school uniform. The key point is the two skirts layered over each other, each with pleats of different widths.

Textured sparks on the skirt lining.

Streamers that indicate wind direction are used as decorations on the hat.

Her shoes suggest rising, spreading flames.

School Uniform ✕ Wind

Wings, airplanes and cloud motifs freely express a boy's dream of the vast sky.

Clouds and wings on sky-blue shoes.

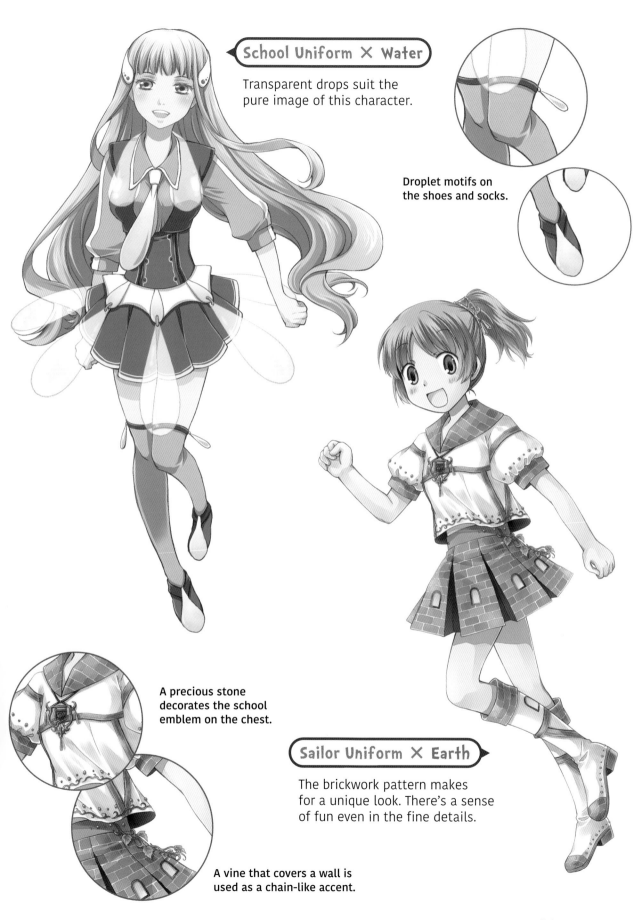

School Uniform ✕ Water

Transparent drops suit the
pure image of this character.

Droplet motifs on
the shoes and socks.

A precious stone
decorates the school
emblem on the chest.

Sailor Uniform ✕ Earth

The brickwork pattern makes
for a unique look. There's a sense
of fun even in the fine details.

A vine that covers a wall is
used as a chain-like accent.

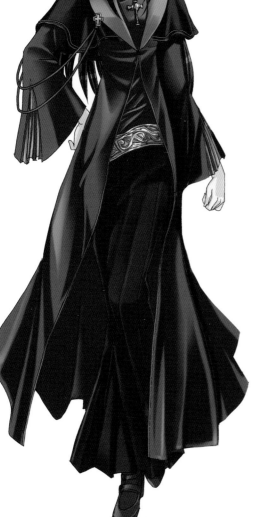

School Uniform ✕ Darkness

A mature look with a sense of dark mystery. The jacket and skirt are on the long side as if to conceal everything, enhancing the character's Gothic appearance.

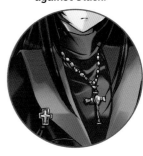

Gold accessories against black.

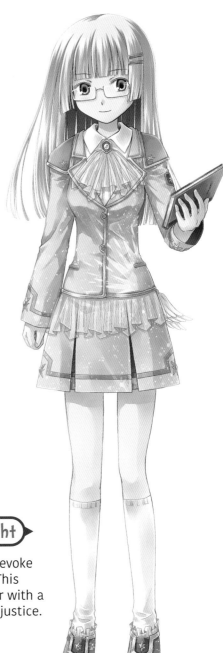

A necktie designed to resemble light descending from the heavens.

Even the details on the shoes emit sparkles of light.

Blazer ✕ Light

White and gold evoke heavenly light. This suits a character with a strong sense of justice.

① School Uniforms ✕ ⑩ Mechanical Objects

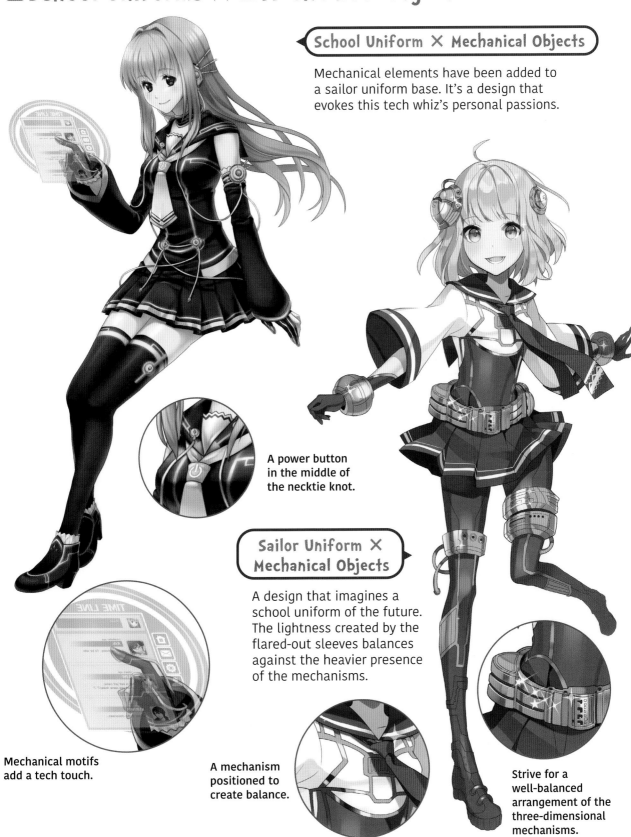

School Uniform ✕ Mechanical Objects

Mechanical elements have been added to a sailor uniform base. It's a design that evokes this tech whiz's personal passions.

A power button in the middle of the necktie knot.

Sailor Uniform ✕ Mechanical Objects

A design that imagines a school uniform of the future. The lightness created by the flared-out sleeves balances against the heavier presence of the mechanisms.

Mechanical motifs add a tech touch.

A mechanism positioned to create balance.

Strive for a well-balanced arrangement of the three-dimensional mechanisms.

1 School Uniforms × 11 Seasons

School Uniform × Spring

Horsetail, clover and cherry blossoms are the theme here. The color scheme conjures both the freshness and calm of spring.

The ribbon and buttons on the chest are clovers.

Sailor Uniform × Summer

The school uniform is worn over the top of a swimsuit. With so much skin exposed, this is a summer-only design.

Summer motifs such as watermelon and inflatable pool rings are used.

The knee-high leggings are made from the same fabric as the swimsuit.

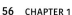

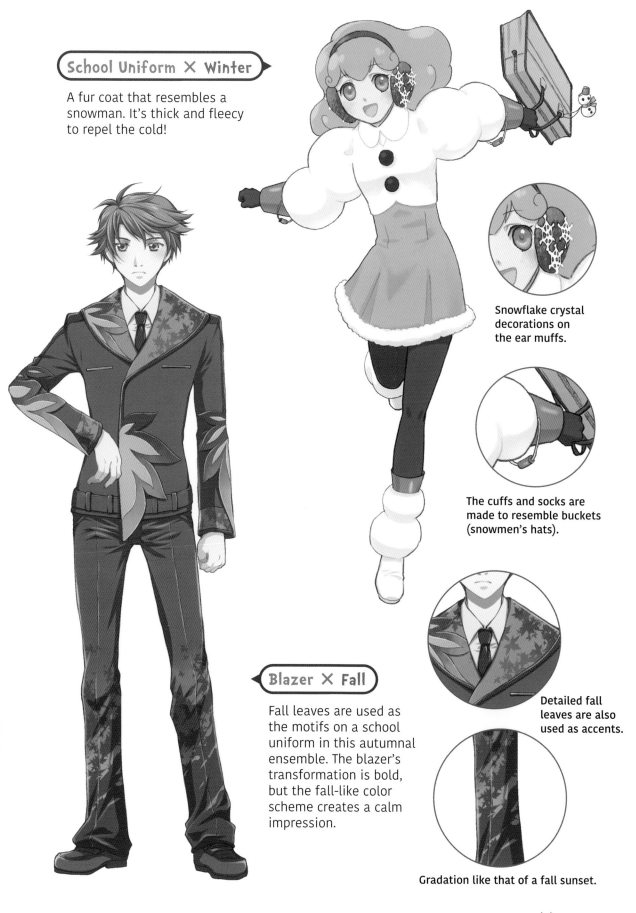

School Uniform ✕ Winter

A fur coat that resembles a snowman. It's thick and fleecy to repel the cold!

Snowflake crystal decorations on the ear muffs.

The cuffs and socks are made to resemble buckets (snowmen's hats).

Blazer ✕ Fall

Fall leaves are used as the motifs on a school uniform in this autumnal ensemble. The blazer's transformation is bold, but the fall-like color scheme creates a calm impression.

Detailed fall leaves are also used as accents.

Gradation like that of a fall sunset.

Ms. Seamstress's Secret #1

Various collars

As collars are close to the face, they're an important point in determining the first impression that a character makes. There are all kinds of collar designs and types of necklines, so try various shapes!

Short point collar

A short collar of the type that's commonly seen.

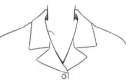

Open collar

Emphasizes coolness and comfort.

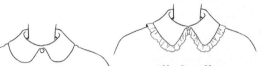

Little girl collar

A rounded collar with little height.

Frilled collar

The ruffed edge is a bold border.

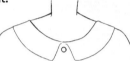

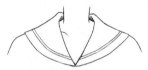

Sailor collar

The back side is blocky and rectangular.

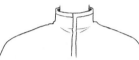

Standing collar

Once a casual look, now it's used for more formal styles.

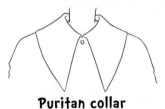

Peter Pan collar

A low-slung style that blends dressy with casual.

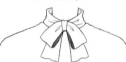

Bow collar

Like the bow of bowtie. The ribbon is attached to the collar and tied in a bow.

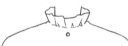

Frill collar

A frill attached to the collar opening. There are various types.

Puritan collar

A wide collar. As it's white, it lends a starched impression.

Neckline: V-neck

A collar with a plunging cut.

Neckline: draped

A loose-fitting neckline that drapes around the neck.

Neckline: high neck

A collar that extends from the body of the garment and does not fold over.

Examples from the artworks

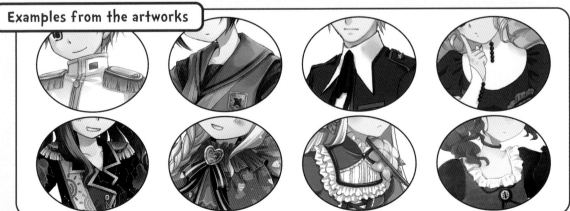

❷Military Apparel ✕ ❸Casual Basics

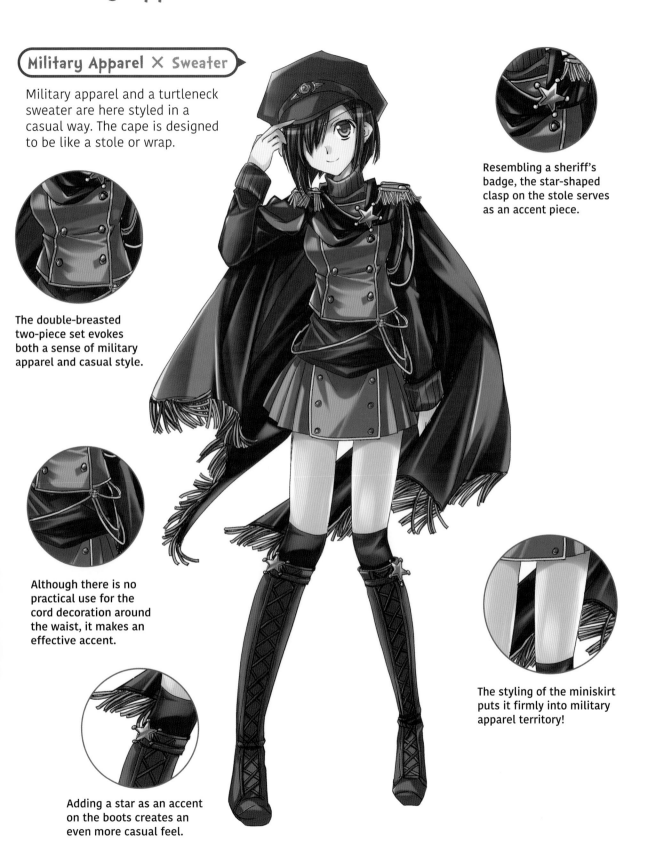

Military Apparel ✕ Sweater

Military apparel and a turtleneck sweater are here styled in a casual way. The cape is designed to be like a stole or wrap.

The double-breasted two-piece set evokes both a sense of military apparel and casual style.

Although there is no practical use for the cord decoration around the waist, it makes an effective accent.

Adding a star as an accent on the boots creates an even more casual feel.

Resembling a sheriff's badge, the star-shaped clasp on the stole serves as an accent piece.

The styling of the miniskirt puts it firmly into military apparel territory!

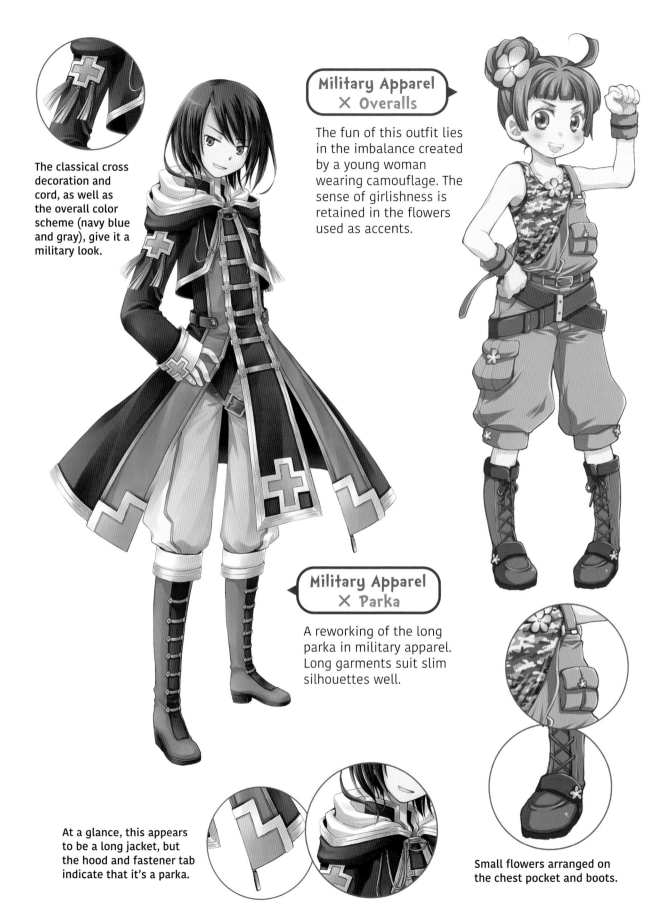

The classical cross decoration and cord, as well as the overall color scheme (navy blue and gray), give it a military look.

Military Apparel × Overalls

The fun of this outfit lies in the imbalance created by a young woman wearing camouflage. The sense of girlishness is retained in the flowers used as accents.

Military Apparel × Parka

A reworking of the long parka in military apparel. Long garments suit slim silhouettes well.

At a glance, this appears to be a long jacket, but the hood and fastener tab indicate that it's a parka.

Small flowers arranged on the chest pocket and boots.

❷Military Apparel ✕ ❹Gothic & Formal Wear

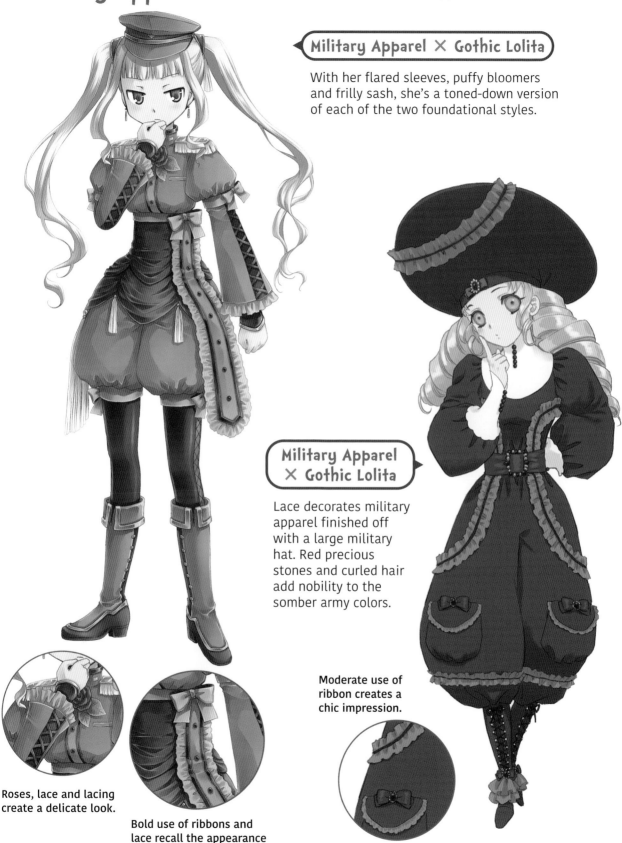

Military Apparel ✕ Gothic Lolita

With her flared sleeves, puffy bloomers and frilly sash, she's a toned-down version of each of the two foundational styles.

Military Apparel ✕ Gothic Lolita

Lace decorates military apparel finished off with a large military hat. Red precious stones and curled hair add nobility to the somber army colors.

Moderate use of ribbon creates a chic impression.

Roses, lace and lacing create a delicate look.

Bold use of ribbons and lace recall the appearance of decorative medals.

② Military Apparel × ⑤ Japanese Dress

Military Apparel × Suikan (informal tunic)

A Japanese-style female sword fighter dressed in a *suikan*. The sleeves, sword decoration, military ornamentation and sophisticated hairstyle highlight the sense of movement.

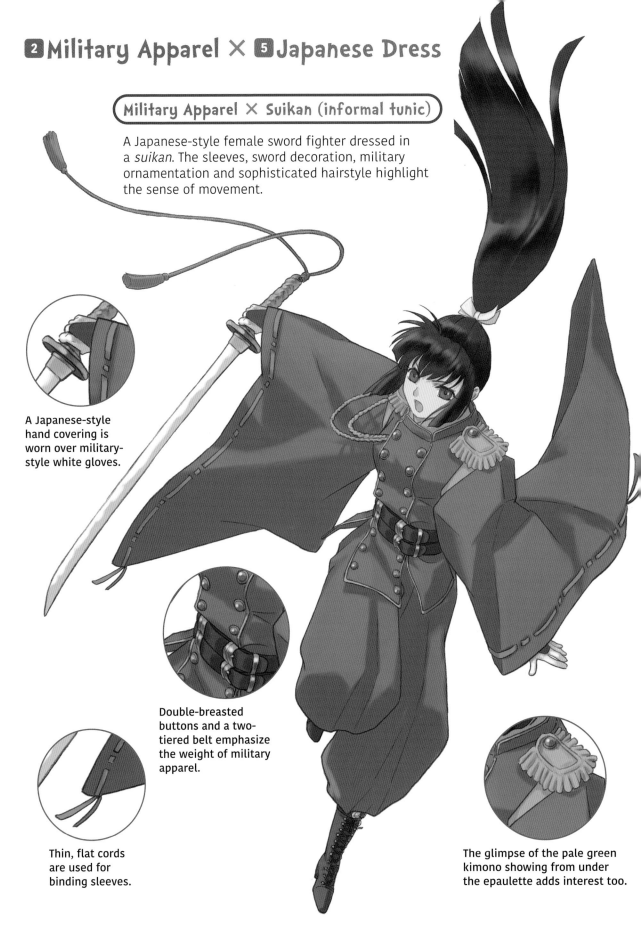

A Japanese-style hand covering is worn over military-style white gloves.

Double-breasted buttons and a two-tiered belt emphasize the weight of military apparel.

Thin, flat cords are used for binding sleeves.

The glimpse of the pale green kimono showing from under the epaulette adds interest too.

❷ Military Apparel ╳ ❽ Animals

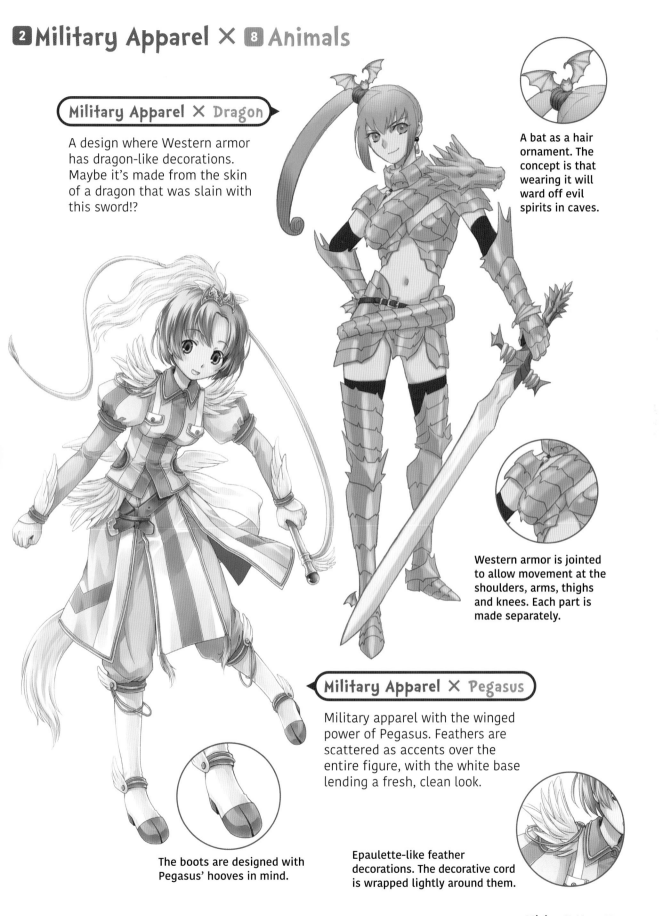

Military Apparel ╳ Dragon

A design where Western armor has dragon-like decorations. Maybe it's made from the skin of a dragon that was slain with this sword!?

A bat as a hair ornament. The concept is that wearing it will ward off evil spirits in caves.

Western armor is jointed to allow movement at the shoulders, arms, thighs and knees. Each part is made separately.

Military Apparel ╳ Pegasus

Military apparel with the winged power of Pegasus. Feathers are scattered as accents over the entire figure, with the white base lending a fresh, clean look.

The boots are designed with Pegasus' hooves in mind.

Epaulette-like feather decorations. The decorative cord is wrapped lightly around them.

❷Military Apparel ✕ ❾Nature

Military Apparel ✕ Fire ▶

Candles and candlesticks express the element of fire. The standing collar, white boots and gold edging create a character in the image of a royal guardsman.

The epaulettes and waist decoration recall burning kindling.

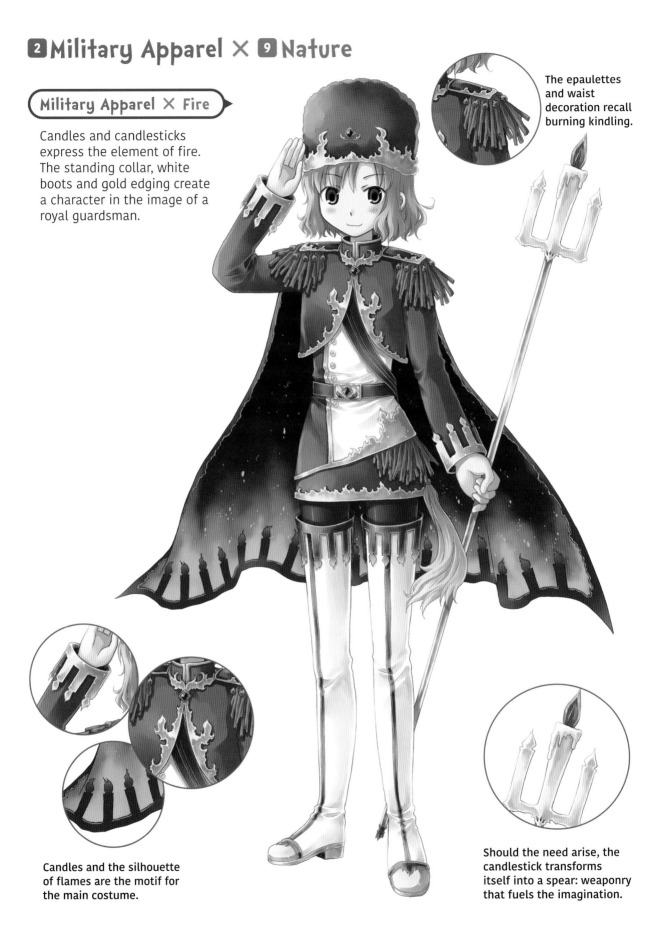

Candles and the silhouette of flames are the motif for the main costume.

Should the need arise, the candlestick transforms itself into a spear: weaponry that fuels the imagination.

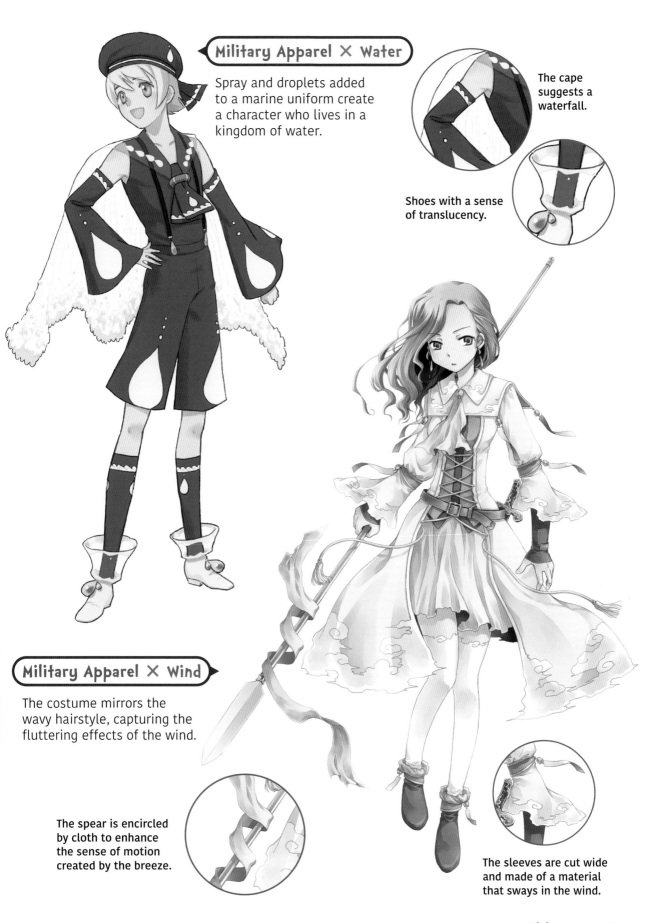

Military Apparel ✕ Water

Spray and droplets added to a marine uniform create a character who lives in a kingdom of water.

The cape suggests a waterfall.

Shoes with a sense of translucency.

Military Apparel ✕ Wind

The costume mirrors the wavy hairstyle, capturing the fluttering effects of the wind.

The spear is encircled by cloth to enhance the sense of motion created by the breeze.

The sleeves are cut wide and made of a material that sways in the wind.

2 Military Apparel × 9 Nature

Embellishment created to evoke minerals dug from the earth.

Ceramic patterns on the pants, cape and apron create cohesion.

◄ Military Apparel × Earth

Military apparel that suggests ceramics and minerals. The subdued color scheme gives the outfit a subdued, classical look.

2 Military Apparel × 10 Mechanical Objects

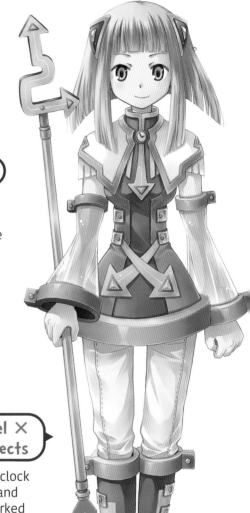

Military Apparel × Mechanical Objects ►

Designed around a clock motif, clock hands and hourglasses are worked into the outfit. Transparent materials and steel parts create a futuristic, machine-made look.

Weapons and the outfit are designed as a set that features the clock motif.

A stylish, angular hairstyle in a futuristic color.

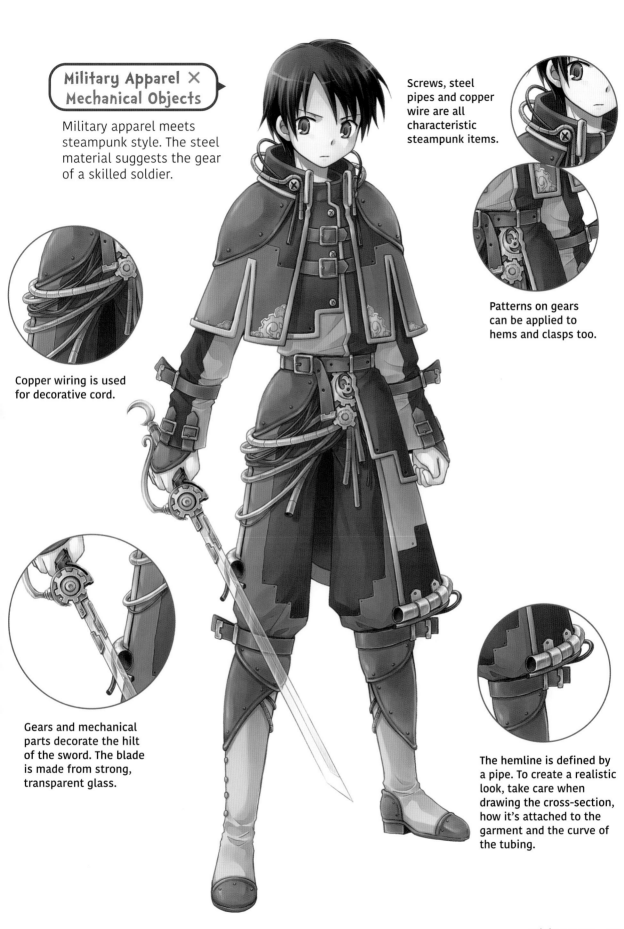

Military Apparel ✕ Mechanical Objects

Military apparel meets steampunk style. The steel material suggests the gear of a skilled soldier.

Screws, steel pipes and copper wire are all characteristic steampunk items.

Patterns on gears can be applied to hems and clasps too.

Copper wiring is used for decorative cord.

Gears and mechanical parts decorate the hilt of the sword. The blade is made from strong, transparent glass.

The hemline is defined by a pipe. To create a realistic look, take care when drawing the cross-section, how it's attached to the garment and the curve of the tubing.

Mixing It Up　67

2 Military Apparel × 11 Seasons

Military Apparel × Summer

An imperial guard from the kingdom of summer. The unique design incorporates the sun, palm fronds, watermelons, rattan blinds, a starry sky and other items associated with summer.

Military Apparel × Winter

A commander in the imperial army of the winter kingdom. The beauty of the snow crystals creates a refined image, while the cold tones of the snow suggest the soldier's loneliness.

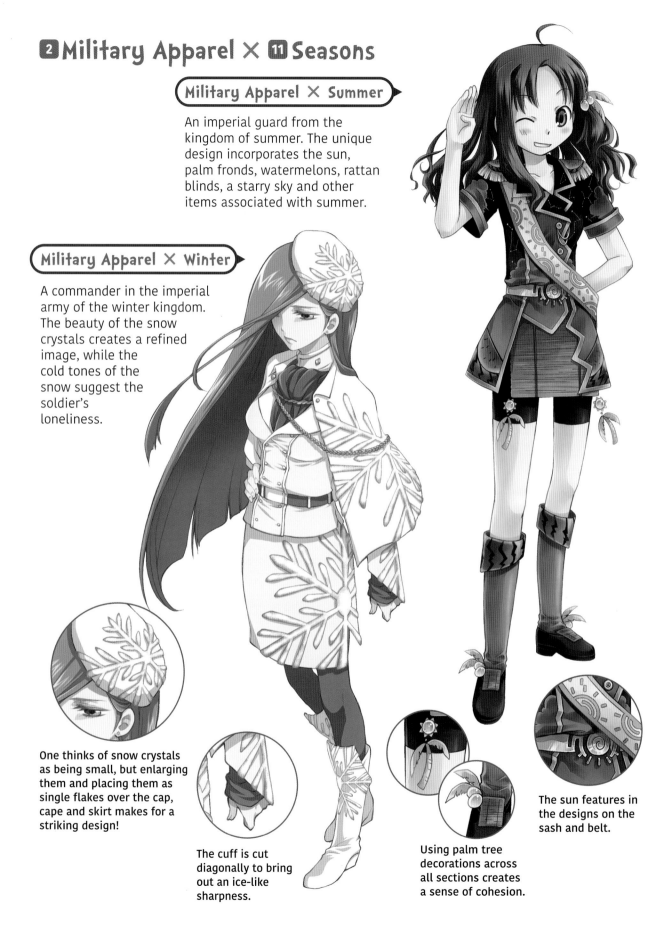

One thinks of snow crystals as being small, but enlarging them and placing them as single flakes over the cap, cape and skirt makes for a striking design!

The cuff is cut diagonally to bring out an ice-like sharpness.

Using palm tree decorations across all sections creates a sense of cohesion.

The sun features in the designs on the sash and belt.

Ms Seamstress's Secret #2

Various sleeves

Usually, we're used to seeing only long and short sleeves, but there are actually all kinds of lengths and styles.

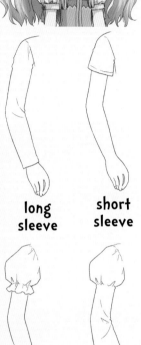

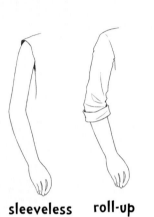

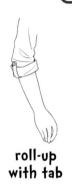

long sleeve

short sleeve

sleeveless

roll-up

roll-up with tab

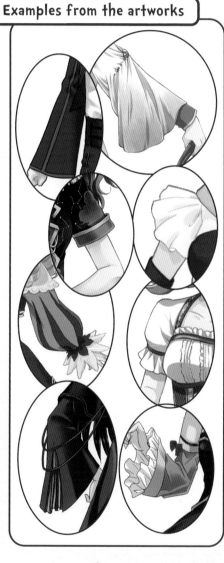

Examples from the artworks

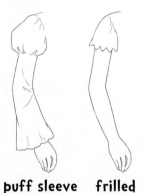

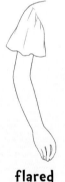

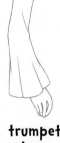

puff sleeve (short)

puff sleeve (long)

frilled sleeve

flared sleeve

trumpet sleeve

cuffed sleeve

flared cuff

buttoned cuff

knitted cuff

turn-up cuff

Dolman sleeve

winged sleeve

❸ Casual Basics ✕ ❹ Gothic & Formal Wear

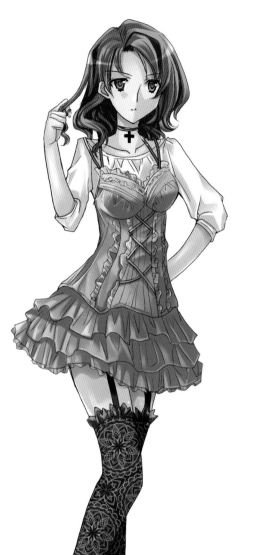

Parka ✕ Gothic

A casual parka made Gothic. The blond hair, ribbon and studs give it a Western appearance.

A mini hat atop the hood makes for unique styling.

The boots are the same color and design as the clothing.

Camisole Dress ✕ Gothic Lolita

A choker and frills bring a Gothic Lolita vibe to a camisole dress. Garters add a slightly racy touch.

The casual air is retained by adding a cut-and-sew top under the dress.

Garters and lace stockings bring out maturity and flair simultaneously.

③Casual Basics ✕ ⑤Japanese Dress

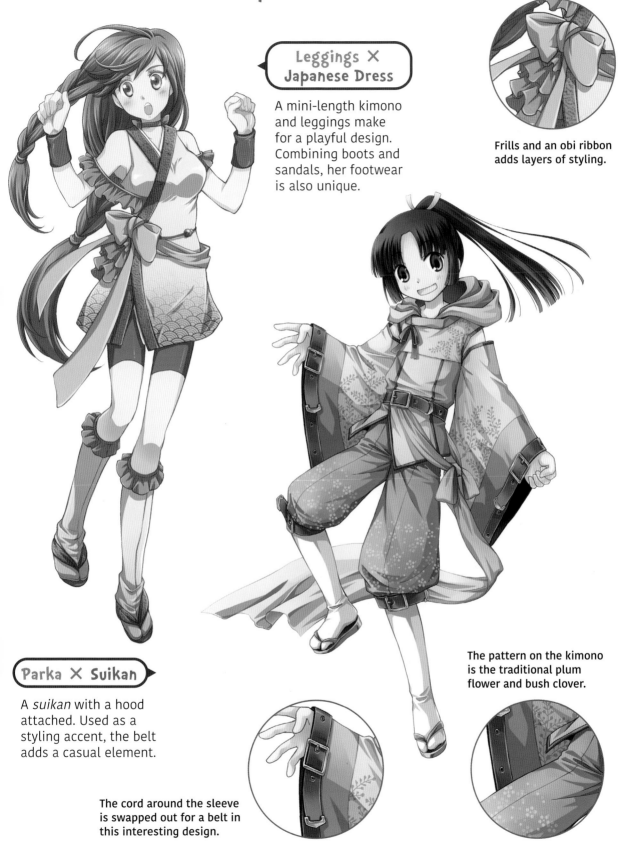

Leggings ✕ Japanese Dress

A mini-length kimono and leggings make for a playful design. Combining boots and sandals, her footwear is also unique.

Frills and an obi ribbon adds layers of styling.

Parka ✕ Suikan

A *suikan* with a hood attached. Used as a styling accent, the belt adds a casual element.

The cord around the sleeve is swapped out for a belt in this interesting design.

The pattern on the kimono is the traditional plum flower and bush clover.

③Casual Basics ✕ ⑥Ethnic Costumes

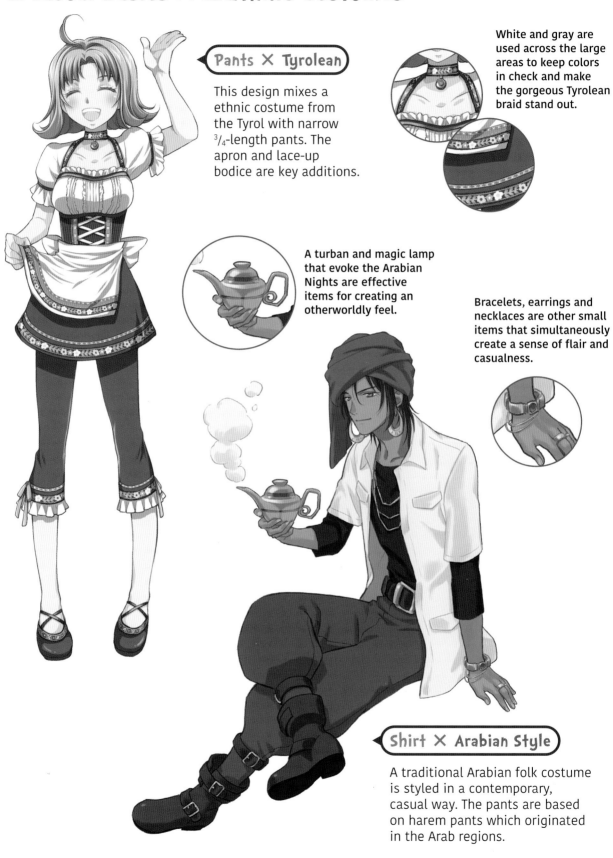

Pants ✕ Tyrolean

This design mixes a ethnic costume from the Tyrol with narrow ³/₄-length pants. The apron and lace-up bodice are key additions.

White and gray are used across the large areas to keep colors in check and make the gorgeous Tyrolean braid stand out.

A turban and magic lamp that evoke the Arabian Nights are effective items for creating an otherworldly feel.

Bracelets, earrings and necklaces are other small items that simultaneously create a sense of flair and casualness.

Shirt ✕ Arabian Style

A traditional Arabian folk costume is styled in a contemporary, casual way. The pants are based on harem pants which originated in the Arab regions.

Sweater ✕ Scotland

A loose mix of Scottish costume and knitwear. The tartan check and use of belts are fun in this casual outfit.

The elaborately designed shoes have clasp decorations on the heels.

The design features non-matching sleeves. The right sleeve is casual while the left has a traditional look.

Camisole Dress ✕ India

Casual styling that features a sari wrapped over a camisole dress. The pattern and shine on the fabric are key.

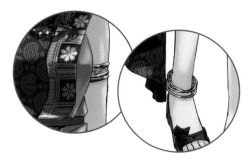

Placing bangles around the upper arm increases the multiethnic vibe. The gold ring-style anklets are also Indian.

③ Casual Basics ✕ ⑦ Plants

Pants ✕ Grapes

A casual rendering of the defining characteristics of grapes. The flamboyant colors evoke a harvest festival.

Grapes are scattered over the outfit like drops of water to form a pattern.

Pants in a color that recalls a grape trellis.

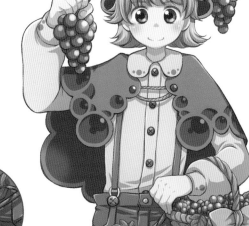

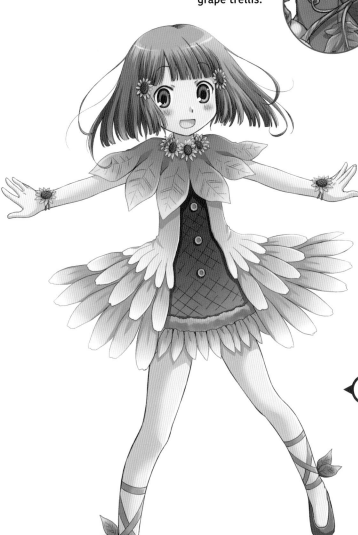

Dress ✕ Sunflower

A summery casual dress created with the image of a sunflower in mind. The movement in the pose helps to suggest a full-blown flower.

The stomach area re-creates the seed section of the sunflower.

3 Casual Basics × 8 Animals

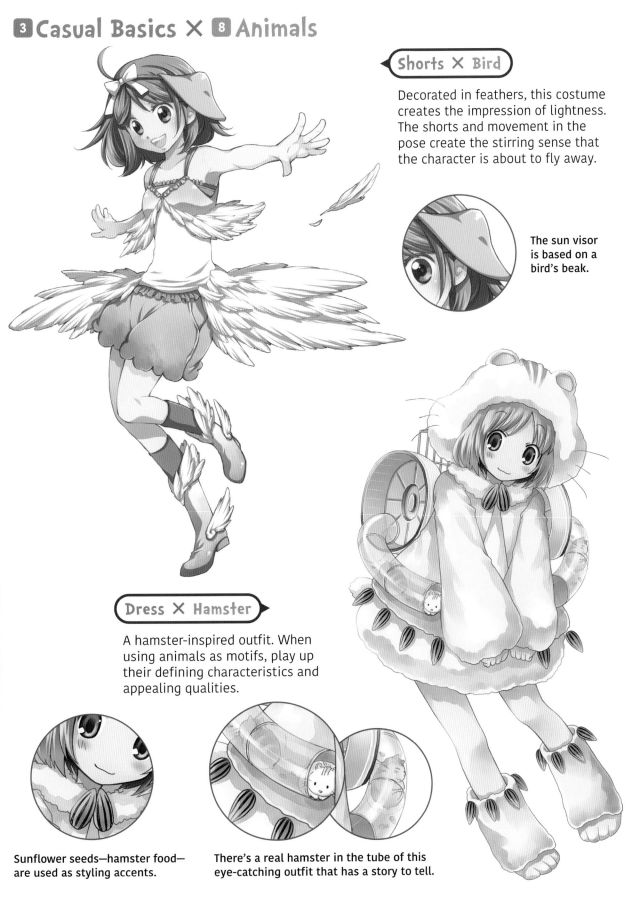

Shorts × Bird

Decorated in feathers, this costume creates the impression of lightness. The shorts and movement in the pose create the stirring sense that the character is about to fly away.

The sun visor is based on a bird's beak.

Dress × Hamster

A hamster-inspired outfit. When using animals as motifs, play up their defining characteristics and appealing qualities.

Sunflower seeds—hamster food— are used as styling accents.

There's a real hamster in the tube of this eye-catching outfit that has a story to tell.

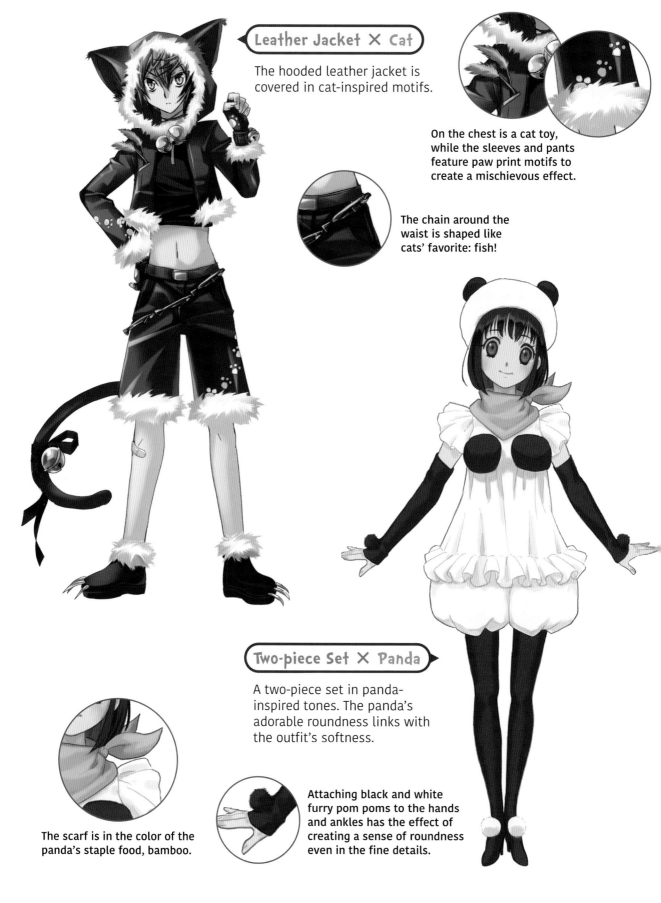

Leather Jacket × Cat

The hooded leather jacket is covered in cat-inspired motifs.

On the chest is a cat toy, while the sleeves and pants feature paw print motifs to create a mischievous effect.

The chain around the waist is shaped like cats' favorite: fish!

Two-piece Set × Panda

A two-piece set in panda-inspired tones. The panda's adorable roundness links with the outfit's softness.

The scarf is in the color of the panda's staple food, bamboo.

Attaching black and white furry pom poms to the hands and ankles has the effect of creating a sense of roundness even in the fine details.

3 Casual Basics × 9 Nature

The belt is themed around coral while the vest has an anemone motif. Starfish substitute for fringing.

Vest × Water

A casual style suggesting the ocean and islands of the Tropics. The translucent look of the clothing and playful motifs conjure the fun atmosphere of a resort.

In a transparent, soft material, the hat resembles a jellyfish.

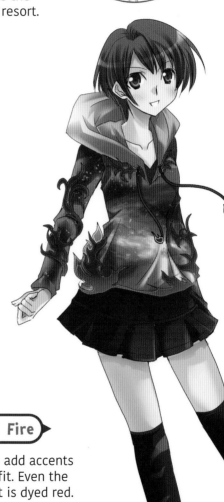

Parka × Fire

Fire motifs add accents to this outfit. Even the denim skirt is dyed red.

The socks are patterned to create the sense of flames.

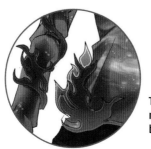

The flame motifs are made from a thin badge-like material.

Miniskirt × Wind

A windmill is the main motif in this design, which is in a green color palette evocative of winds that blow through mountain plateaus. The softly billowing summer stole also conveys the movement of wind.

Two types of windmills—traditional and modern—feature as motifs.

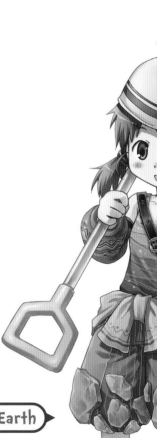

Tank Top × Earth

Images associated with rocks and the earth are in abundance here, including ceramics, excavation and strata. The mismatch between the large helmet and shovel and the short character creates a cute effect.

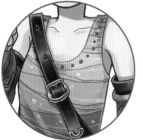

The tank top recalls the earth's strata. Gradation is key here.

3 Casual Basics ✕ 10 Mechanical Objects

> ## Jumper ✕ Mechanical Objects

A young girl mechanic. Whether it's analog mechanisms or digital devices, bring them on!

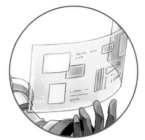

A transparent monitor projected in mid-air creates a futuristic sense. The visor of the cap worn to the side is also a monitor.

She wears a battery on her leg.

> ## Long Vest ✕ Mechanical Objects

A futuristic fantasy-style costume featuring electronic circuit boards as patterns. The fur scarf around the neck, purple knit and check shirt allow a sense of casualness to prevail.

Plugs hanging from the hem.

Clasps in the form of connector cords. Items with a digital feel are scattered all over the outfit.

3 Casual Basics × 11 Seasons

Dress × Spring

A costume scattered with cherry blossoms, twigs and cherries. The differently sized cherries add accents to the look.

Massively enlarged cherries are impressive as hair ties.

The hems of the leggings have little cherries attached to them.

Seagulls create an accent on this translucent-looking sun visor.

There is a cloud decoration adorning the chest.

Shorts × Summer

The sun visor has a sky pattern while the tank top features a sunflower field and the tights sport a cumulonimbus cloud pattern. The socks are the color of fresh green leaves. The entire look expresses the scenery of summer.

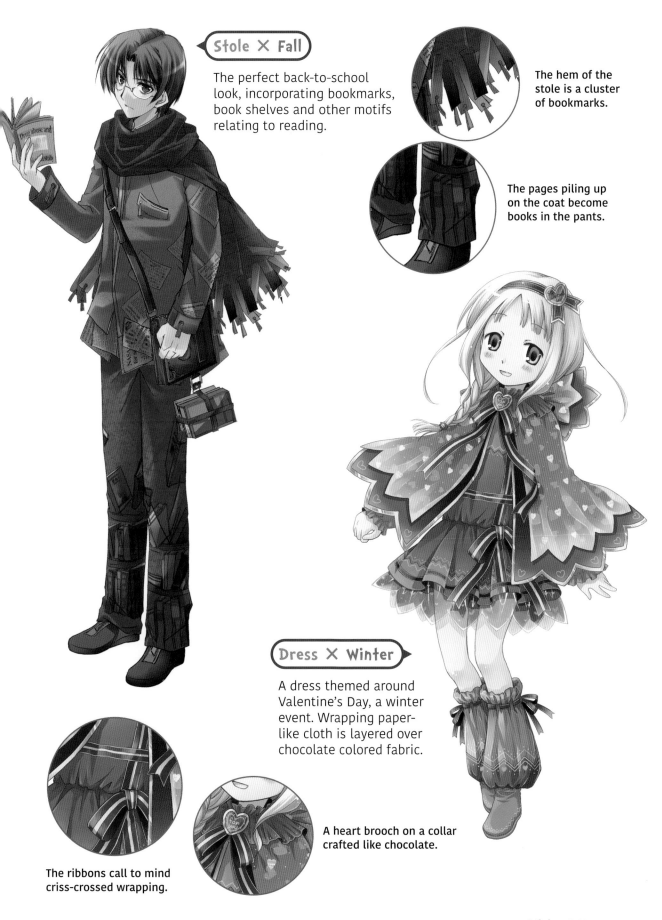

Stole × Fall

The perfect back-to-school look, incorporating bookmarks, book shelves and other motifs relating to reading.

The hem of the stole is a cluster of bookmarks.

The pages piling up on the coat become books in the pants.

Dress × Winter

A dress themed around Valentine's Day, a winter event. Wrapping paper-like cloth is layered over chocolate colored fabric.

A heart brooch on a collar crafted like chocolate.

The ribbons call to mind criss-crossed wrapping.

Ms Seamstress's Secret #3

Brainstorming (a free association game for creative thinking)

Brainstorming is a method for generating more and more ideas by jotting down the words that come to mind as suggested by a word or phrase. Starting for example with "rabbit" and thinking of carrots, which in turn brings to mind the color orange, which in turn brings to mind sunsets. You can also do this by using dictionaries, searching for related works in bookshops and libraries, or using the internet. By freeing up your mind and getting rid of preconceived notions, you may find combinations that you had not thought of before or encounter new settings and situations.

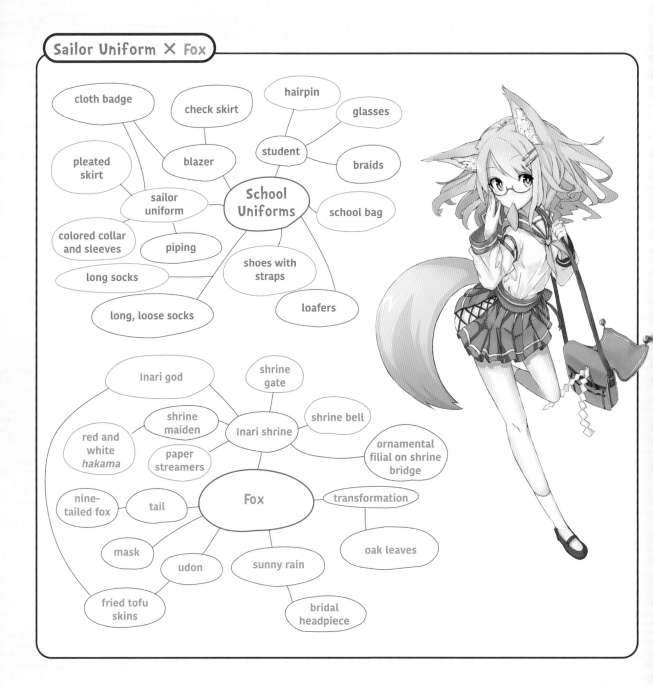

Sailor Uniform ✕ Fox

cloth badge

check skirt

hairpin

glasses

pleated skirt

blazer

student

braids

sailor uniform

School Uniforms

colored collar and sleeves

piping

school bag

long socks

shoes with straps

long, loose socks

loafers

Inari god

shrine gate

shrine maiden

Inari shrine

shrine bell

red and white *hakama*

paper streamers

ornamental filial on shrine bridge

nine-tailed fox

tail

Fox

transformation

mask

oak leaves

udon

sunny rain

fried tofu skins

bridal headpiece

Sailor Uniform ✕ Penguin

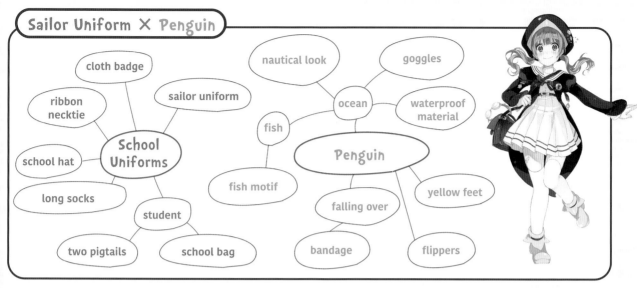

- cloth badge
- sailor uniform
- nautical look
- goggles
- ribbon necktie
- ocean
- waterproof material
- School Uniforms
- fish
- Penguin
- school hat
- fish motif
- long socks
- falling over
- yellow feet
- student
- two pigtails
- school bag
- bandage
- flippers

Military Apparel ✕ Wind

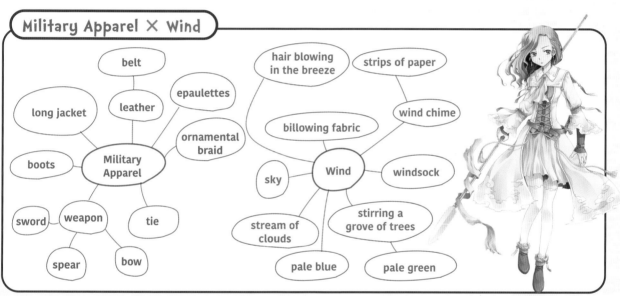

- belt
- hair blowing in the breeze
- strips of paper
- epaulettes
- leather
- long jacket
- ornamental braid
- wind chime
- billowing fabric
- boots
- Military Apparel
- Wind
- windsock
- sky
- sword
- weapon
- tie
- stream of clouds
- stirring a grove of trees
- spear
- bow
- pale blue
- pale green

Dancer ✕ Mechanical Objects

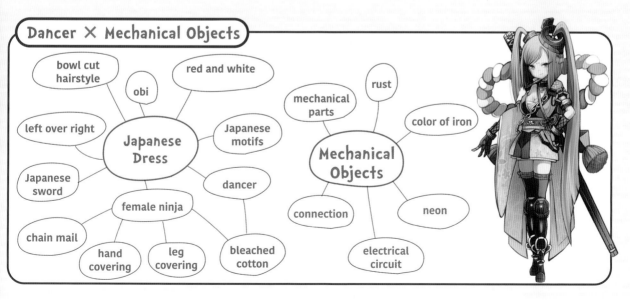

- bowl cut hairstyle
- red and white
- rust
- obi
- mechanical parts
- color of iron
- left over right
- Japanese Dress
- Japanese motifs
- Mechanical Objects
- Japanese sword
- dancer
- neon
- female ninja
- connection
- chain mail
- hand covering
- leg covering
- bleached cotton
- electrical circuit

⁴Gothic & Formal Wear ✕ ⁵Japanese Dress

⟨ Gothic Lolita ✕ Japanese Dress ⟩

Check patterns are placed on a diagonal to form a checker pattern. Polka dot leggings are paired with straw sandals, creating a mix of elements.

Antique-style hair ornaments with small flowers.

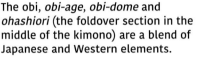

The obi, *obi-age*, *obi-dome* and *ohashiori* (the foldover section in the middle of the kimono) are a blend of Japanese and Western elements.

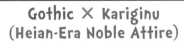

⟨ Gothic ✕ Kariginu (Heian-Era Noble Attire) ⟩

Adding Gothic style to a diviner's outfit creates an East-meets-West sorcerer.

The collar of the *kariginu* is styled as if for a formal occasion.

In some cultures, silver was said to ward off evil, hence the silver accessories on the shoes and at the waist.

4 Gothic & Formal Wear ✕ 6 Ethnic Costumes

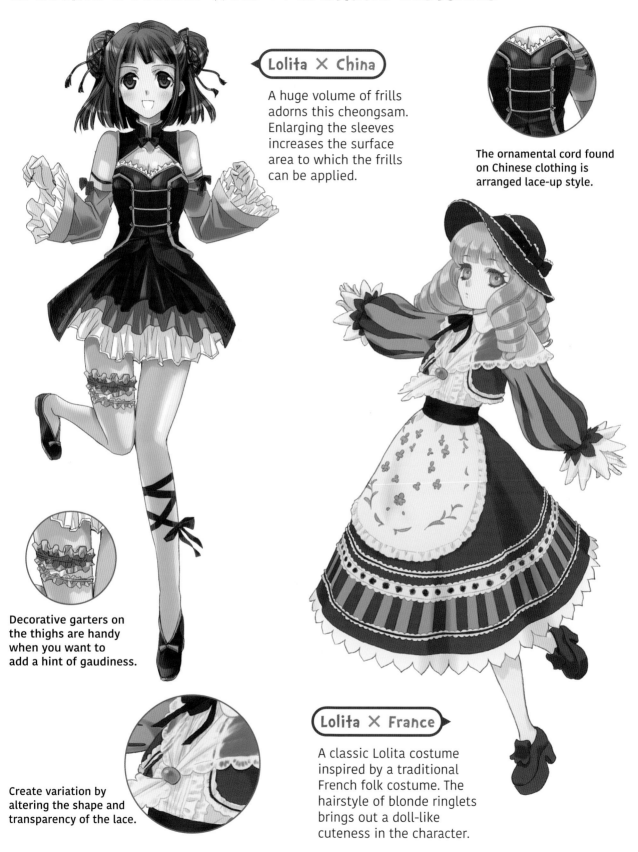

Lolita ✕ China

A huge volume of frills adorns this cheongsam. Enlarging the sleeves increases the surface area to which the frills can be applied.

The ornamental cord found on Chinese clothing is arranged lace-up style.

Decorative garters on the thighs are handy when you want to add a hint of gaudiness.

Create variation by altering the shape and transparency of the lace.

Lolita ✕ France

A classic Lolita costume inspired by a traditional French folk costume. The hairstyle of blonde ringlets brings out a doll-like cuteness in the character.

❹ Gothic & Formal Wear ✕ ❼ Plants

Gothic Lolita ✕ Plants

The entire body suggests a tree, with the blouse as the sky, the chest area as the canopy, the waist as the trunk and the skirt as a meadow.

In order for the darker colors not to become too heavy, the skirt hem is in a transparent fabric.

Creating slits around the torso balances out the surface area of fabric and skin.

Formal ✕ White Lily

A formal dress inspired by a white lily. The petals open out at the hemline. The green of the leaves creates an accent.

Lolita ✕ Strawberry

A dress with large strawberries as the motif. The strawberry shape informs the puff sleeves, while the calyx transforms into frills.

Tailcoat ✕ Peacock

A peacock-style tailcoat. The characteristic feathers are scattered over the costume as a motif, with gradation further expressing the colors of the feathers.

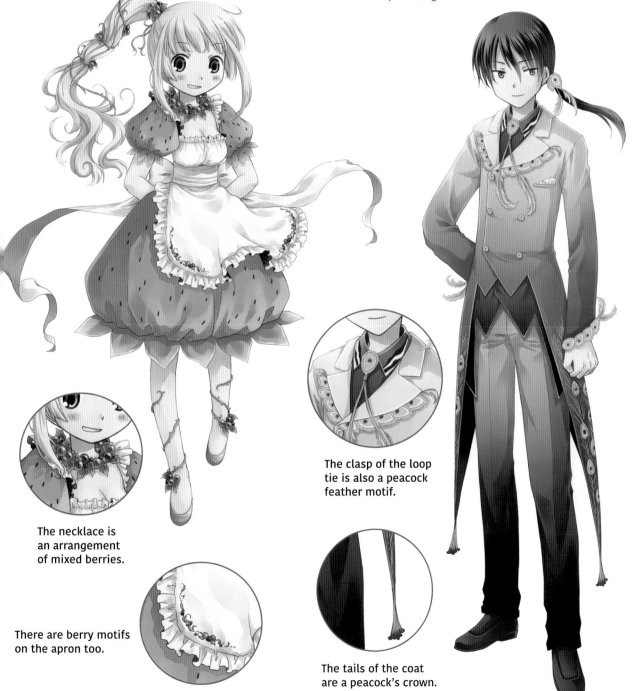

The clasp of the loop tie is also a peacock feather motif.

The necklace is an arrangement of mixed berries.

There are berry motifs on the apron too.

The tails of the coat are a peacock's crown.

Lolita × Rabbit

The drooping ears of the lop-eared rabbit are expressed as ponytails. Carrots are placed on the bows as accents.

The sleeves resemble rabbit paw pads.

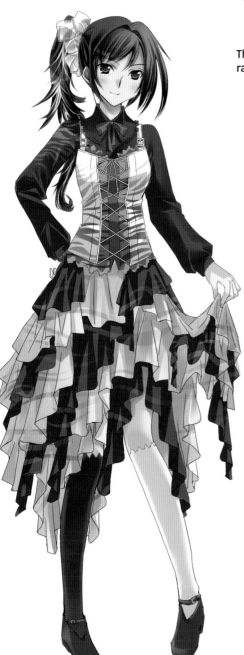

Gothic Lolita × Zebra

Monotone colors create a cohesive scheme, while white and black are used simultaneously to highlight characteristic parts.

Hair extensions are often used for Gothic Lolitas. White hair is mixed in as an accent against the naturally black hair.

Making the left and right socks different colors reinforces the black-and-white contrast.

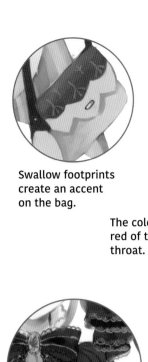

Swallow footprints create an accent on the bag.

Tailcoat ✕ Swallow

The reverse association from tailcoat to swallow is interesting. The pale blue lace evokes the sky.

The color evokes the red of the swallow's throat.

The ribbon is carefully patterned for a chic yet flamboyant look.

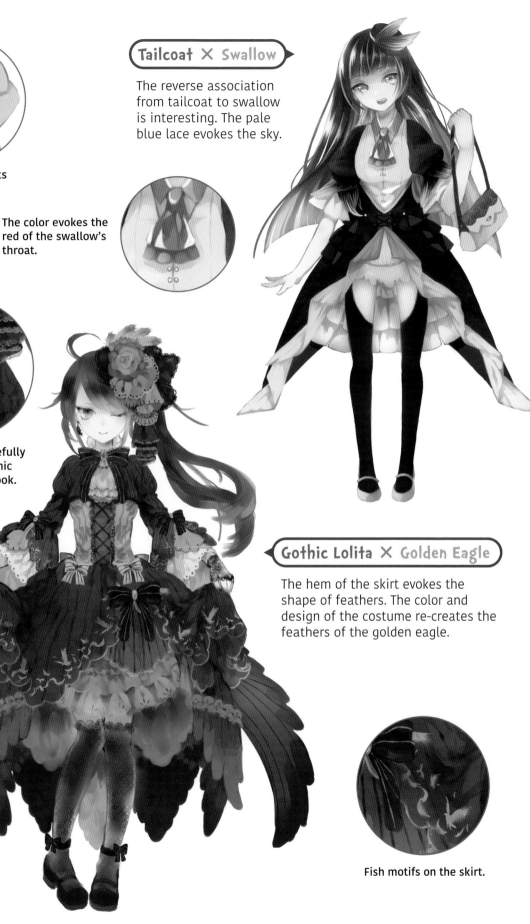

Gothic Lolita ✕ Golden Eagle

The hem of the skirt evokes the shape of feathers. The color and design of the costume re-creates the feathers of the golden eagle.

Fish motifs on the skirt.

4 Gothic & Formal Wear ✕ 9 Nature

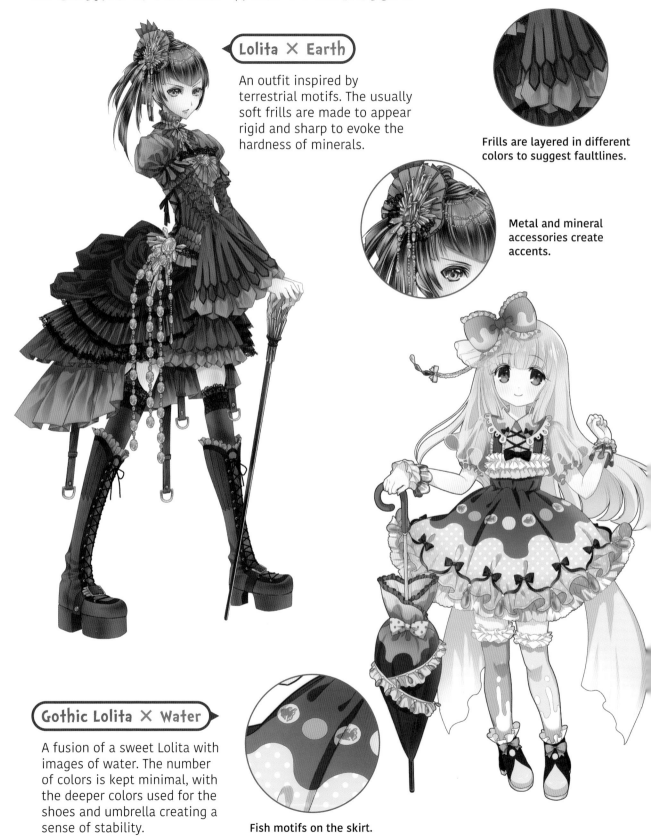

Lolita ✕ Earth

An outfit inspired by terrestrial motifs. The usually soft frills are made to appear rigid and sharp to evoke the hardness of minerals.

Frills are layered in different colors to suggest faultlines.

Metal and mineral accessories create accents.

Gothic Lolita ✕ Water

A fusion of a sweet Lolita with images of water. The number of colors is kept minimal, with the deeper colors used for the shoes and umbrella creating a sense of stability.

Fish motifs on the skirt.

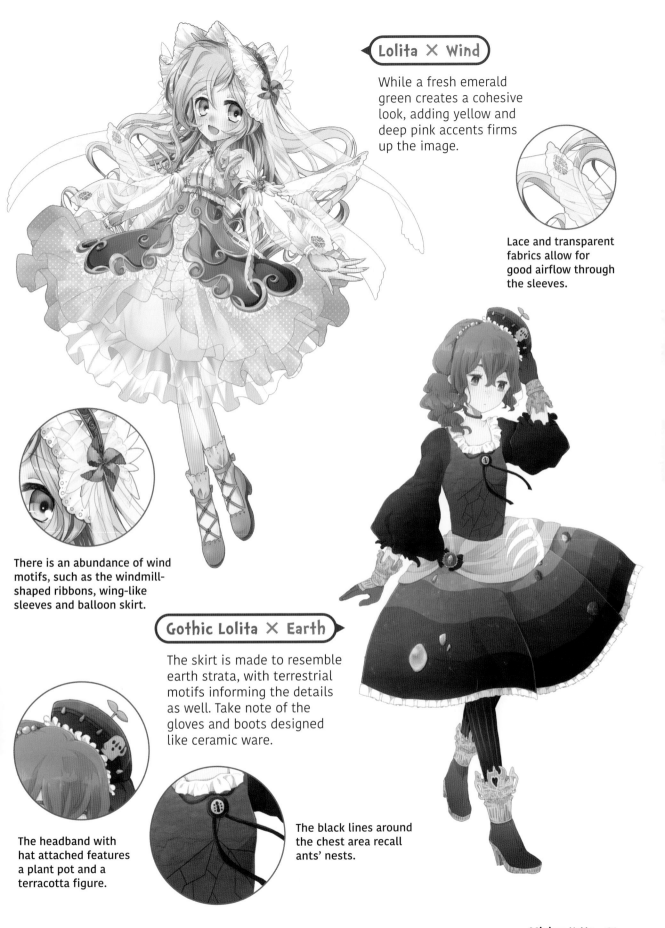

Lolita × Wind

While a fresh emerald green creates a cohesive look, adding yellow and deep pink accents firms up the image.

Lace and transparent fabrics allow for good airflow through the sleeves.

There is an abundance of wind motifs, such as the windmill-shaped ribbons, wing-like sleeves and balloon skirt.

Gothic Lolita × Earth

The skirt is made to resemble earth strata, with terrestrial motifs informing the details as well. Take note of the gloves and boots designed like ceramic ware.

The headband with hat attached features a plant pot and a terracotta figure.

The black lines around the chest area recall ants' nests.

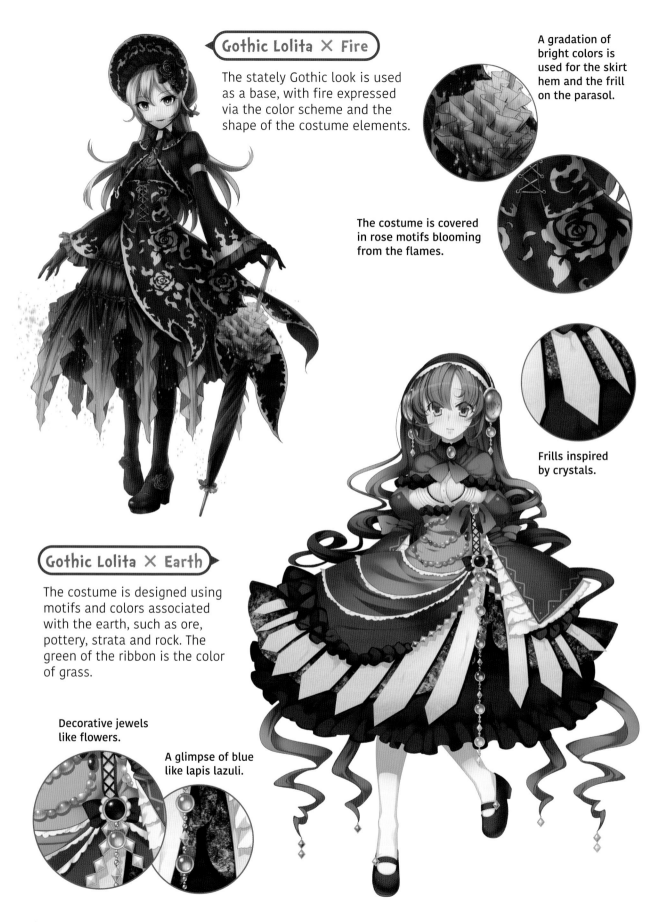

Gothic Lolita × Fire

The stately Gothic look is used as a base, with fire expressed via the color scheme and the shape of the costume elements.

A gradation of bright colors is used for the skirt hem and the frill on the parasol.

The costume is covered in rose motifs blooming from the flames.

Frills inspired by crystals.

Gothic Lolita × Earth

The costume is designed using motifs and colors associated with the earth, such as ore, pottery, strata and rock. The green of the ribbon is the color of grass.

Decorative jewels like flowers.

A glimpse of blue like lapis lazuli.

④ Gothic & Formal Wear ✕ ⑩ Mechanical Objects

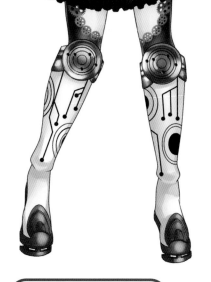

Gothic Lolita ✕ Mechanical Objects

This is in the style of steampunk, but there are also electrical circuit motifs. The large gear wheel on the back resembles a bow, making a stunning impression.

The buttons on the jacket and skirt feature motifs of the screw heads.

The skirt pattern blends together gears and electrical circuits.

The asymmetrical design on the chest is unique too.

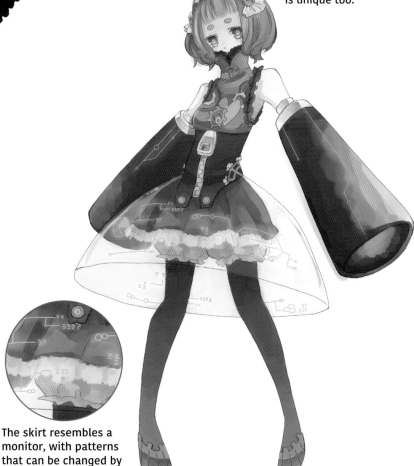

Gothic Lolita ✕ Mechanical Objects

A fusion of a Gothic Lolita costume with a standing collar and electronic devices. The number of colors is kept minimal to bring out the inorganic look of machinery.

The skirt resembles a monitor, with patterns that can be changed by entering data.

❹Gothic & Formal Wear ✕ ❿Mechanical Objects

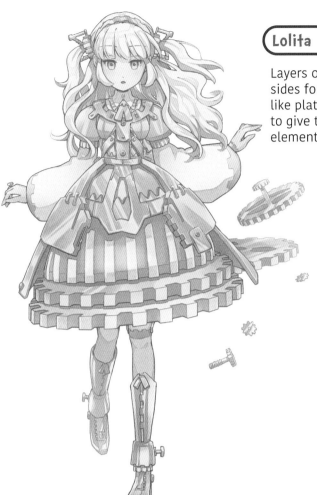

Lolita ✕ Mechanical Objects

Layers of gears placed on their sides form a skirt. Light colors like platinum are interwoven to give the heavy mechanical elements an air of elegance.

The hair decoration is made by combining a mechanical arm with a bow.

❹Gothic & Formal Wear ✕ ⓫Seasons

Formal ✕ Spring

A formal dress decorated with flowers for a spring-like feel. Use both large and small flowers to create a gorgeous effect.

Flowers decorate the ends of the frills, creating a design in which the frills and flowers appear to merge together.

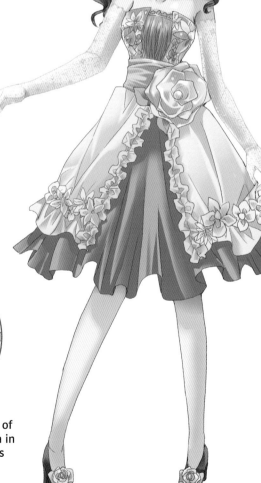

Gothic Lolita × Summer

A Gothic Lolita outfit featuring hydrangeas, which evoke the rainy season. The parasol, a characteristic item in the Lolita look, is also a hydrangea. The gray base of the outfit brings out the vivid hues of the flowers.

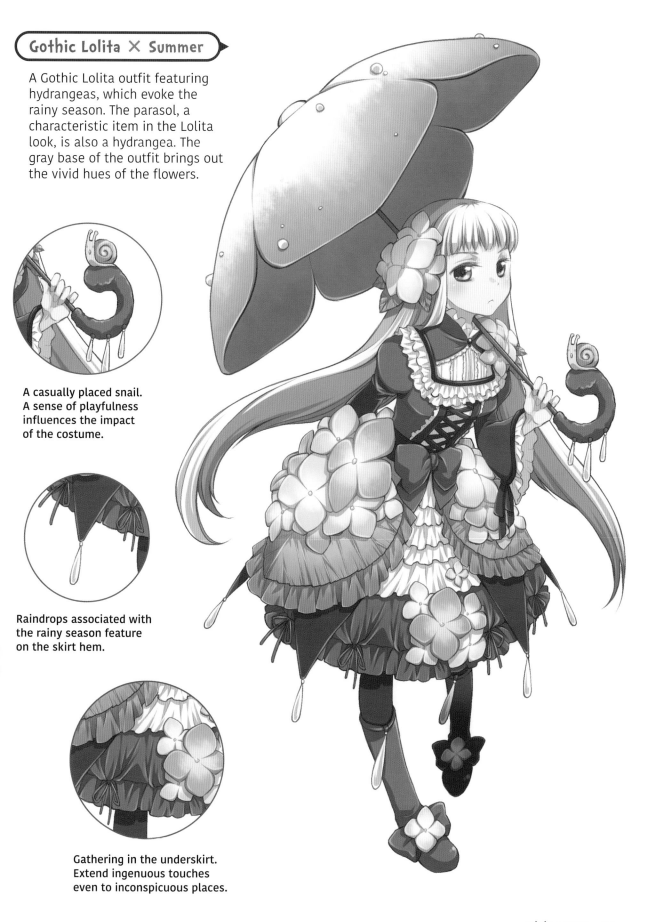

A casually placed snail. A sense of playfulness influences the impact of the costume.

Raindrops associated with the rainy season feature on the skirt hem.

Gathering in the underskirt. Extend ingenuous touches even to inconspicuous places.

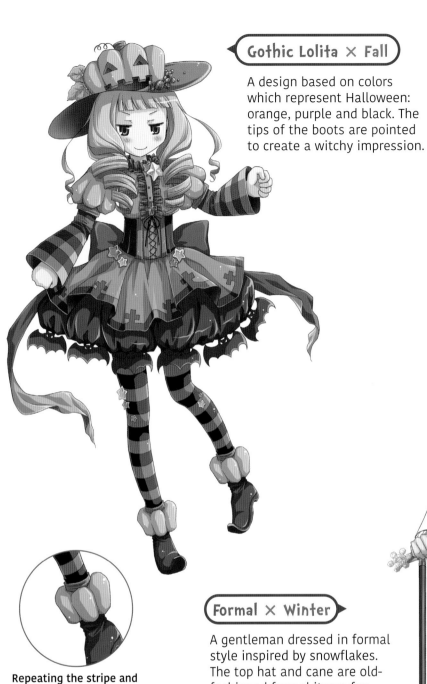

Gothic Lolita × Fall

A design based on colors which represent Halloween: orange, purple and black. The tips of the boots are pointed to create a witchy impression.

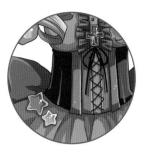

Small star decorations like candy.

Repeating the stripe and pumpkin motifs throughout the outfit creates a sense of cohesion.

Formal × Winter

A gentleman dressed in formal style inspired by snowflakes. The top hat and cane are old-fashioned formal items for Western gentlemen.

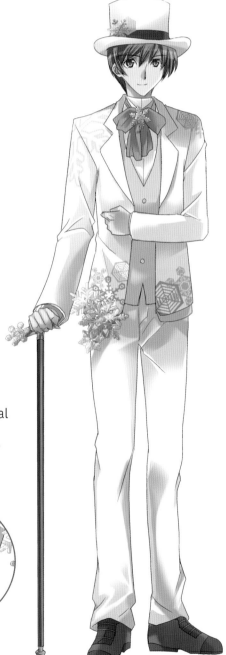

Intentionally adding decorations in similar colors to the white suit maintains the elegance.

The handle of the artful cane is carefully crafted.

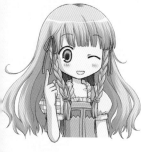

Ms Seamstress's Secret #4

Posing characters to show costumes to good effect

During shoots, fashion models consider how to show the outfits to best effect and pose accordingly. For a fitted jacket, they'll strike a formal pose, but for a floaty skirt, they'll make bold movements. The same thing could be said when illustrating.

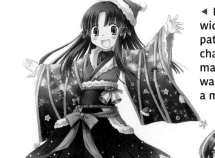

◀ Both hands are flung out wide and bold to show the pattern on the sleeves. The character's light bounce makes the ribbon at the waist stream out, creating a memorable impression.

▶ Jumping conveys the lightweight material of the feathers!

◀ A salute expresses the elements of a military uniform, while the hand in the pocket evokes a student.

▶ Raising the skirt creates folds in the fabric, communicating the thickness and tension in the fabric.

▶ Having both hands resting languidly in the pockets increases the casual air, at the same time boosting the sense of presence in the wide pants.

◀ Evoking the gait of a penguin, the pose matches the outfit. The airily flowing pigtails make the outfit give off even more of a pop-art vibe.

▶ The character is sitting flat on the ground in order to draw the gaze to the skirt, which resembles fallen leaves.

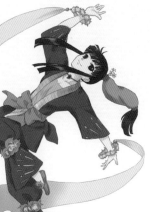

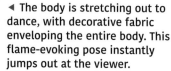

◀ The body is stretching out to dance, with decorative fabric enveloping the entire body. This flame-evoking pose instantly jumps out at the viewer.

⑤ Japanese Dress ✕ ⑦ Plants

Japanese Dress ✕ Cherry & Plum

The dual fruit motif is softly melded with the traditional garment and old-fashioned hat.

The knotted part of the obi is expressed as a leaf.

The tree growing from the hat and the cherry blossom robe add to the air of fantasy.

Shrine Maiden ✕ Bitter Orange

The main color of shrine maiden's attire—vermilion—is replaced with the bitter orange. The sleeve-binding cord seen in dancing girls' costumes is incorporated into the outfit.

The end of the sleeve binding cord features the bitter orange fruit as an accent.

Small fruit on the straw sandals play up the motif.

5 Japanese Dress ✕ 8 Animals

The ribbon calls to mind a frog's tongue catching an insect; it features an insect decoration.

Japanese Dress ✕ Frog

The silhouette of a frog is merged with Japanese dress. As frogs live near water, the edges of the sleeves feature running water and there's a lotus flower pattern enveloping the torso.

The light, pale robe recalls bird feathers.

The shoes are a lotus leaf design.

Japanese Dress ✕ Peacock

This design melds a traditional loose-fitting children's outfit with the palette of a male peacock.

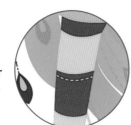

Striped tights enhance her height and give her a statuesque elegance.

⑤ Japanese Dress ✕ ⑨ Nature

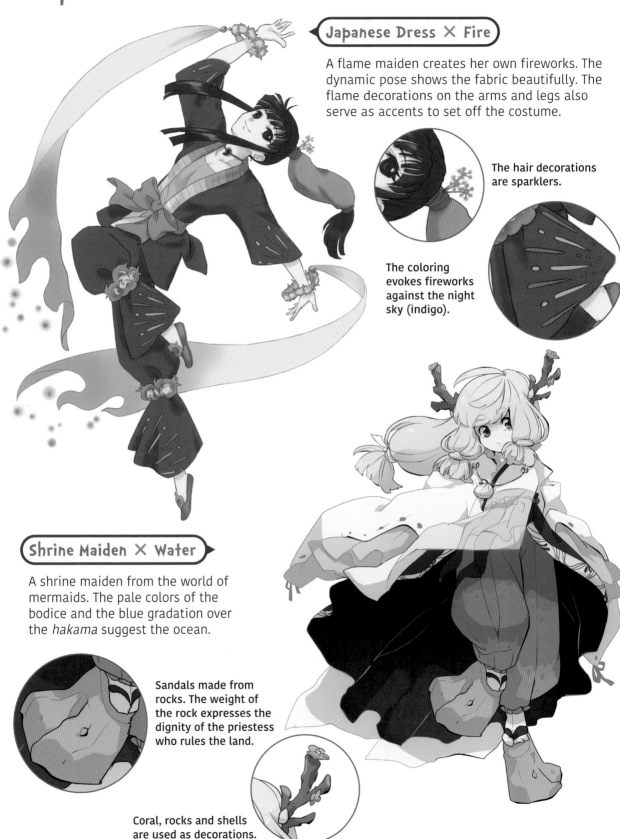

Japanese Dress ✕ Fire

A flame maiden creates her own fireworks. The dynamic pose shows the fabric beautifully. The flame decorations on the arms and legs also serve as accents to set off the costume.

The hair decorations are sparklers.

The coloring evokes fireworks against the night sky (indigo).

Shrine Maiden ✕ Water

A shrine maiden from the world of mermaids. The pale colors of the bodice and the blue gradation over the *hakama* suggest the ocean.

Sandals made from rocks. The weight of the rock expresses the dignity of the priestess who rules the land.

Coral, rocks and shells are used as decorations.

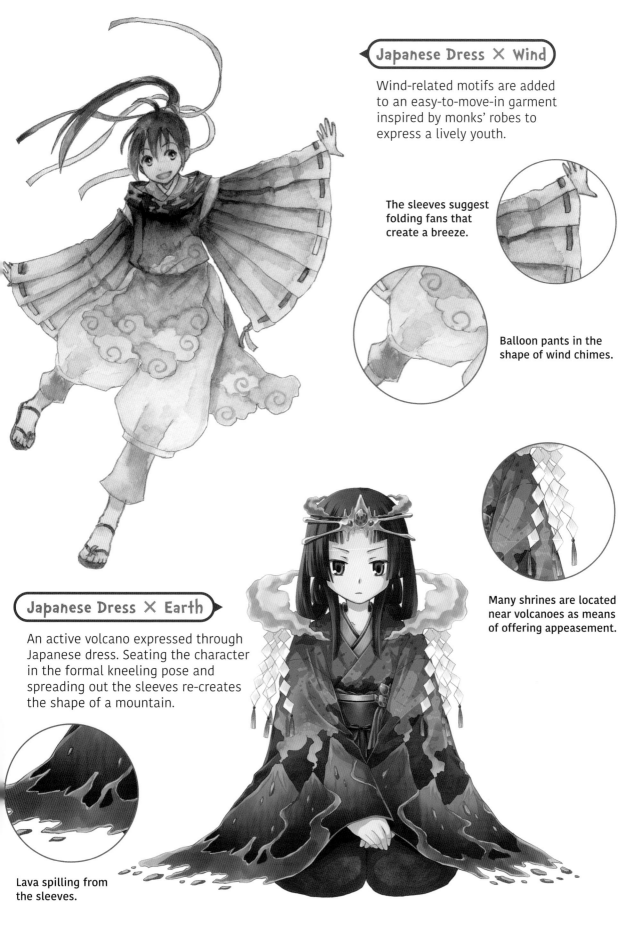

Japanese Dress × Wind

Wind-related motifs are added to an easy-to-move-in garment inspired by monks' robes to express a lively youth.

The sleeves suggest folding fans that create a breeze.

Balloon pants in the shape of wind chimes.

Many shrines are located near volcanoes as means of offering appeasement.

Japanese Dress × Earth

An active volcano expressed through Japanese dress. Seating the character in the formal kneeling pose and spreading out the sleeves re-creates the shape of a mountain.

Lava spilling from the sleeves.

⑤Japanese Dress ✕ ⑨Nature

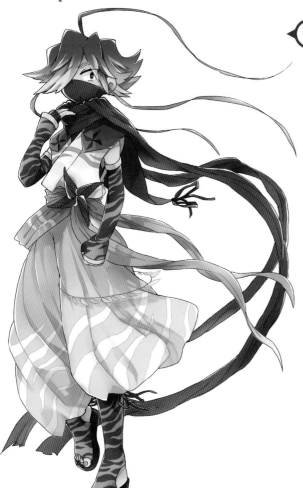

> Ninja ✕ Wind

The concept is a ninja who manipulates the wind. Fabric streaming out from the neck wrapping and the hip sash suggests the flowing currents of wind.

The pattern on the pleated skirt suggests wind.

Pinwheel motifs are a whimsical inclusion.

⑤Japanese Dress ✕ ⑩Mechanical Objects

> Geisha ✕ Mechanical Objects

A geisha's ensemble is given a mechanistic makeover. While white and dazzling luminous color are used for a cohesive look, black is added as an accent hue.

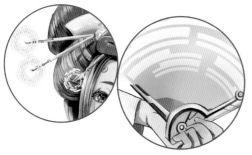

Hair ornaments and the folding fan fuse Japanese-style accessories with mechanical elements.

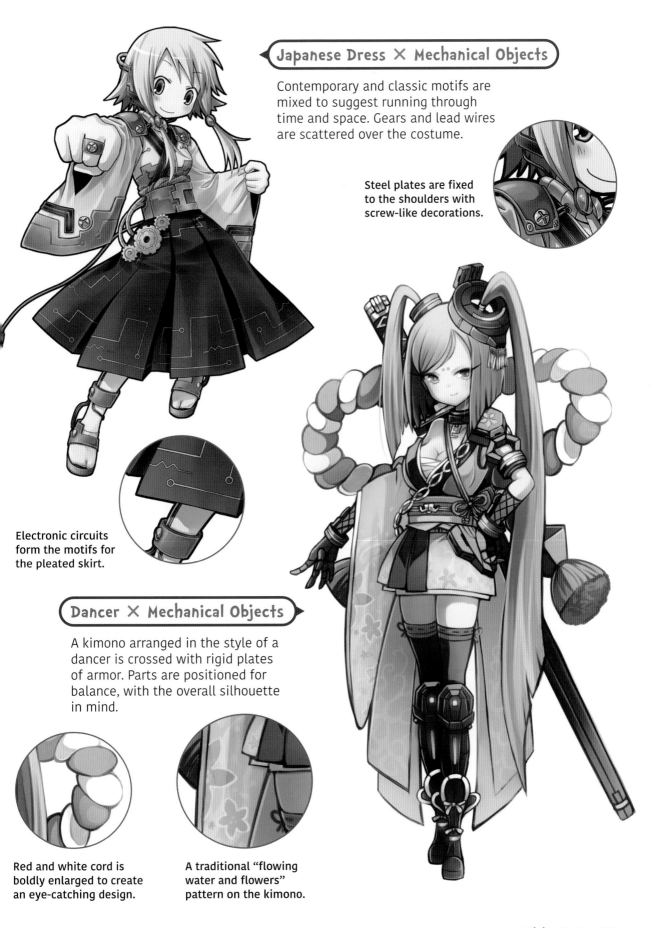

Japanese Dress ✕ Mechanical Objects

Contemporary and classic motifs are mixed to suggest running through time and space. Gears and lead wires are scattered over the costume.

Steel plates are fixed to the shoulders with screw-like decorations.

Electronic circuits form the motifs for the pleated skirt.

Dancer ✕ Mechanical Objects

A kimono arranged in the style of a dancer is crossed with rigid plates of armor. Parts are positioned for balance, with the overall silhouette in mind.

Red and white cord is boldly enlarged to create an eye-catching design.

A traditional "flowing water and flowers" pattern on the kimono.

Digital device motifs are added to a shrine maiden costume. The precision of the electronic circuit is expressed as a delicate pattern.

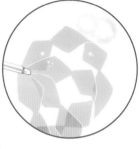

The ceremonial wand is also made of luminous transparent material.

The instruction booklet resembles a ritual prayer scroll.

Japanese Dress ✕ Mechanical Objects

The figure of a female student in a pleated *hakama* is combined with mechanical robotic parts lit up in places to show that it's activated.

Note the differences in how the softness of the fabric and the rigidity of the metal are expressed.

Paying attention to shading allows you to bring out a mechanical three-dimensional effect.

5 Japanese Dress × 11 Seasons

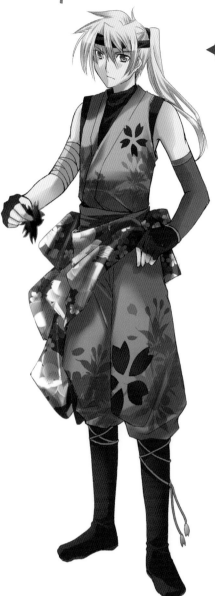

Ninja × Spring

A ninja costume with cherry blossom motifs, so care was taken not to use gaudy colors.

A ninja star in the shape of a cherry blossom.

The ends of the gaiter cords also feature little cherry blossoms.

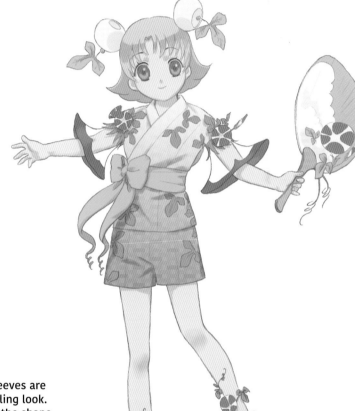

The morning glory sleeves are transparent for a cooling look. Properly researching the shape of the leaves makes them look more authentic.

The hair decorations call to mind wind chimes.

Jinbei (informal summer suit) × Summer

A *jinbei* which incorporates summer motifs such as morning glories, wind chimes and fans. The obi and sandal straps are made to resemble vines.

Japanese Dress × Fall

A Japanese outfit inspired by moon viewing. The hat is moon-shaped. The motifs and color scheme capture the fun and frivolity of fall.

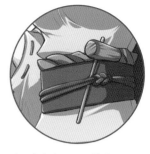

A miniature mallet forms an obi decoration.

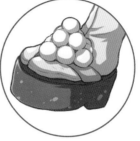

Moon-viewing dumplings decorate the straps of the sandals. They and the skirt are the color of the sky during a full moon.

Glittering tree ornaments are sewn to the sleeves.

Japanese Dress × Winter

Christmas as seen through Japanese dress. The kimono evokes a fir, while the *hakama*, or pleated kilt-like skirt, shows snow falling in a winter sky.

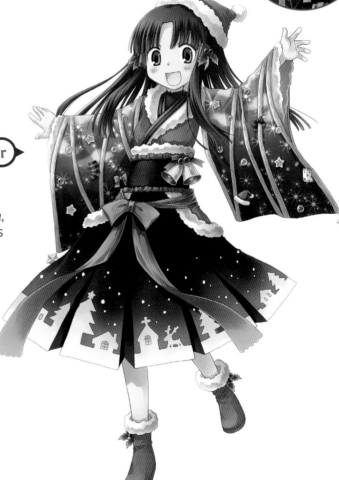

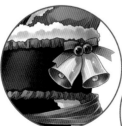

Bell decorations for the obi.

Even the shoes suggest Santa.

Ms Seamstress's Secret #5

Basic construction of clothing (shirts and jackets)

Clothing isn't made up of a single piece of fabric, but of a number of parts that are sewn together. If you understand clothing construction, it may lead to new ideas such as changing the fabric and materials of each part!

Shirts

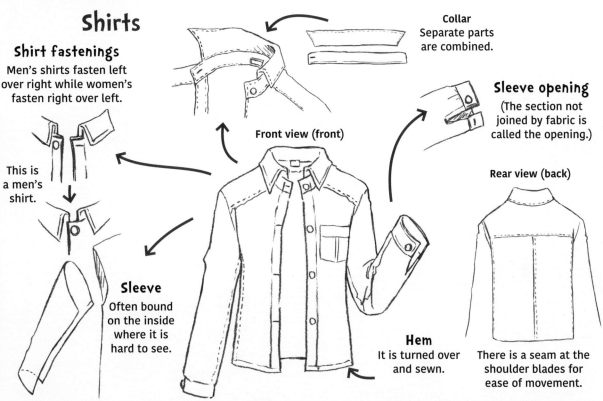

Collar
Separate parts are combined.

Shirt fastenings
Men's shirts fasten left over right while women's fasten right over left.

This is a men's shirt.

Front view (front)

Sleeve opening
(The section not joined by fabric is called the opening.)

Rear view (back)

Sleeve
Often bound on the inside where it is hard to see.

Hem
It is turned over and sewn.

There is a seam at the shoulder blades for ease of movement.

Jacket

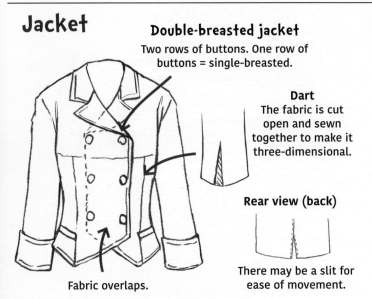

Double-breasted jacket
Two rows of buttons. One row of buttons = single-breasted.

Dart
The fabric is cut open and sewn together to make it three-dimensional.

Rear view (back)

There may be a slit for ease of movement.

Fabric overlaps.

Other points

Properly drawing turned-up fabric and seams brings out a sense of dimension and reality.

Single stitching
One row of stitching.

Double stitching
Two rows of stitching. This makes it sturdier.

There are various types of fasteners such as buttons, zips, hooks and eyes. This is a snap fastener.

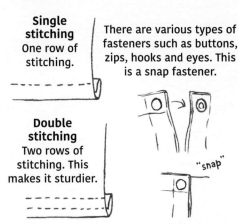

"snap"

Ms Seamstress's Secret #6

Basic construction of clothing (skirts and pants)

What is worn under a skirt? What's going on with the hems of jeans? Researching clothes you're not used to wearing and getting into the habit of looking carefully at the details will broaden the range of your designs.

Skirt

The waistband and skirt sections are often separate.

Gathered skirt

Back

After creating a row of stitches on the sewing machine, the top thread only is pulled up to gather the fabric.

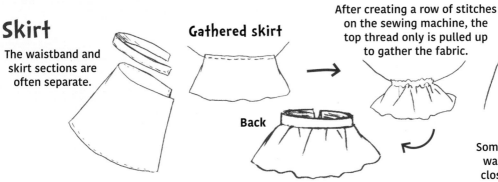

Front

Zipper
Some skirts have elastic waistbands, but most close up with a zipper.

Tight skirt

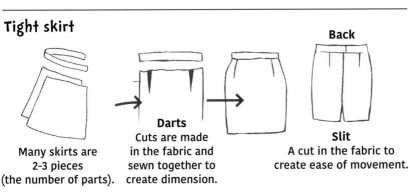

Many skirts are 2-3 pieces (the number of parts).

Darts
Cuts are made in the fabric and sewn together to create dimension.

Back

Slit
A cut in the fabric to create ease of movement.

Items worn under skirts

Petticoats
An undergarment made from a slippery fabric that prevents the skirt from getting caught on the legs.

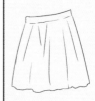

Pannier
An undergarment made from layers of gathered skirts, worn to bring out volume in the overskirt.

Pleated skirt

There are various types of pleats.

Cross-section of the folds.

Pants

Zipper

Jeans Front

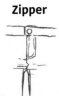

Back

Belt

Often worn as part of a set with jeans.

Hems are usually finished with a single row of stitching.

Rolled up
To turn up the cuffs. As jeans are dyed, the color is different on the reverse of the fabric.

6 Ethnic Costumes ✕ 7 Plants

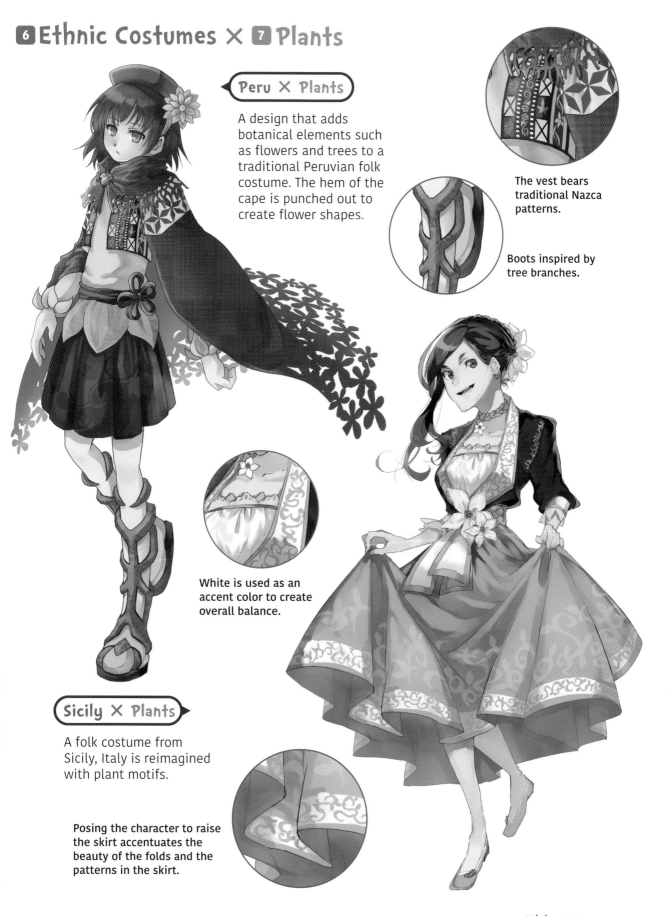

Peru ✕ Plants

A design that adds botanical elements such as flowers and trees to a traditional Peruvian folk costume. The hem of the cape is punched out to create flower shapes.

The vest bears traditional Nazca patterns.

Boots inspired by tree branches.

White is used as an accent color to create overall balance.

Sicily ✕ Plants

A folk costume from Sicily, Italy is reimagined with plant motifs.

Posing the character to raise the skirt accentuates the beauty of the folds and the patterns in the skirt.

6 Ethnic Costumes × 8 Animals

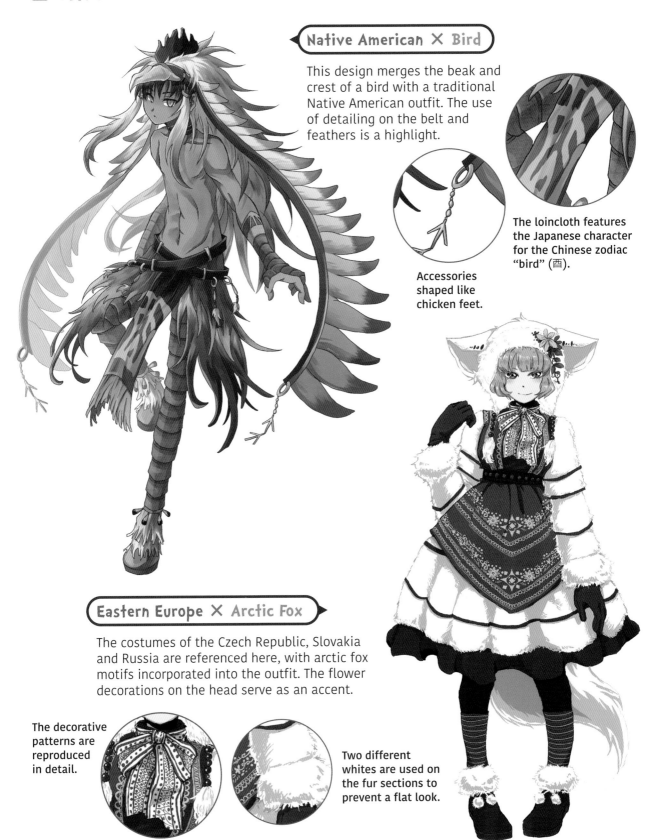

Native American × Bird

This design merges the beak and crest of a bird with a traditional Native American outfit. The use of detailing on the belt and feathers is a highlight.

The loincloth features the Japanese character for the Chinese zodiac "bird" (酉).

Accessories shaped like chicken feet.

Eastern Europe × Arctic Fox

The costumes of the Czech Republic, Slovakia and Russia are referenced here, with arctic fox motifs incorporated into the outfit. The flower decorations on the head serve as an accent.

The decorative patterns are reproduced in detail.

Two different whites are used on the fur sections to prevent a flat look.

6 Ethnic Costumes ✕ 9 Nature

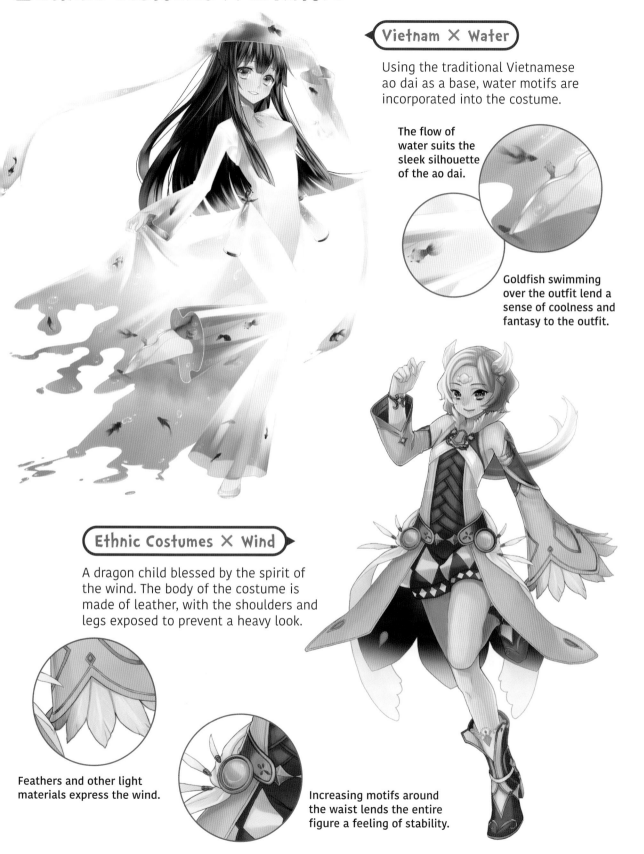

Vietnam ✕ Water

Using the traditional Vietnamese ao dai as a base, water motifs are incorporated into the costume.

The flow of water suits the sleek silhouette of the ao dai.

Goldfish swimming over the outfit lend a sense of coolness and fantasy to the outfit.

Ethnic Costumes ✕ Wind

A dragon child blessed by the spirit of the wind. The body of the costume is made of leather, with the shoulders and legs exposed to prevent a heavy look.

Feathers and other light materials express the wind.

Increasing motifs around the waist lends the entire figure a feeling of stability.

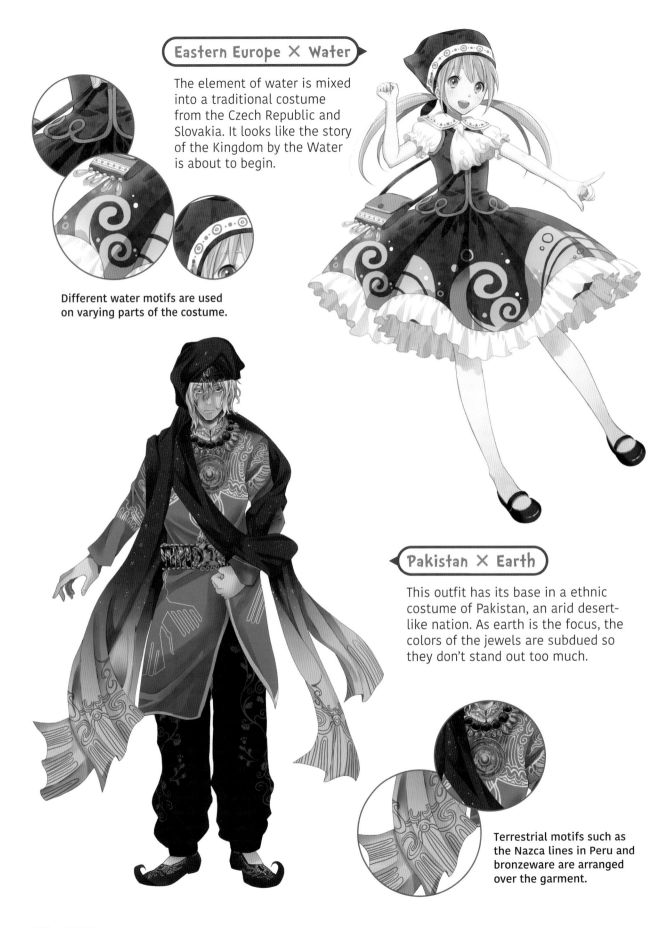

Eastern Europe × Water

The element of water is mixed into a traditional costume from the Czech Republic and Slovakia. It looks like the story of the Kingdom by the Water is about to begin.

Different water motifs are used on varying parts of the costume.

Pakistan × Earth

This outfit has its base in a ethnic costume of Pakistan, an arid desert-like nation. As earth is the focus, the colors of the jewels are subdued so they don't stand out too much.

Terrestrial motifs such as the Nazca lines in Peru and bronzeware are arranged over the garment.

6 Ethnic Costumes ✕ 10 Mechanical Objects

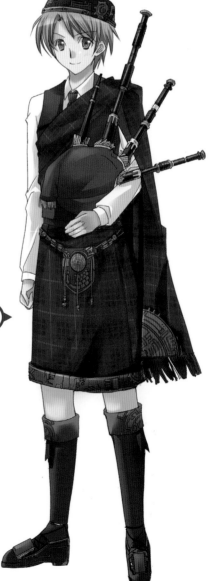

> ## Thailand ✕ Mechanical Objects

Mechanical elements are mixed with a traditional Thai look. The vivid green electrical lights draw the eye.

The waistcloth used in Thailand and other countries is re-created using mechanical elements.

Using warm colors creates the impression of heat even in the mechanical materials.

> ## Scotland ✕ Mechanical Objects

Scottish folk attire reconceived to take on a mechanical look. Electrical circuitry and gear patterns are positioned over the outfit as accents.

The characteristic bag worn with the kilt sports an ENTER key. Electrical cords replace the more traditional elements.

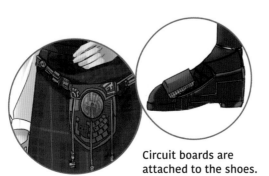

Circuit boards are attached to the shoes.

6 Ethnic Costumes × 11 Seasons

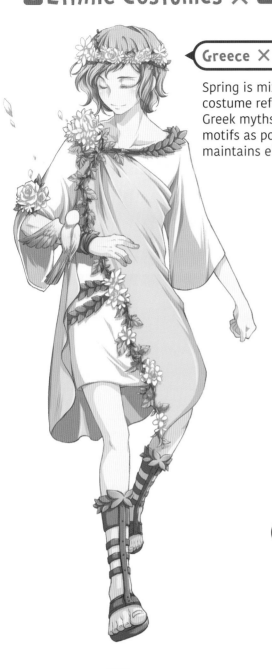

Greece × Spring

Spring is mixed into a costume referencing the Greek myths. Using floral motifs as points of interest maintains elegance.

Replacing a laurel wreath with a floral crown adds an aesthetic impression.

Subtle gradation on the greenery expresses nature's transitions.

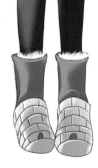

Inuit × Summer

The thick, warm attire of Inuits is rearranged in summer style in this design inspired by their often harsh northern environment.

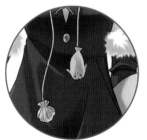

Motifs such as seals and shells call to mind the arctic region.

Boots that express igloos, the domed houses of Inuit families.

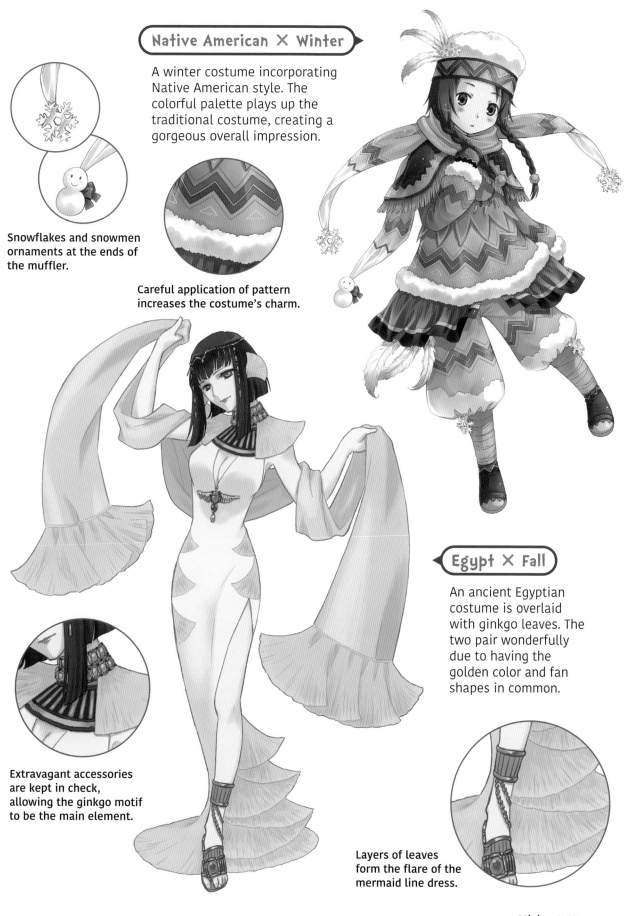

Native American ✕ Winter

A winter costume incorporating Native American style. The colorful palette plays up the traditional costume, creating a gorgeous overall impression.

Snowflakes and snowmen ornaments at the ends of the muffler.

Careful application of pattern increases the costume's charm.

Egypt ✕ Fall

An ancient Egyptian costume is overlaid with ginkgo leaves. The two pair wonderfully due to having the golden color and fan shapes in common.

Extravagant accessories are kept in check, allowing the ginkgo motif to be the main element.

Layers of leaves form the flare of the mermaid line dress.

Ms Seamstress's Secret #7

Fabric & Material

In order to create realistic-looking costumes, it's important to imagine the types of materials that are actually used as you draw. Even if you're creating an imaginary material, having some knowledge will make for a more convincing result. Try observing the characteristics of various materials and fabrics, including leather and plastic, in your daily life!

Transparent fabrics include chiffon, organdie and gauze.

Many Middle Eastern fabrics are silk and have a glossy luster to them.

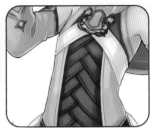

For expressing floaty, soft fabrics, gradation is effective.

When drawing thick, firm fabrics, make the seams thick too.

For tanned leather, such as belts, apply color to create subtle transitions.

When drawing crystals and gemstones, pay attention to the roundness of the spheres and how light is applied.

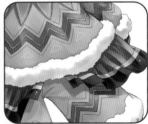

Fleecy fabrics can be conveyed by creating fluffy, airy outlines and shadows.

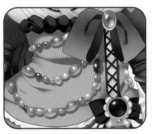

Shadow brings out dimension in the complex overlapping of birds' feathers.

For metallic accessories, study their thickness and how shadows and light affect them.

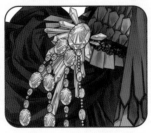

Minerals are not made up of one color, but a mix of several similar shades.

For slightly aged antique metals, make sure they are not too shiny.

Adding precise shadows to resin materials creates dimension and imparts a sense of solidity.

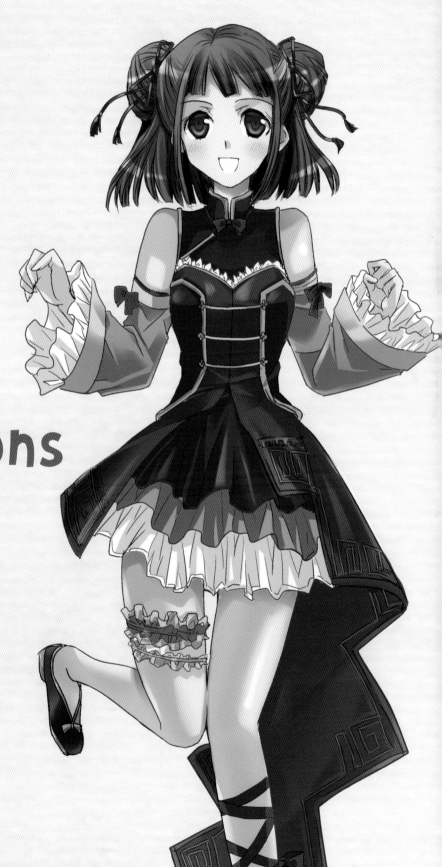

Variations

CHAPTER 2 Variations

Changing or transforming colors or specific parts of the design broadens the range of looks and options. Try making a garment so long that it reaches the ground, or shortening a long skirt as much as possible... be brave and make bold changes!

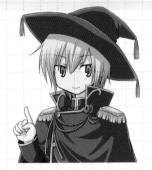

Color Variations

Even clothes with the same form make a significantly different impression if you alter the color scheme. One trick when coloring costumes is to apply color with the scheme you want to create in mind. In the example works on these pages, care has been taken to maintain an overall sense of cohesion by using the same color in the hat and skirt, for example. Where to use the same color and which color to use as an accent are also key when altering the design's palette.

A Color Variation Using Colors Common in School Uniforms X Colors Common in Gothic Lolita Costumes

Original Costume

School Uniform X Lolita
Page 45

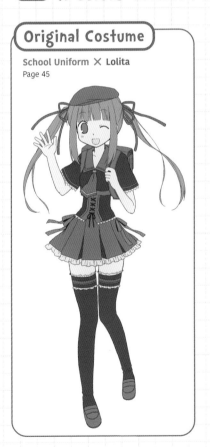

A color scheme based around shades of brown creates a sense of calm and security. The blond hair makes for a clean impression.

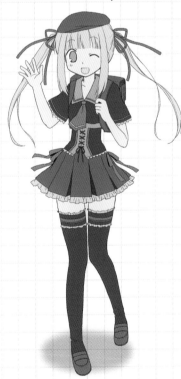

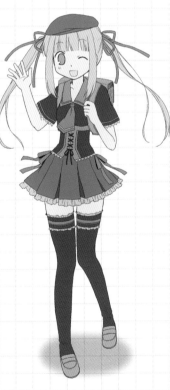

A blue-based color scheme creates a cool looking uniform. Pink hair is often used for naïve, innocent characters.

Black hair and a navy-based color palette make for a character with a sense of calm. Red was added to prevent the look from becoming too dark.

Using warm shades creates a relatable character. The orange hair gives her a cheerful air.

Blue-based coloring and purple hair give a slightly less innocent impression.

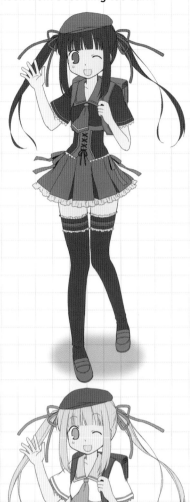

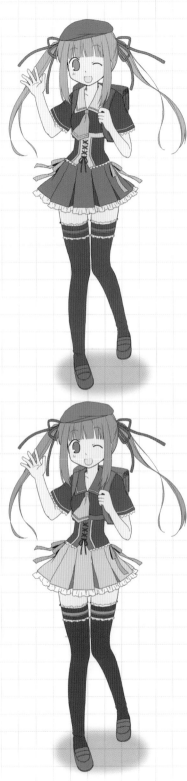

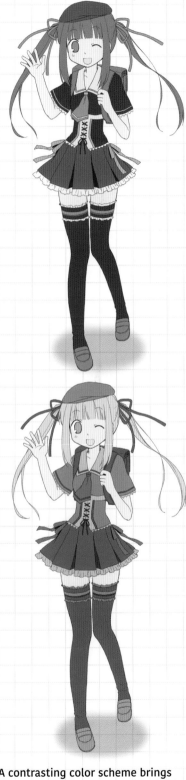

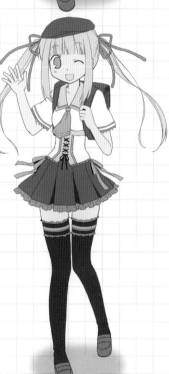

A white-based uniform with light hair creates a clean, classy impression.

The use of warm colors suggests a sense of security.

A contrasting color scheme brings together classical green with pink hair conveying suppressed innocence.

B Resembling Both a School Uniform and Military Apparel. The Colors of the Check Patterns are Also Key.

Original Costume

Standing Collar × Military Apparel
Page 43

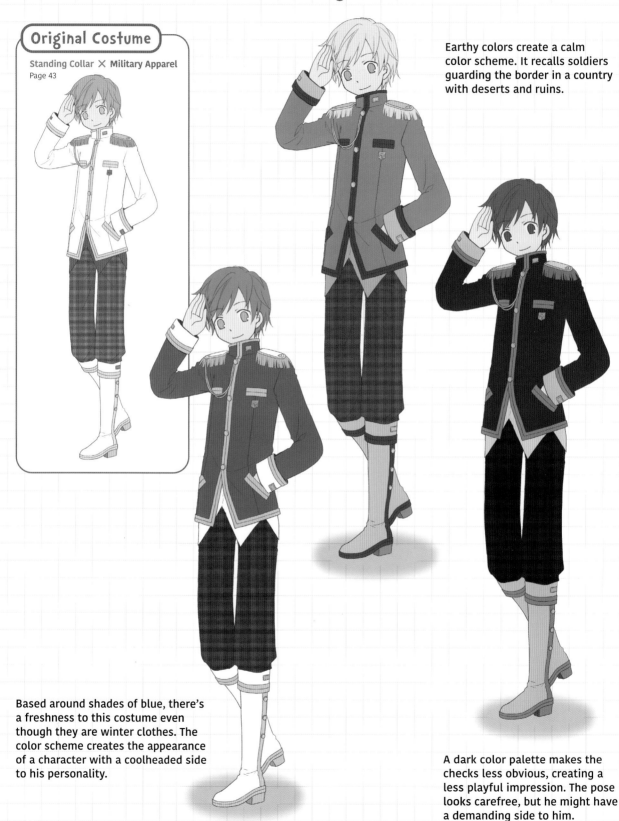

Earthy colors create a calm color scheme. It recalls soldiers guarding the border in a country with deserts and ruins.

Based around shades of blue, there's a freshness to this costume even though they are winter clothes. The color scheme creates the appearance of a character with a coolheaded side to his personality.

A dark color palette makes the checks less obvious, creating a less playful impression. The pose looks carefree, but he might have a demanding side to him.

C The Colors of the Double-Layered Skirt and Floral Waist Decoration Form Accents

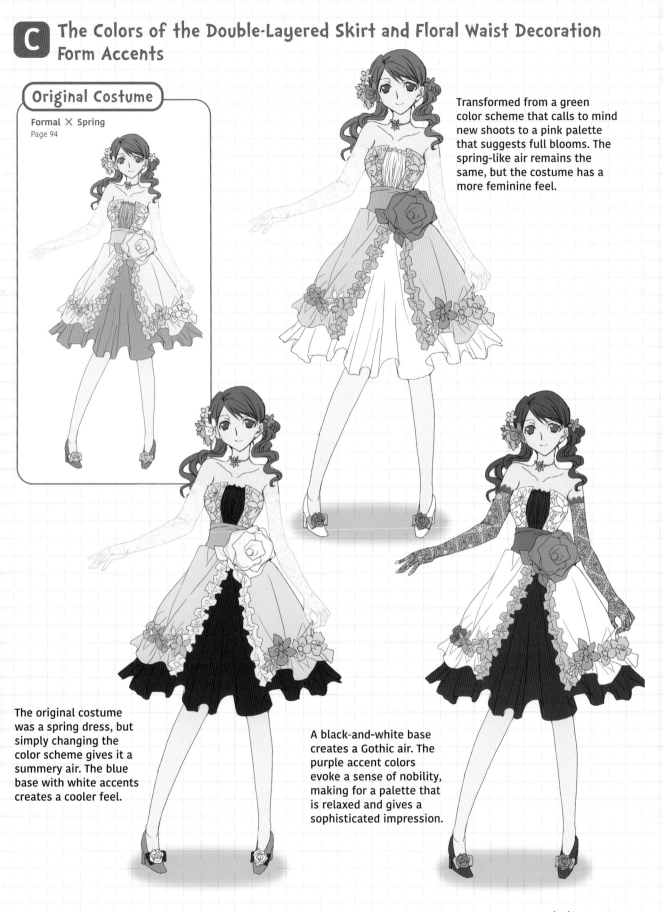

Original Costume

Formal × Spring
Page 94

Transformed from a green color scheme that calls to mind new shoots to a pink palette that suggests full blooms. The spring-like air remains the same, but the costume has a more feminine feel.

The original costume was a spring dress, but simply changing the color scheme gives it a summery air. The blue base with white accents creates a cooler feel.

A black-and-white base creates a Gothic air. The purple accent colors evoke a sense of nobility, making for a palette that is relaxed and gives a sophisticated impression.

D A Combination of Colors Borrowed from Natural Phenomenon that Evoke Celestial Shades

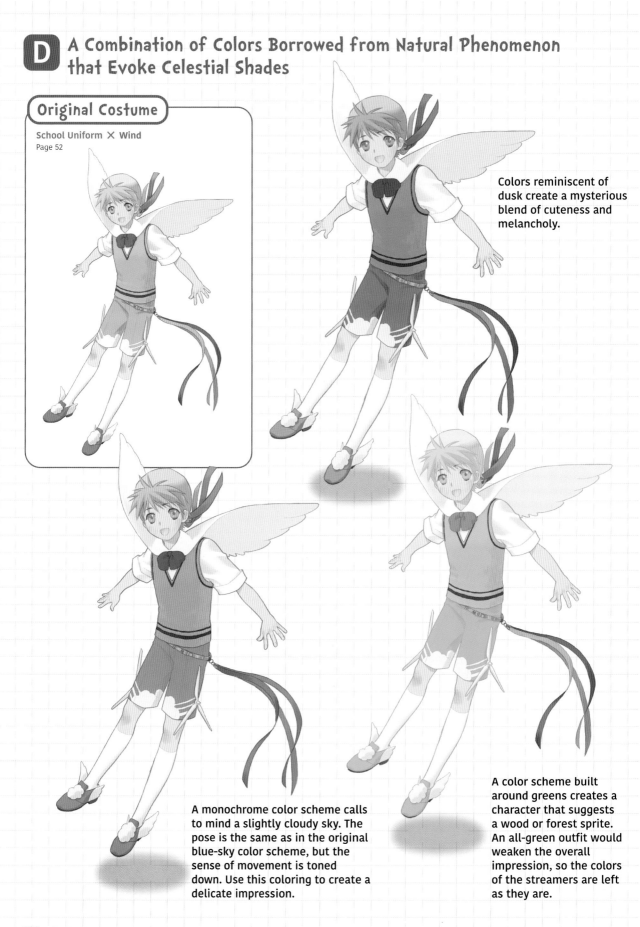

Original Costume

School Uniform ✕ Wind
Page 52

Colors reminiscent of dusk create a mysterious blend of cuteness and melancholy.

A monochrome color scheme calls to mind a slightly cloudy sky. The pose is the same as in the original blue-sky color scheme, but the sense of movement is toned down. Use this coloring to create a delicate impression.

A color scheme built around greens creates a character that suggests a wood or forest sprite. An all-green outfit would weaken the overall impression, so the colors of the streamers are left as they are.

E Not Bound by Stereotypes, The Use of Unexpected Colors is Also Eyecatching

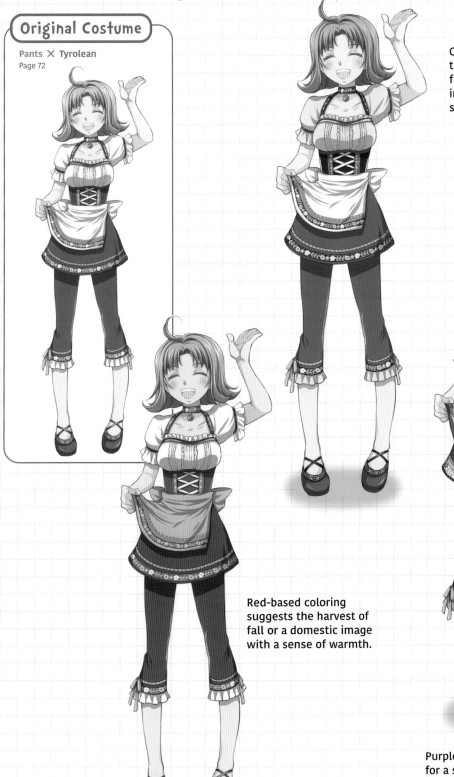

Original Costume

Pants ✕ Tyrolean
Page 72

Green-based coloring evokes the color of meadows and fields. Adding a little green into the blouse creates a sense of cohesion.

Red-based coloring suggests the harvest of fall or a domestic image with a sense of warmth.

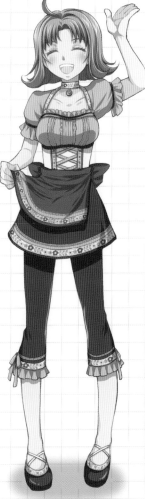

Purple-based coloring makes for a slightly unfamiliar, exotic air. Intentionally using gray—a little-used color—for the apron creates a chic impression.

Changing Parts of the Costume

Even if you believe your design to be complete, deliberately altering parts or aspects of it, such as the sleeves, collar or hem, may lead to unexpected discoveries. A slight or partial change can create a completely different impression. Give it a go, thinking about how altering parts of the design could affect how the character is presented while you work.

A Enlarging/Reducing

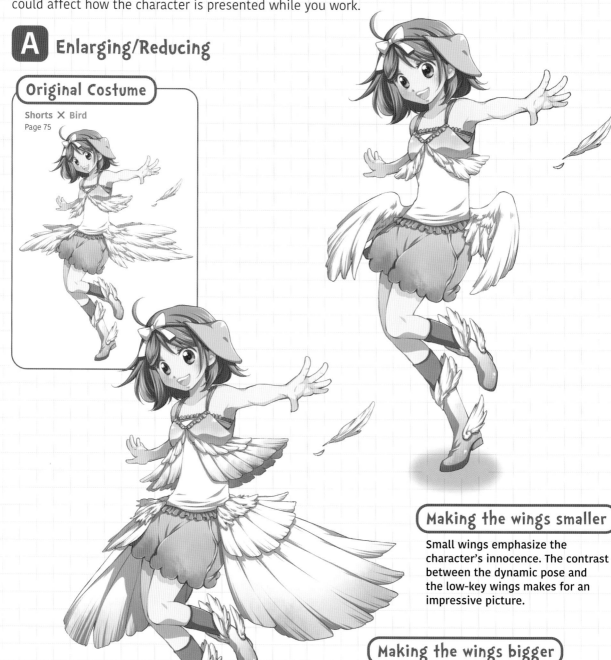

Original Costume

Shorts ✕ Bird
Page 75

Making the wings smaller

Small wings emphasize the character's innocence. The contrast between the dynamic pose and the low-key wings makes for an impressive picture.

Making the wings bigger

Enlarging the wings conveys a sense of their heaviness, lending the image a slightly subdued impression. At the same time, one gets the feeling that the character could boldly flap her wings and fly far away.

B Enlarging/Reducing

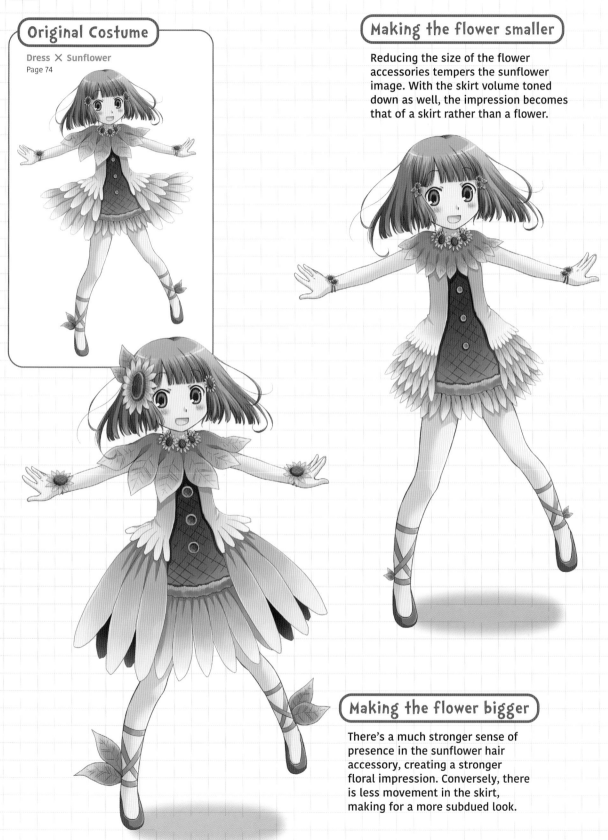

Original Costume

Dress ✕ Sunflower
Page 74

Making the flower smaller

Reducing the size of the flower accessories tempers the sunflower image. With the skirt volume toned down as well, the impression becomes that of a skirt rather than a flower.

Making the flower bigger

There's a much stronger sense of presence in the sunflower hair accessory, creating a stronger floral impression. Conversely, there is less movement in the skirt, making for a more subdued look.

C Making Shorter/Making Longer

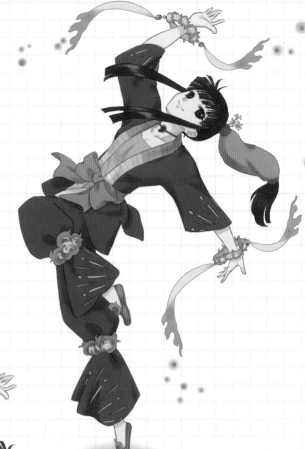

Original Costume

Japanese Dress ✕ Fire
Page 100

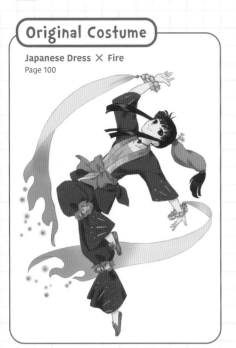

Making the fabric shorter

Shortening the characteristic lengths of fabric shifts the focus of the picture from the fabric to the character's movement. Sparks help to show the character's agility and dynamism.

Making the fabric longer

Lengthening the fabric draws the viewer's gaze to the movement of the fabric and the play of the sparks, rather than to the character. It also adds a flame-like smoothness to the character's pose.

D Making Shorter/Making Longer

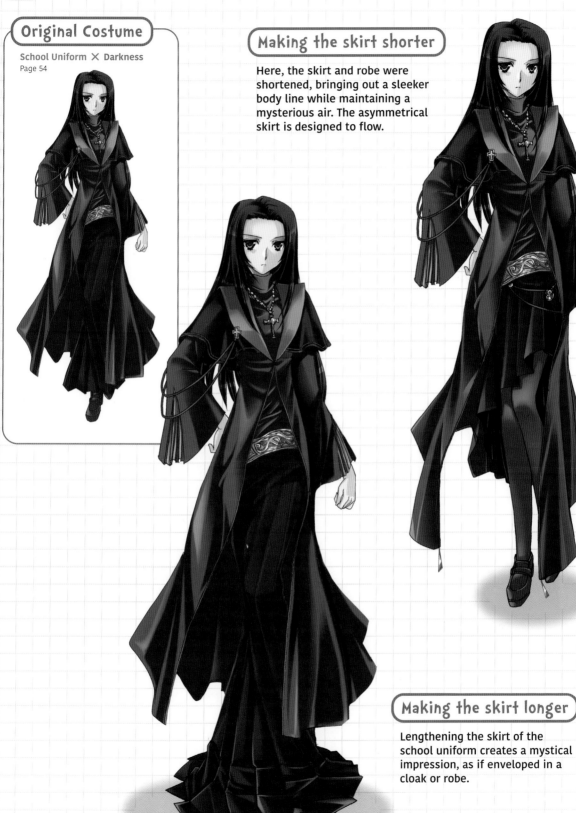

Original Costume

School Uniform ✕ Darkness
Page 54

Making the skirt shorter

Here, the skirt and robe were shortened, bringing out a sleeker body line while maintaining a mysterious air. The asymmetrical skirt is designed to flow.

Making the skirt longer

Lengthening the skirt of the school uniform creates a mystical impression, as if enveloped in a cloak or robe.

E Layering Fabric/Making It More Transparent

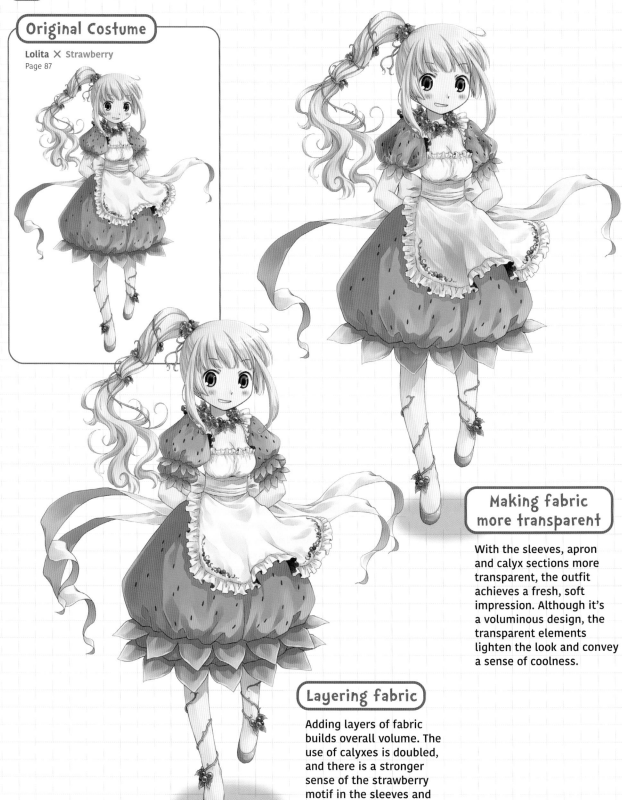

Original Costume

Lolita ✕ **Strawberry**
Page 87

Making fabric more transparent

With the sleeves, apron and calyx sections more transparent, the outfit achieves a fresh, soft impression. Although it's a voluminous design, the transparent elements lighten the look and convey a sense of coolness.

Layering fabric

Adding layers of fabric builds overall volume. The use of calyxes is doubled, and there is a stronger sense of the strawberry motif in the sleeves and hem, making for a lively impression.

F Layering Fabric/Making It More Transparent

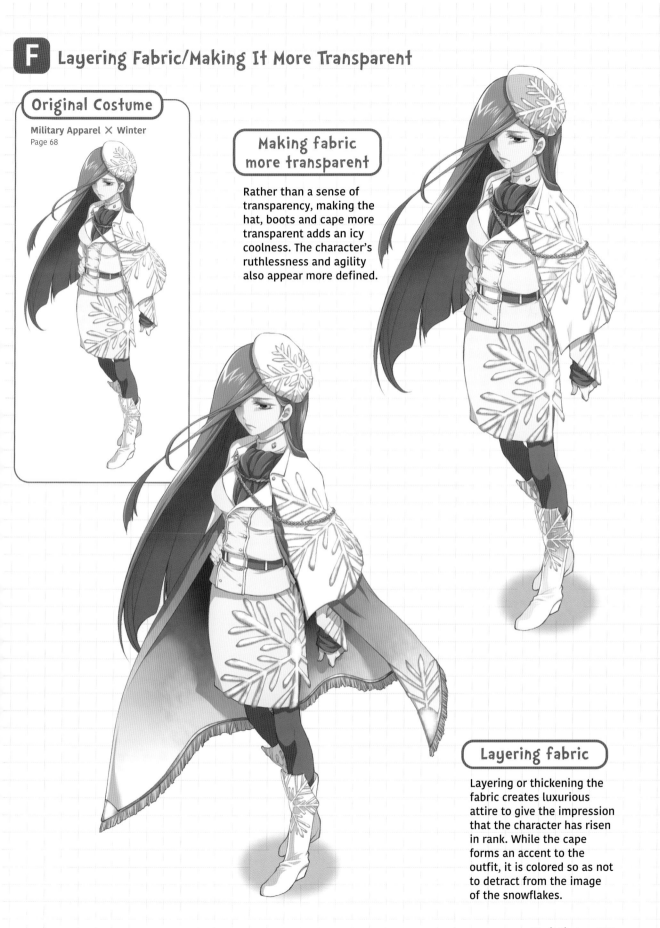

Original Costume

Military Apparel ✕ Winter
Page 68

Making fabric more transparent

Rather than a sense of transparency, making the hat, boots and cape more transparent adds an icy coolness. The character's ruthlessness and agility also appear more defined.

Layering fabric

Layering or thickening the fabric creates luxurious attire to give the impression that the character has risen in rank. While the cape forms an accent to the outfit, it is colored so as not to detract from the image of the snowflakes.

G Embellish

Original Costume

Gothic Lolita × Fall
Page 96

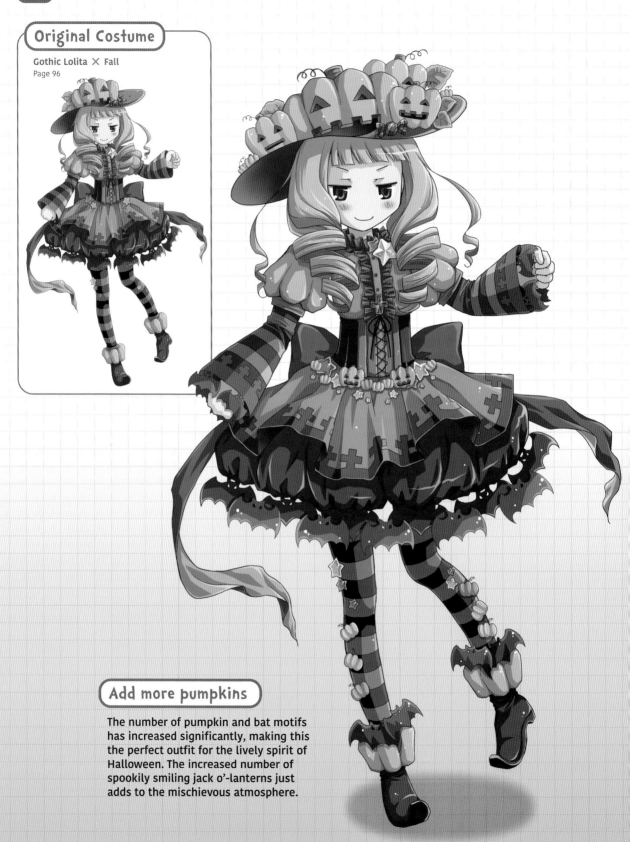

Add more pumpkins

The number of pumpkin and bat motifs has increased significantly, making this the perfect outfit for the lively spirit of Halloween. The increased number of spookily smiling jack o'-lanterns just adds to the mischievous atmosphere.

H Embellish

Original Costume

Gothic Lolita ✕ **Summer**
Page 95

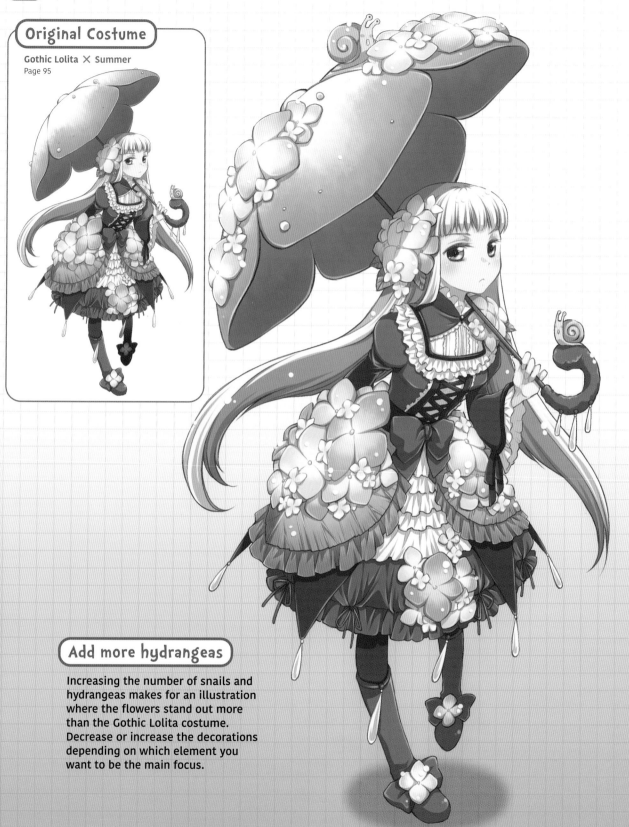

Add more hydrangeas

Increasing the number of snails and hydrangeas makes for an illustration where the flowers stand out more than the Gothic Lolita costume. Decrease or increase the decorations depending on which element you want to be the main focus.

I Making It Symmetrical

Original Costume

Camisole Dress ✕ India
Page 73

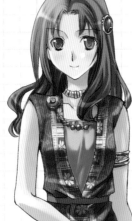

Make the garment symmetrical

Turning the sari into a symmetrical sarong-style garment lessens the ethnic costume effect but makes for a richer, more gorgeous impression. This works when you want to prioritize unique styling over an exotic look.

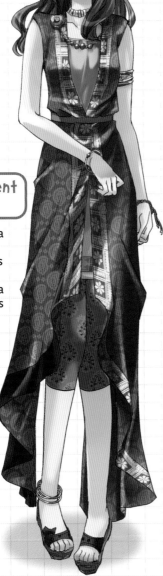

J Making It Asymmetrical

Original Costume

Lolita ✕ China
Page 85

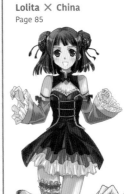

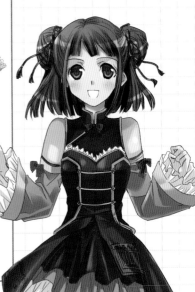

Make the hem of the upper garment asymmetrical

The collar of the cheongsam, which in the original picture was arranged symmetrically, has been returned to its original style, which fastens on one side, while the hem is given the asymmetrical treatment. Don't forget Chinese-style motifs on the hem.

K L Making It Asymmetrical

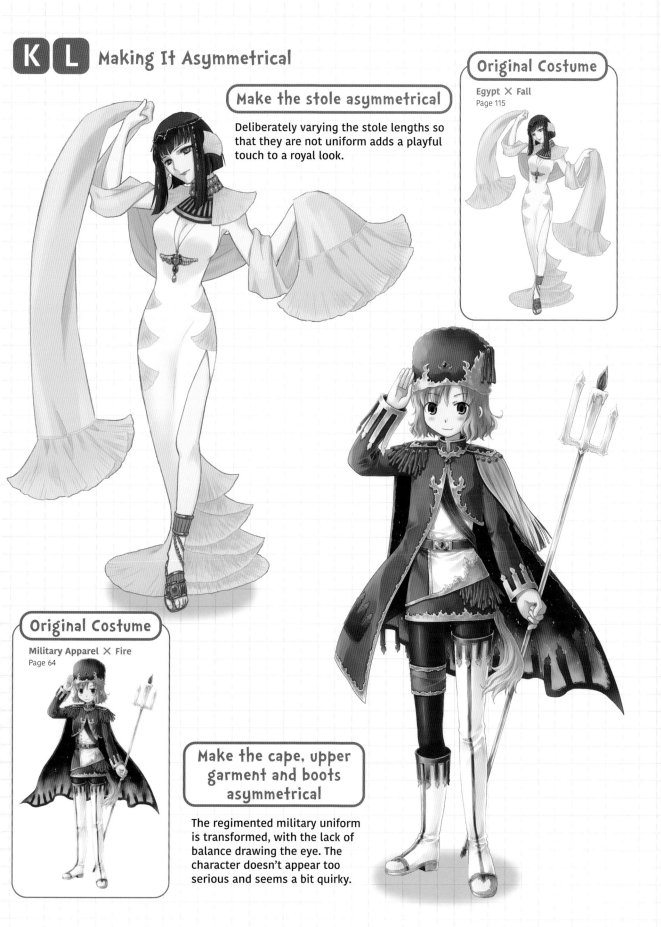

Make the stole asymmetrical

Deliberately varying the stole lengths so that they are not uniform adds a playful touch to a royal look.

Original Costume

Egypt ✕ Fall
Page 115

Original Costume

Military Apparel ✕ Fire
Page 64

Make the cape, upper garment and boots asymmetrical

The regimented military uniform is transformed, with the lack of balance drawing the eye. The character doesn't appear too serious and seems a bit quirky.

M Alter the Amount of Skin Displayed

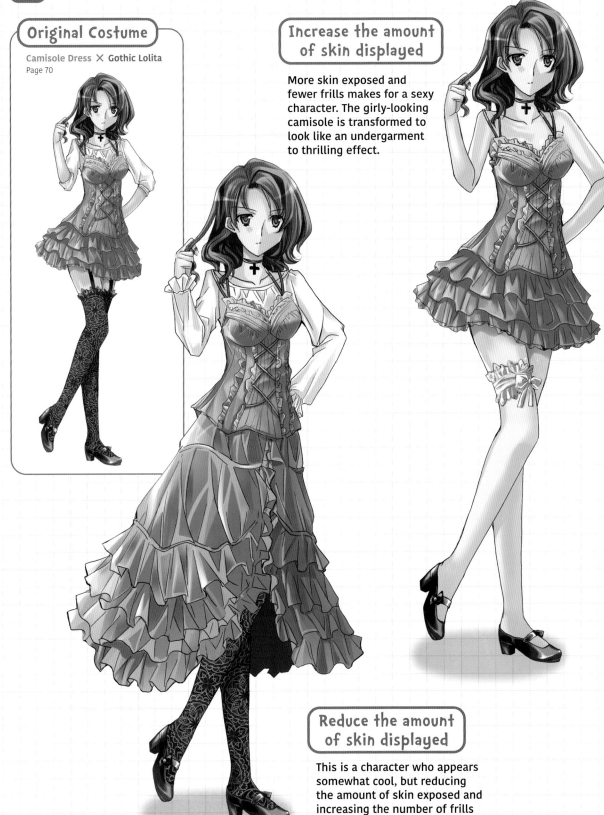

Original Costume

Camisole Dress ✕ Gothic Lolita
Page 70

Increase the amount of skin displayed

More skin exposed and fewer frills makes for a sexy character. The girly-looking camisole is transformed to look like an undergarment to thrilling effect.

Reduce the amount of skin displayed

This is a character who appears somewhat cool, but reducing the amount of skin exposed and increasing the number of frills adds a hint of playfulness.

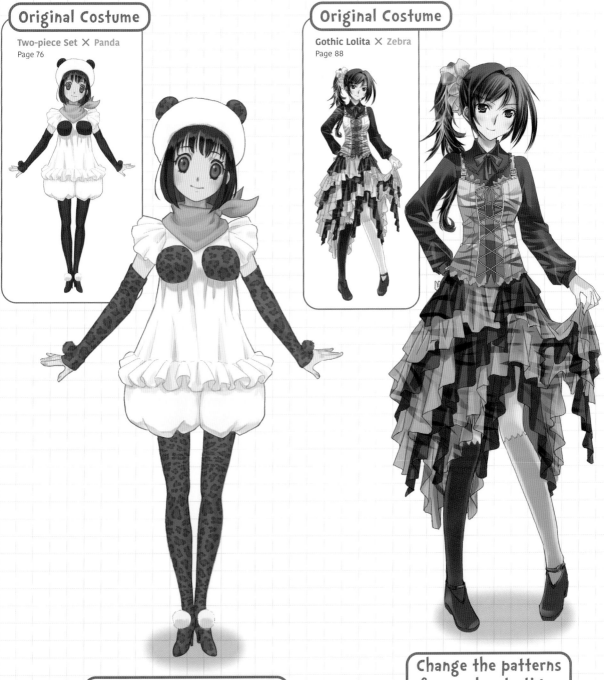

Original Costume

Two-piece Set × Panda
Page 76

Original Costume

Gothic Lolita × Zebra
Page 88

Change the black sections to leopard print

The costume design itself is unchanged, but by making the black parts leopard print, the character who seemed to have a laidback demeanor is transformed to appear active and cheerful.

Change the patterns from zebra to tiger

Adding color to the sections that were monochromatic weakens the Gothic Lolita elements, transforming the character from a conservative indoor type to an active, aggressive woman.

P Changing Materials (Upgrading)

Original Costume

Military Apparel ✕ **Dragon**
Page 63

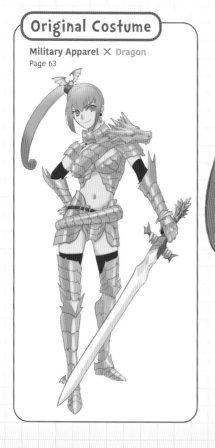

Upgrade the material

Changing the parts of the armor
that were green to red makes the
iron look beaten and wrought,
creating a stronger look. The hilt
of the sword is a slightly rusty
color, giving it an aged, upgraded
look. The dragon wrapped around
the torso also seems to have
awakened to his abilities to show
his true power.

Q Changing Materials (Degrading)

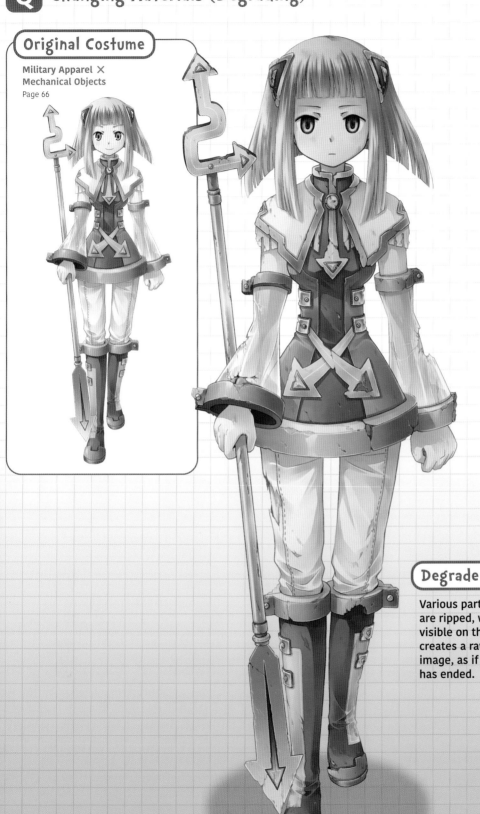

Original Costume

Military Apparel ✕
Mechanical Objects
Page 66

Degrade the material

Various parts of the costume
are ripped, with shadows
visible on the surface. It
creates a raw and ragged
image, as if a fierce battle
has ended.

Ms Seamstress's Secret #8

Various Footwear

Of course the costume is important, but the shoes worn with it are just as key. Use common shoe and footwear styles as a reference to bring special designs to the feet!

Shoes with a strap

Consider the foot inside the shoe as you draw it, taking care regarding the size and shape.

From diagonally front

Heel (the section on the sole of the shoe)

Inner side (big toe side)

Sole

Outer side
The strap fastener is on the outer side (little toe side).

From diagonally behind

From directly behind
There is a seam at the direct center of the heel cup. Don't forget to draw the heel.

Sneakers

Stilettos

Sandals

Boots

From the artworks

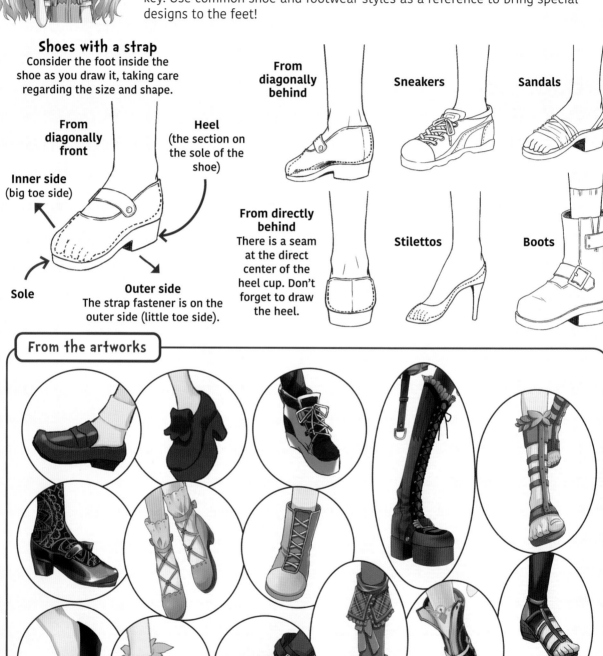

Distinctive Accessories

CHAPTER 3 Distinctive Accessories

Characters that leave an impression use small items and accessories well. Once the clothing is decided, try adding small items that create accents on the head, arms and waist area. The reason for using those particular items is also important.

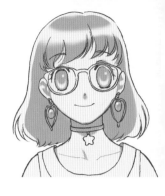

Items Worn on the Head

The head and face area tend to leave an impression as they attract the eye. Try adding a hat or hair accessory that matches the outfit, such as a bandana, hairband, wide-brimmed hat, cap, ten-gallon hat or straw hat.

Caps suit androgynous styles. Knit hats are associated with the outdoors, so they're perfect for characters who like exercise. A beret creates a quiet, intellectual impression.

Small items for the hair can convey a character's age. A scrunchie suggests a young character, while a simple barrette or hairpins evoke an older woman.

Hairbands are often worn by leader types such as a chairperson, while bows are for dreamy young girls. Flowers work well for when you want to dress the character up a little.

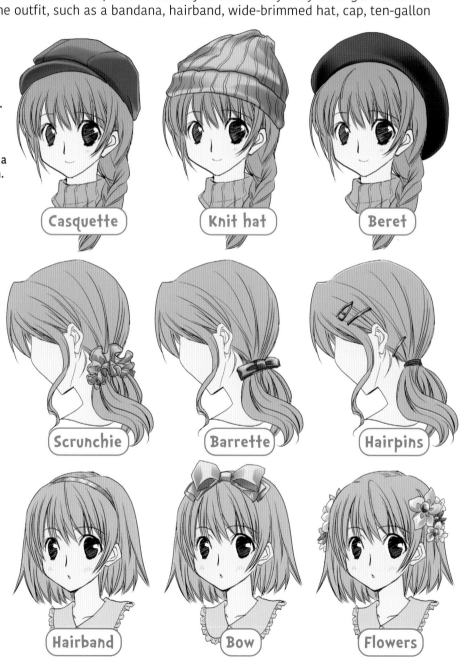

Casquette · Knit hat · Beret

Scrunchie · Barrette · Hairpins

Hairband · Bow · Flowers

Items Worn on the Body

Dressing a character in accessories and other physical embellishments creates a stylish impression. There's no need to overdo it, so be selective and choose items that suit and express the character.

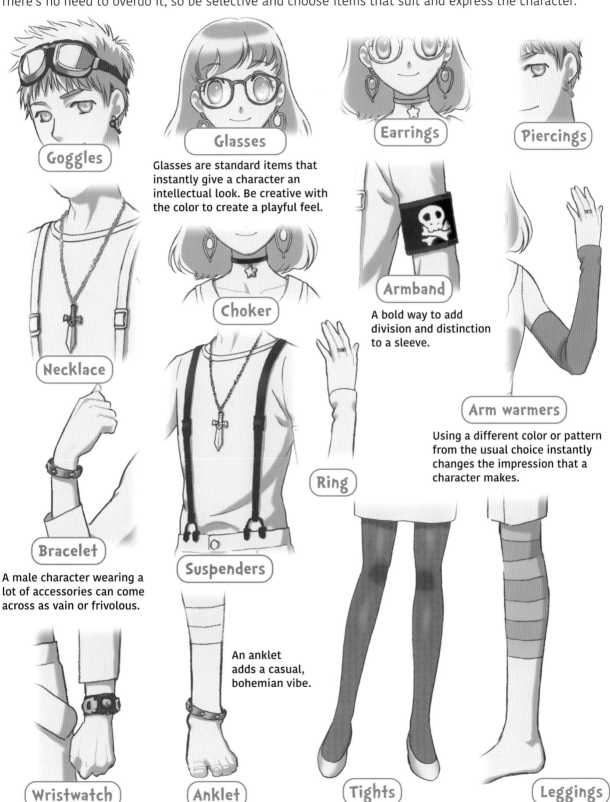

Goggles

Glasses

Glasses are standard items that instantly give a character an intellectual look. Be creative with the color to create a playful feel.

Earrings

Piercings

Necklace

Choker

Armband

A bold way to add division and distinction to a sleeve.

Arm warmers

Using a different color or pattern from the usual choice instantly changes the impression that a character makes.

Bracelet

A male character wearing a lot of accessories can come across as vain or frivolous.

Ring

Suspenders

Wristwatch

Anklet

An anklet adds a casual, bohemian vibe.

Tights

Leggings

Items Wrapped Around the Body

These are useful when you want to increase the surface area of fabric slightly or add an accent color. Stoles, mufflers, chains and other light items that sway when moved alter their form depending on the pose, so try using them when you want to bring out a dynamic feel, too.

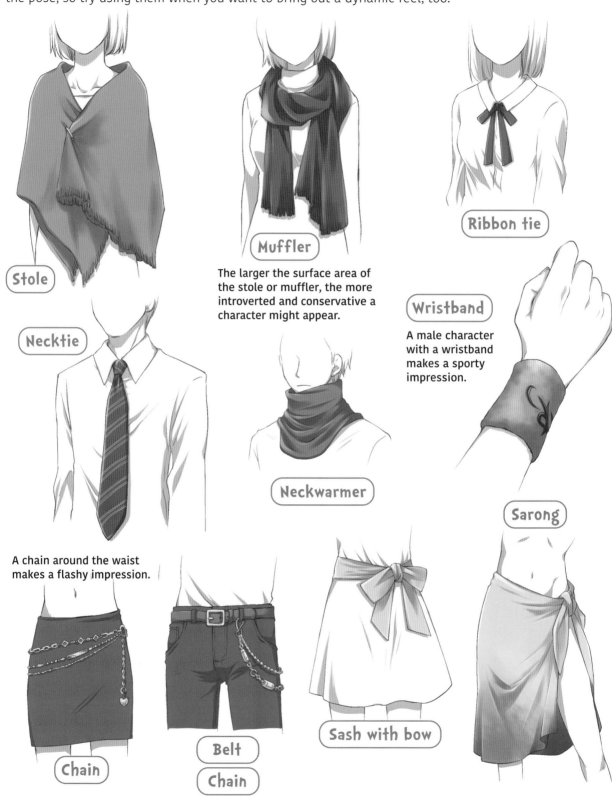

Stole

Muffler

The larger the surface area of the stole or muffler, the more introverted and conservative a character might appear.

Ribbon tie

Wristband

A male character with a wristband makes a sporty impression.

Necktie

Neckwarmer

Sarong

A chain around the waist makes a flashy impression.

Chain

Belt
Chain

Sash with bow

Items Held or Carried

It's possible to express the setting and situation the character is in depending on what kind of bag they are carrying. Tweak the color and shape to match the costume. Apart from these examples, there are also Boston bags, pochettes and tote bags, to name a few.

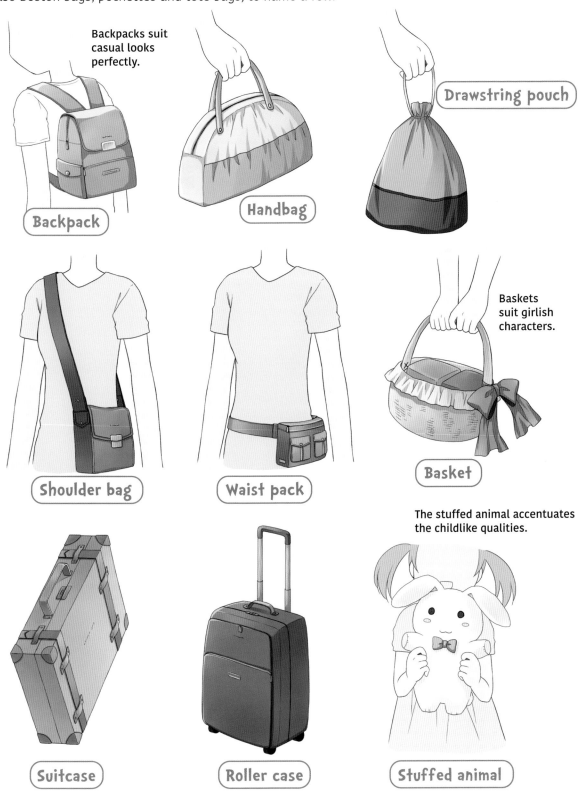

Backpacks suit casual looks perfectly.

Backpack

Handbag

Drawstring pouch

Shoulder bag

Waist pack

Baskets suit girlish characters.

Basket

The stuffed animal accentuates the childlike qualities.

Suitcase

Roller case

Stuffed animal

Ms Seamstress's Secret #9

Various Hairstyles

When we talk about "head-to-toe styling," it's not only the clothes involved, but hairstyles as well. Use this reference to think of styles that pair well with the design. A unique cut or do can become the character's main focus.

Girls/Women

Ponytail
Tie it high on the head.

Side ponytail
A ponytail shifted to the side.

Short style
For a sporty, active look.

Updo
A style that suits adult women.

Pigtails
Hair tied up in two bunches.

Half ponytail
Only half the hair is tied up.

One-length bob
For uniformity and cohesion.

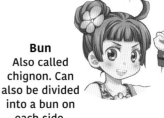

Bun
Also called chignon. Can also be divided into a bun on each side.

Low pigtails
Hair divided in two and tied below the ears. Can also be tied in braids.

Princess cut
Hair is cut blunt on the sides of the face.

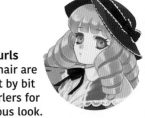

Rag curls
Hanks of hair are wound bit by bit around curlers for this gorgeous look.

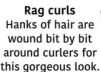

Flared bob
Perfect for a bright, cheerful character.

Boys/Men

Center part
The hair is parted in the exact center.

7:3 part (side part)
The bangs are parted at a 7:3 ratio.

Short hair
Energetic characters are often drawn with short hair.

Long
Flowing hair or tied back allows for styling options.

Decorations &
Embellishments

CHAPTER 4 Decorations & Embellishments

When you've finished your costume design but feel like something's missing, maybe it needs some decoration. Add pattern or ornamentation to parts of the costume to give the character a stronger sense of individuality.

Patterns, Lines & Markings

They might all be called stars, but they can be divided into many types according to their outline, the number of points, the color and other factors. It's easy to incorporate wavy lines and zigzags into the hems of clothing, so think up some patterns to use in future illustrations.

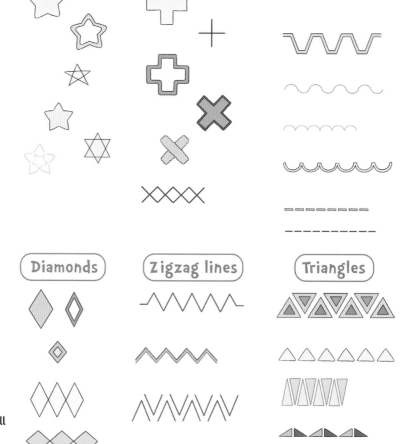

Original Costume

Star

Cross

Bumpy or dotted lines

Diamonds

Zigzag lines

Triangles

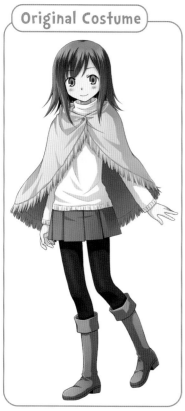

The character is wearing a cape draped over a white turtleneck sweater. With the pleated skirt, black tights and brown boots, it's a standard combination, but the overall look lacks focus, with nothing that particularly stands out.

Try decorating the sleeves and hem of the outfit with regular patterns. Even if you don't add pattern to the outfit as a whole, just adding it to sections creates accents!

Let's Decorate!

Adding decoration to the hem of a cape or sweater makes for an outfit with a sense of refinement and cohesion. The stars on the cape clasp and hairpins create accents and lend the character a contemporary, youthful air. Adding fringe and cords to the boots brings out movement in the illustration.

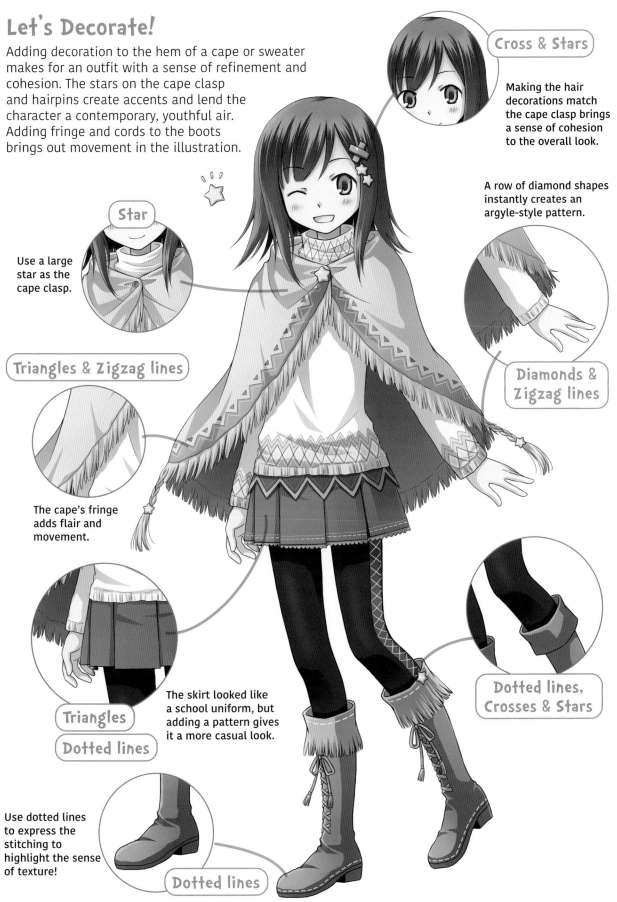

Cross & Stars

Making the hair decorations match the cape clasp brings a sense of cohesion to the overall look.

A row of diamond shapes instantly creates an argyle-style pattern.

Star

Use a large star as the cape clasp.

Diamonds & Zigzag lines

Triangles & Zigzag lines

The cape's fringe adds flair and movement.

Triangles

Dotted lines

The skirt looked like a school uniform, but adding a pattern gives it a more casual look.

Dotted lines, Crosses & Stars

Use dotted lines to express the stitching to highlight the sense of texture!

Dotted lines

Patterns and Fringes

Polka dots and checks are standard patterns that are as popular today as in the past. You can create completely different impressions via the size of the dots, the thickness of the lines and the use of color. There are also all kinds of ribbons and lace to incorporate.

Original Costume

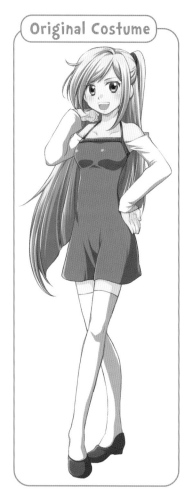

Polka dots

Checks

Stripes

Hearts

Ribbons

Lace

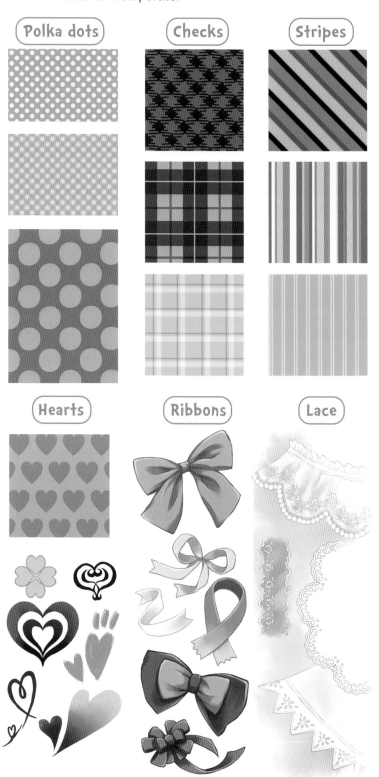

In this outfit of a low-cut top and a gray camisole-style dress, the layers and socks are key points, but as the fabric is plain and the overall colors are simple, the impression is one of everyday clothing.

Using patterns even on only part of the outfit creates a significantly different look. For this reason, using too many patterns may make for an overly busy impression. Rather than using a pattern over the entire outfit, incorporate it a lot of pattern, ribbon and lace in one area as a focal point!

Let's Decorate!

A simple outfit is completely transformed into a gorgeous going-out look! Bow and heart decorations of the same shape adorn the sleeves, shoes and socks. When you want to use various decorations, repeat the same type of embellishment over the outfit for a cohesive effect.

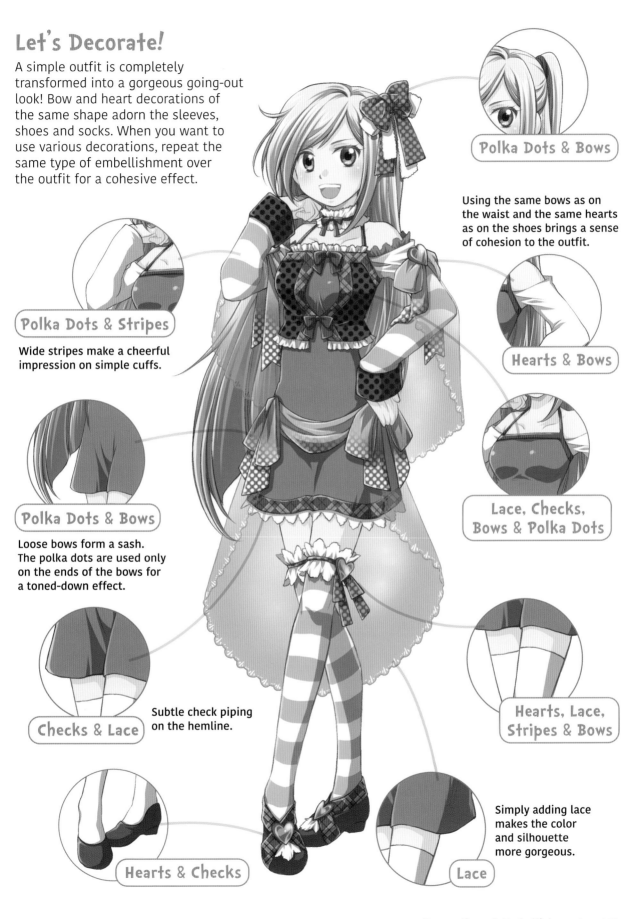

Polka Dots & Bows

Using the same bows as on the waist and the same hearts as on the shoes brings a sense of cohesion to the outfit.

Polka Dots & Stripes

Wide stripes make a cheerful impression on simple cuffs.

Hearts & Bows

Polka Dots & Bows

Loose bows form a sash. The polka dots are used only on the ends of the bows for a toned-down effect.

Lace, Checks, Bows & Polka Dots

Checks & Lace

Subtle check piping on the hemline.

Hearts, Lace, Stripes & Bows

Hearts & Checks

Lace

Simply adding lace makes the color and silhouette more gorgeous.

Sweets & Candy

There is a genre known as "sweets decoration" in which small items are made to resemble sweets. Think of it as adding plastic or felt parts that look exactly like the real thing to a costume.

Original Costume

A blouse with puffed sleeves, a flared skirt and a frilly apron is cute, but it doesn't have a particularly fun vibe. The sandals are plain too, and it looks like something is missing.

For sweets with a simple silhouette like round donuts and macarons or square cookies and chocolates, it's fun to line them up to create motifs rather than using just one as an accent point. Try arranging them to play up the cute color schemes and patterns on the sweets.

Macarons · **Candy** · **Cookies** · **Donuts** · **Whipped cream** · **Wafers**

Let's Decorate!

The blouse sleeves and skirt hem are decorated with motifs taken from sweets, as if the character has stumbled into the land of candy!

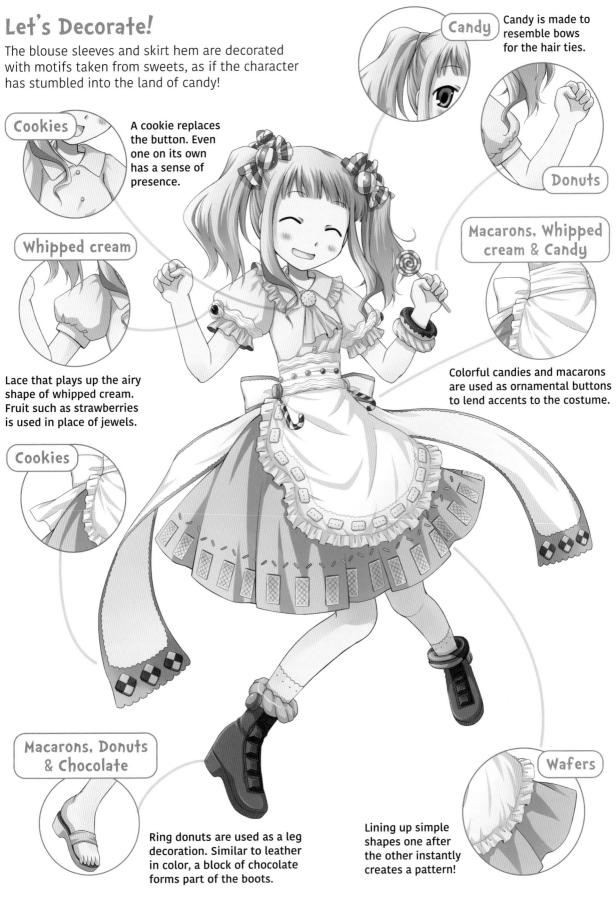

Candy

Candy is made to resemble bows for the hair ties.

Cookies

A cookie replaces the button. Even one on its own has a sense of presence.

Donuts

Whipped cream

Lace that plays up the airy shape of whipped cream. Fruit such as strawberries is used in place of jewels.

Macarons, Whipped cream & Candy

Colorful candies and macarons are used as ornamental buttons to lend accents to the costume.

Cookies

Macarons, Donuts & Chocolate

Ring donuts are used as a leg decoration. Similar to leather in color, a block of chocolate forms part of the boots.

Wafers

Lining up simple shapes one after the other instantly creates a pattern!

Decorations & Embellishments 151

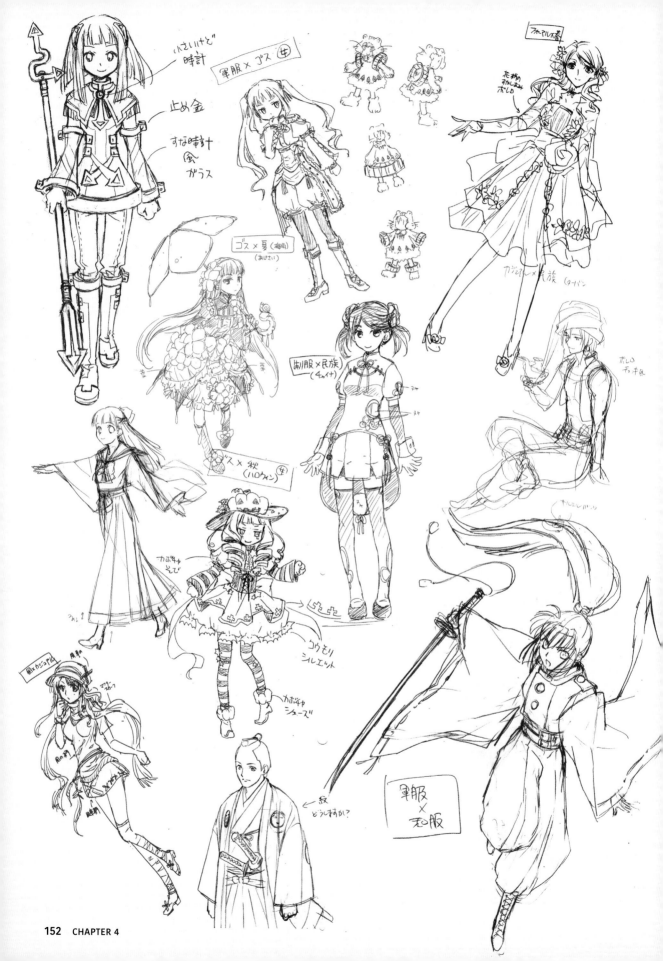

Epilogue

Recently we had the pleasure of launching the Maar-sha Costume Design Contest on the illustration site TINAMI. It was launched after the theme for this book had been determined, but at that time we weren't sure whether anyone would be interested in the theme and we worried that we might not receive even one entry.

However, when it came time to see what we'd gotten, there were way more entries than we'd anticipated, and we were surprised by the innovative costumes, utterly amazing combinations of elements and many fabulous new ideas. We were pleased not only that our theme of creating limitless ideas by combining two elements resonated so well with the audience, but also that even within the same theme for a combination, people were creating different designs. It was an opportunity to realize once again the limitlessness of the human imagination.

It would be great if ideas would magically come from nowhere, but in reality that's quite difficult. Apart from the bases and motifs presented in this book, there are lots of prompts for the imagination by considering what would arise from crossing particular elements. Try looking at the clothes in your own closets and surreptitiously observing what people on the street are wearing—it might lead to a new discovery. Furthermore, it's likely that by taking an interest in things you've only ever casually observed before, such as the patterns on certain garments, the next fashions in casual clothing, how ethnic costume came about or how the sense of heaviness in Gothic Lolita outfits is created, you'll come up with more and more ideas.

It is our hope that this book will help you to realize that costumes are not mere "add-ons" to a character, but rather something that brings out the character's personality and charm. We hope that for those of you who have always loved drawing clothes, it will be a source of further ideas, and for those who feel lost when it comes to designing costumes, it will be the cue to start enjoying drawing them.

Notes on Secondary Use

This book is a collection of ideas for readers to refer to when designing their own original costumes. Each image is subject to copyright. No direct reproduction or imitation of the costume designs in this book is allowed.

These notes include the following:
- Works presented on home pages, blogs or Twitter accounts belonging to individuals
- Works posted externally (such as on general illustration websites or community pages)
- Works published in fanzines and commercial magazines
- Commissioned works

How to Use This Book

○ Using some of the costume ideas and features as a reference when creating

For example, using the picture on the right as a reference and creating only sleeves shaped like strawberries is OK

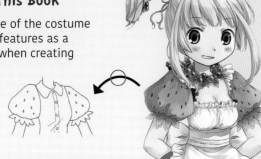

Prohibited Actions

✗ Tracing published illustrations

✗ Copying or imitating the design of a costume without making changes to it

Copying more than one design element—such as the sleeves, neckline and placement of lace—is not allowed

Matrix

Presented as a chart, the combinations in this book are as shown.

[...] indicates that things don't end there.

Base

	School uniforms 1	Military apparel 2	Casual 3	Gothic & Formal 4	Japanese dress 5	Ethnic costumes 6	·	·	·
School uniforms 1	■								
Military apparel 2		■							
Casual 3			■						
Gothic & Formal 4				■					
Japanese dress 5					■				
Ethnic costumes 6						■			
Plants 7									
Animals 8									
Nature 9									
Mechanical Objects 10									
Seasons 11									
·									
·									
·									

Base (vertical rows 1–6), **Motif** (vertical rows 7–11·)

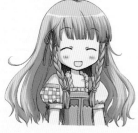

Wow, that's so cool! If you look for them, there must be countless bases and motifs to join together. How about playing cards or a tarot deck, or Greek myths as motifs? And if you look further into casual clothing, ethnic costumes and formal dress for aspects that are not covered in this book, you're sure to come up with new ideas! World history or food in various cultures would probably also be great references.

Artists' Profiles

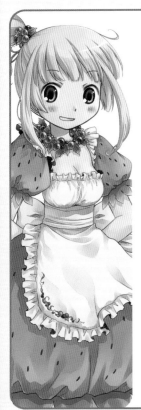

Tomomi Mizuna

Born in Fukuoka prefecture. After working as a graphic artist for a game company, started her career as a freelance cartoonist and illustrator. Work also includes character design, corporate illustrations and children's book illustrations. Her works published in book form include "Super Biography of the Shogun" (Hobunsha) and "Mimori Rocks On!" (Takeshobo).

Home page:
http://mizutomo.com/

Responsible for basic pages:
Casual, Ethnic costumes (China, Tyrol, Spain), Mechanical Objects (page 39), Seasons

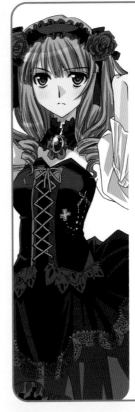

Junka Morozumi

Born in Tokyo. Worked for a general company at the same time as writing manga, then became a freelance cartoonist. After gaining experience in anthology comics, she won first prize in the Dengeki Daioh Comic contest and began focusing on youth magazines. Her works published in book form include "Scary Tales from Apathy School: Suicide Club Revenge" (ASCII Media Works) and "Golden Dreams" (Kadokawa Shoten).

Home page:
http://morozumix.com/

Responsible for basic pages:
Gothic & Formal, Ethnic costumes (Greece, Switzerland, Egypt), Mechanical Objects (page 38), Nature

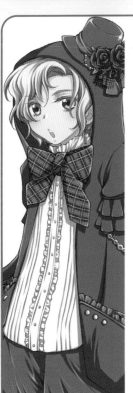

Miki Kizuki

Born in Shizuoka. Freelance manga artist and illustrator. Her works published in book form include "Grand Grace" (Enterbrain) and "Eureka Seven: Gravity Boys & Lifting Girl" (Kadokawa Shoten). She also worked on the visual illustrations for WeMadeOnline's MMORPG Seal Online and creates 4-panel comic strips for the web.

Home page:
http://mikik.main.jp/

Responsible for basic pages:
School uniforms, Ethnic costumes (Vietnam, India, Greece), Plants, Nature

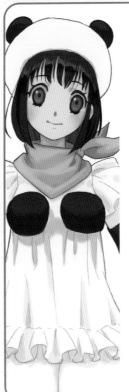

Kaliha

Born in Toyama prefecture. After working on original drawings and direction for anime on television and in theaters, she designed characters and worked on illustrations for "Fire Emblem: Thracia 776" (Nintendo) and "Tear Ring Saga: Utna Heroes Saga" (Enterbrain).

Home page:
http://excalpier.sakura.ne.jp/

Responsible for basic pages:
Military apparel, Japanese dress, Ethnic costumes (Russia, Scotland, Native American), Plants

All the Winners from the
Tinami Maar-sha Costume Design Contest

The following people's 43 artworks were chosen from a total of 268 entries in this year's contest. Thank you so much for all your entries.

(PN = Pen name. Honorific omitted. Within each award category winners are listed in no particular order)

Cooperation: Tinami Co. Ltd.

Grand Prize Winners

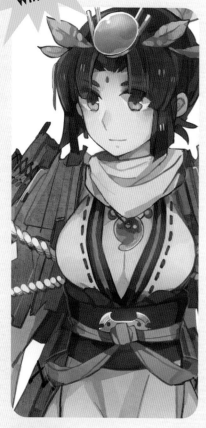

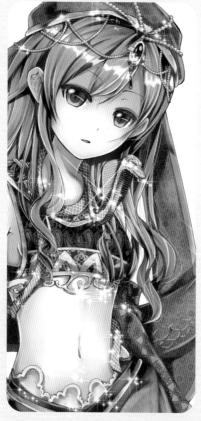

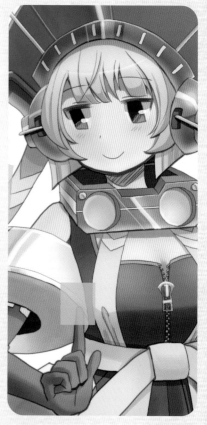

PN: Rororoko
TINAMI ID: 47135
Page 11 Japanese Dress x Earth

I like thinking up all sorts of detailed situations while creating original character drawings, so I am delighted to have been selected for this award. Thank you so much.

PN: Hotaru Takeda
TINAMI ID: 32472
Page 12 Ethnic Costumes x Animals

I really didn't expect to be selected, so I'm very surprised. I love ethnic costumes from other countries and create them myself; it's so nice to be appreciated for something I love. Thank you so much for choosing my work out of so many entries!

PN: sava
TINAMI ID: 30172
Page 13 Ethnic Costumes x Mechanical Objects

I was curious about the novel combination of mechanisms and ethnic dress, which is why I decided to enter. I really enjoyed creating the illustration, so was happy to receive the award. Thank you to everyone who supported me at TINAMI.

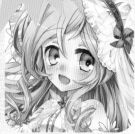

PN: Mike Mizumori
TINAMI ID: 14809
Page 91 Lolita x Wind

I incorporated some motifs I really love. I'm so honored to receive an outstanding performance award! Thank you.

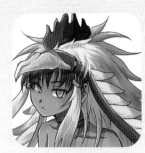

PN: Fumi Akari
TINAMI ID: 19467
Page 110 Native American x Bird

I'm so happy to have received an award like this for a drawing that I had so much fun creating.

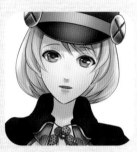

PN: ekm
TINAMI ID: 23050
Page 93 Gothic Lolita x Mechanical Objects

Thank you so much for this outstanding performance award. I was surprised when I saw the announcement of the results, but I'm very happy.

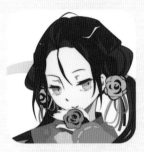

PN: nasako
TINAMI ID: 13871
Page 99 Japanese Dress x Peacock

I was able to enjoy coming up with a costume by combining two things that I love. Thank you!

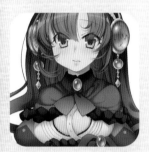

PN: Mozuku Ototsuki
TINAMI ID: 32079
Page 92 Gothic Lolita x Earth

As a creator, I'm happy to be able to produce a work that catches the eye of the public amidst all the brilliant ideas. Thank you!

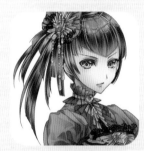

PN: Kiri Fukuyama
TINAMI ID: 14045
Page 90 Lolita x Earth

I was aiming to create a cool design by pairing the Gothic Lolita look that I love with minerals, so I'm happy to have won the award.

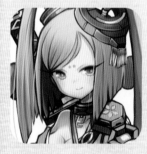

PN: Keijo
TINAMI ID: 10750
Page 103 Dancer x Mechanical Objects

I'm so happy to have won an award like this. I hope my work will be even a tiny bit useful as a costume design reference.

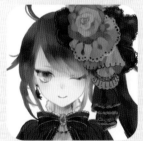

PN: Arimura
TINAMI ID: 27324
Page 89 Gothic Lolita x Golden Eagle

Thank you so much! The Costume Matrix leads to endless inspirations! I can't wait to produce more unusual fantasy mash-ups.

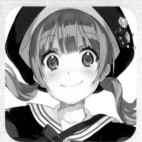

PN: Shiina
TINAMI ID: 35371
Page 50 Sailor Uniform x Penguin

Thank you so much for the outstanding performance award. Costume is an area I'm interested in, so I'm very happy!

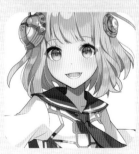

PN: Enishi
TINAMI ID: 48135
Page 55 School Uniform x Mechanical Objects

Thank you for the outstanding performance award. I am extremely honored. I hope my work will be of some use for those who create illustrations.

PN: **Nekotaro Shinonome**
TINAMI ID: 18866
Page 52 Blazer x Fire

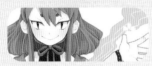

PN: **mochi**
TINAMI ID: 19106
Page 98 Japanese Dress x
 Cherry & Plum

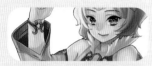

PN: **Nekota**
TINAMI ID: 35162
Page 111 Ethnic Costumes x
 Wind

PN: **hariko**
TINAMI ID: 48872
Page 49 School Uniform x
 Flowers

PN: **Tsukikage**
TINAMI ID: 48048
Page 110 Eastern Europe x
 Arctic Fox

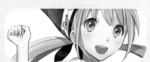

PN: **Nakahara**
TINAMI ID: 11050
Page 112 Eastern Europe x
 Water

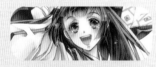

PN: **Ako Tenma**
TINAMI ID: 5509
Page 104 Japanese Dress x
 Mechanical Objects

PN: **Yui Hazuki**
TINAMI ID: 7322
Page 99 Japanese Dress x Frog

PN: **Aoi Mizuumi**
TINAMI ID: 21510
Page 93 Gothic Lolita x
 Mechanical Objects

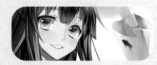

PN: **Koken**
TINAMI ID: 39621
Page 111 Vietnam x Water

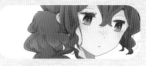

PN: **musubi**
TINAMI ID: 41582
Page 91 Gothic Lolita x Earth

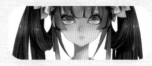

PN: **Nia**
TINAMI ID: 48529
Page 86 Gothic Lolita x Plants

PN: **akito**
TINAMI ID: 18110
Page 55 School Uniform x
 Mechanical Objects

PN: **Tunotsuki**
TINAMI ID: 23711
Page 50 School Uniform x Fox

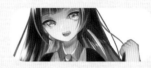

PN: **Kure**
TINAMI ID: 17274
Page 89 Tailcoat x Swallow

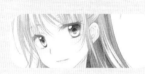

PN: **Yuenatsuki**
TINAMI ID: 1307
Page 51 Sailor Uniform x Bird

PN: **Iro s**
TINAMI ID: 2457
Page 113 Thailand x
 Mechanical Objects

PN: **Koharu Fukami**
TINAMI ID: 30039
Page 109 Sicily x Plants

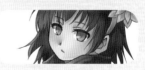

PN: **Fumi Akari**
TINAMI ID: 19467
Page 109 Peru x Plants

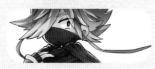

PN: **Karumon**
TINAMI ID: 34902
Page 102 Ninja x Wind

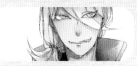

PN: **inari**
TINAMI ID: 43497
Page 51 Standing Collar x
 Sea Dragon

PN: **Reira**
TINAMI ID: 45533
Page 92 Gothic Lolita x Fire

PN: **murach**
TINAMI ID: 28110
Page 101 Japanese Dress x
 Wind

PN: **Riku Takahashi**
TINAMI ID: 2127
Page 94 Lolita x
 Mechanical Objects

PN: **Amo**
TINAMI ID: 34183
Page 90 Gothic Lolita x Water

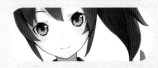

PN: **Jun**
TINAMI ID: 23564
Page 104 Japanese Dress x
 Mechanical Objects

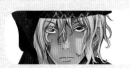

PN: **Sena Shinboku**
TINAMI ID: 47403
Page 112 Pakistan x Earth

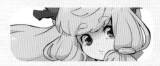

PN: **Utsuhira**
TINAMI ID: 48421
Page 100 Shrine Maiden x
 Water

PN: **Raichi Kohinata**
TINAMI ID: 14849
Page 49 Blazer x Fallen Leaves

PN: **Chanami**
TINAMI ID: 3931
Page 102 Geisha x
 Mechanical Objects

Other References (in no particular order)

- Research and Design for Fashion *Simon Seivewright, Richard Sorger (BNN)*
- The Chronology of Fashion: From Empire Dress to Ethical Design *N J Stevenson (Bunka Publishing Bureau)*
- Watanabe Mayu School Uniforms Illustrated The Last School Uniform *Mayu Watanabe (Shueisha)*
- The Worldwide History of Dress 1: Middle East, Europe, Asia *Patricia Rieff Anawalt (Shufusha)*
- 100 Ideas that Changed Fashion *Harriet Worsley (BNN)*
- Western Armor: Pose and Action Collection *Toshi Miura (Bijutsu Shuppan-sha)*
- History of Western Clothing, Illustrated Edition *Edited by Iku Tanno (Tokyodo Shuppan)*
- Sanseido Illustrated Library: History of Fashion *Written and illustrated by Piero Ventura (Sanseido)*
- History of Fashion, Newly Revised, Third Edition *Norio Chimura (Heibonsha)*
- Food, Clothing, and Housing around the World for International Understanding 9 Asian Folk Costumes Supervised by Akira Ishiyama / Written by Yoko Kubota *(Komine Shoten)*
- Food, Clothing, and Housing around the World for International Understanding 10 Traditional Folk Costumes of Europe, North & South America, Africa and Oceania *Supervised by Akira Ishiyama / Written by Yoko Kubota (Komine Shoten)*
- Research to Learn: Japanese Food, Clothing and Housing What Have the Japanese Worn? *Supervised by Yasuhiko Murata / Written by Mie Fukuhara (Dainippon-Tosho)*
- The Chronicle of Western Costume *John Peacock Thames & Hudson*
- Napoleon's Army 1790-1815 *Lucien Rousselot Andrea Press*
- Historic Costume in Pictures (Dover Fashion and Costumes) *Braun & Schneider Dover Publications*
- Fuzoku Museum home page (as of February 2014) http://www.iz2.or.jp/
- Kimono Club (as of February 2014) http://www.kimonoclub.info/
- Medieval Military Costume: Recreated in Colour Photographs *Gerry Embleton (The Crowood Press)*
- Costume in Detail: Women's Dress 1730-1930 *Nancy Bradfield (Eric Dobby Publishing)*

"Books to Span the East and West"

Tuttle Publishing was founded in 1832 in the small New England town of Rutland, Vermont [USA]. Our core values remain as strong today as they were then—to publish best-in-class books which bring people together one page at a time. In 1948, we established a publishing outpost in Japan—and Tuttle is now a leader in publishing English-language books about the arts, languages and cultures of Asia. The world has become a much smaller place today and Asia's economic and cultural influence has grown. Yet the need for meaningful dialogue and information about this diverse region has never been greater. Over the past seven decades, Tuttle has published thousands of books on subjects ranging from martial arts and paper crafts to language learning and literature—and our talented authors, illustrators, designers and photographers have won many prestigious awards. We welcome you to explore the wealth of information available on Asia at www.tuttlepublishing.com.

Published by Tuttle Publishing, an imprint of Periplus Editions (HK) Ltd.

www.tuttlepublishing.com

COSTUME MATRIX
© Junka Morozumi, Tomomi Mizuna 2014
English translation rights arranged with
MAAR-sha Publishing Co., Ltd
through Japan UNI Agency, Inc., Tokyo

English translation Copyright © 2023 Periplus (HK) Ltd.

Library of Congress Cataloging-in-Publication Data in process

ISBN 978-4-8053-1749-5

25 24 23 10 9 8 7 6 5 4 3 2 1

Printed in China 2305EP

Distributed by

North America, Latin America & Europe
Tuttle Publishing
364 Innovation Drive
North Clarendon, VT 05759-9436 U.S.A.
Tel: 1 (802) 773-8930
Fax: 1 (802) 773-6993
info@tuttlepublishing.com
www.tuttlepublishing.com

Japan
Tuttle Publishing
Yaekari Building 3rd Floor
5-4-12 Osaki
Shinagawa-ku
Tokyo 141 0032
Tel: (81) 3 5437-0171
Fax: (81) 3 5437-0755
sales@tuttle.co.jp
www.tuttle.co.jp

Asia Pacific
Berkeley Books Pte. Ltd.
3 Kallang Sector, #04-01
Singapore 349278
Tel: (65) 67412178
Fax: (65) 67412179
inquiries@periplus.com.sg
www.tuttlepublishing.com